*Dag*

ESSAYS IN ART AND CULTU1

*as always.*

*Raymond.*

# Francis Bacon
## *and the Loss of Self*

Ernst van Alphen

Harvard University Press

*Cambridge, Massachusetts* 1993

*for Mieke*

First published in the United States of America in 1993
by Harvard University Press, Cambridge, Massachusetts
Published in Great Britain in 1992 by Reaktion Books, London
Copyright © 1992 Ernst van Alphen
Printed in Great Britain
10 9 8 7 6 5 4 3 2 1

This book is printed in 130gsm Fineblade Smooth,
an acid-free stock made from 100 per cent chemical woodpulp,
and its materials have been chosen for strength
and durability.

*Library of Congress Cataloging-in-Publication Data*
Alphen, Ernst van.
    Francis Bacon and the loss of self / Ernst van Alphen.
        p.   cm.—(Essays in art and culture)
    Includes bibliographical references.
    ISBN 0-674-31762-9
    1. Bacon, Francis. 1909—  —Criticism and interpretation.
I. Title.   II. Series.
ND497.B16A9   1993                                    92-10641
759.2—dc20                                                CIP

# Contents

# Acknowledgements

A postdoctoral fellowship awarded by the Dutch Foundation for Scientific and Scholarly Research (NWO) in 1989 permitted me to spend a year studying within the context of the Word and Image programme at the Free University of Amsterdam. A grant from the National Endowment for the Humanities made it possible for me to participate in the summer school 'Theory and Interpretation in the Visual Arts' at the University of Rochester in 1990. An earlier version of the first chapter of this volume appeared in *Poetics Today*, II, no. 3 (Fall, 1990), while parts of Chapter Two were published in *Word and Image*, VII, no. 1 (March, 1991). I am grateful to the editors of these journals for their willingness to reassign me the necessary permissions.

Conversations I have had with many friends have contributed to this book. I would especially like to mention Frans Willem Korsten, Norman Bryson, Kaja Silverman, Cynthia Chase, Maaike Meijer, John Neubauer, Sandor Kibédi Varga, Susan Suleiman, Brian McHale, Michael Holly and Keith Moxey. Kate Austin of Marlborough Fine Art London was indefatigably helpful in locating paintings and providing photographs and other information. I would also like to thank Stephen Bann and the staff at my publishers, including Harry Gilonis and Robert Jameson. Jane Carter provided valuable help in correcting my English. I am especially grateful to Mieke Bal for her stimulating criticism, and for the support and confidence she has provided. I dedicate this book to her.

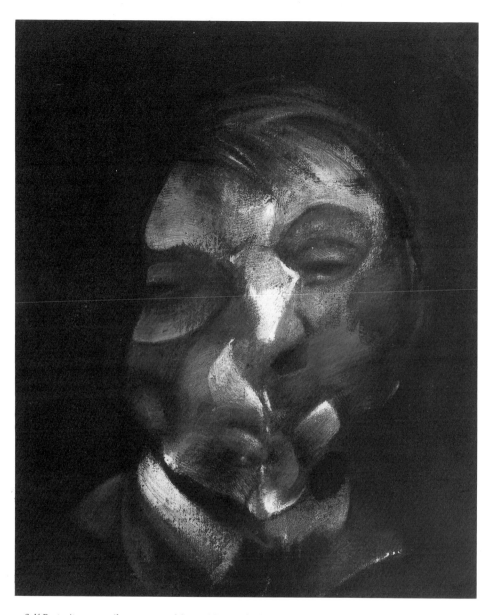

1 *Self Portrait*, 1971, oil on canvas. Musée Nationale d'Art Moderne, Paris.

# Introduction: Reading as Loss of Self

Seeing a work by Francis Bacon hurts. It causes pain. The first time I saw a painting by Bacon, I was literally left speechless. I was touched so profoundly because the experience was one of total engagement, of being dragged along by the work. I was perplexed about the level on which these paintings touched me: I could not even formulate what the paintings were about, still less what aspect of them hurt me so deeply.

As soon as I became aware of this incapacitation, however, I realized that it was not new, and that other works of literature and art have also had this disabling effect on me. Whether I am unable to write about this effect, or have simply refrained from trying, I do not know; but the truth is that I have never written a word about the fascination I have felt for specific novels or works of art. Of course, I manage to write (I hope) interesting and relevant things about these paintings or about literary works. But my own emotional involvement, which is, after all, the impetus behind these analyses, remains unaddressed and unclear even to myself. This blank, this paralysis in my inter-course with works that affect me, has been reflected in my silence about that feeling of paralysis – until now. The sense of paralysis became the starting-point for this book when I noticed that others, too, were incapacitated by Bacon in this way, and when I realized that critics of Bacon had also avoided discussing this effect. This book is an attempt to avoid that avoidance; it is an attempt to deal with the 'affective' quality of Bacon's works in a way that simultaneously demonstrates and explains it.

This inability to reflect upon the very aspects of works that touch one most seems to be caused by a momentary *loss of self*. The capacity to reflect seems to be temporarily narcotized, so that the intensity of the experience itself precludes reflection upon one's emotional state. However, rather than using this insight as an excuse to avoid further efforts to account for the effect that certain works of art produce, I will pursue the investigation. To be sure, any unmediated insight into

the experience must be impossible, because I, the writer of this book, have been suspended from existence, my self drawn and drowned inside the work. At the moment of being touched, 'I' was 'lost'. But still, if I am to say who 'I' am, I need to know more about my moments of self-loss. It is this 'self-ish' need that pushes me to inquire into what might be termed 'affective reading'.

Francis Bacon's paintings are an obvious starting-point for such an inquiry, since they almost appear to be *about* self-loss, and to deal with the *theme* of loss of self. What I am interested in discovering here is, precisely, the relationship between theme and effect; in other words, I am interested in finding out why it is that works whose constative message is about loss of self also actively bring about such a loss.

According to most critics of Bacon, his works are about violence, torment, fragmentation, loss. His work is discussed in terms of existential themes. Although such readings are not completely beside the point, they do not tackle the most characteristic aspect of Bacon's work. For it is not the violence as subject-matter of the paintings that must be addressed; rather, it is the violence done to the viewer that demands to be examined if we are to understand how these works function. Although the critics always express intense admiration for Bacon's paintings, they are usually unwilling to reflect upon the effect that the works have on them. They do not reflect upon the connection between their own admiration and the theme of violence that they read in the works. No critic has admitted that the violence itself exercises a particular attraction for him or her; yet when one asserts the thematic centrality of violence, while at the same time expressing admiration, such an inference is hard to avoid. The thematic approach to Bacon's works seems to create a distance, which his critics apparently feel to be necessary. But this approach only thinly veils the recurrent feature of this criticism: the denial of the effect of the paintings.[1]

The other vein of Bacon criticism, the one more traditionally art historical, avoids the issue of effect in an even more blatant manner. Here, the focus on visual art in terms of the history of forms and motifs masks a profound denial of what this particular visual art most acutely is: an act, a performance, and an event. The insistence on the act of painting in terms of colour, shape and composition, covers up the denial of 'painting

according to Francis Bacon': its particular *moving* quality – in the literal sense.[2]

Bacon himself directs the discussion towards a collaboration of theme and effect by his famous phrase that he wants his work to 'hit the nervous system'. This is precisely what seems to happen *in* the paintings: it explains the distortion of bodies and faces, the dissolution of boundaries, the pain, the mouths opened as if screaming, the agonies, paralyses, crises. The figures appear as nervous systems laid bare and struck. But it is also what happens *through* the paintings. Bacon's paintings also make viewing a painful experience; they render viewers speechless. This explains the failure of Bacon's critics to analyse – rather than to describe or applaud – the paintings. It also explains the critics' intense engagement, their inability to leave the works alone, for Bacon's work makes indifference impossible.

In each of the five chapters of this book, I will try to demonstrate how Bacon's works hit the nervous system, not only of the viewer, but also of Western culture and its artistic traditions. His works take issue with conventions of language and representation that are central to the history of Western art. Bacon's paintings call into question expectations of narrative, reflection, chiaroscuro, life-likeness, discovery and truth, beauty and the body. In this study, therefore, I will address not only the question of *affect*, in all its violence, but also the way this 'affect' works against conventions that are so much a part of our way of seeing that attempts to touch them, touch us.

Bacon's paintings contain important propositions about the conditions and premises of figural representation. Bacon has crucially important things to say about issues that lie at the core of contemporary culture: issues of representation, of gender, of the body, of vision, as well as the intricate connections between these; and these are issues that art history as a discipline has not allowed itself to address. To be sure, contemporary art history has developed, and cherishes, a discourse that is distinct from that of iconography and influence: the discourse of context. But, as Norman Bryson has noted, this notion of context sits firmly within a rhetoric of synecdoche which fails to address the challenging paradox formulated by Culler: 'meaning is context-bound, but context is boundless'.[3] Moreover, this notion of context does not place the art it attempts to explain within the cultural-theoretical context

of contemporary debate. That is why I will refrain from linking up with the formulaic art historical discourse of context.

But saying that these paintings contain propositions about figural representation is, perhaps, to miss the point. For the paintings enact, embody, *are* or *do* those propositions. Rather than subjecting them to a theoretical discourse, then, I will make Bacon's works speak 'theoretically' in their own right. This should not be taken as a form of theoretical imperialism; on the contrary, the very gesture by which I propose Bacon as a theorist profoundly modifies the notion of theory. Taking that notion back to its etymological sense of 'in-sight', I will endorse, and then move beyond, the Yve-Alain Bois vision of 'painting as model'.[4] Painting becomes a model for theoretical thought, a philosophy of representation and a paradoxical aesthetic, but only by turning theory into a confrontation that is by definition dialogical.[5]

I will make Bacon speak theoretically, then, by analysing five different but related aspects of Bacon's work, each consisting of an apparent paradox and its solution. Thus, in the first chapter, I will start from the tendency in Bacon criticism to take the paintings as narratives, despite the artist's resistance to such readings. Rather than accepting either the critics or the artist as 'owner' of the truth about these works of art, I will consider this conflict of interpretation as itself a symptom of a central feature of the works. I will argue that the paintings do, indeed, strongly convey a sense of narrative and that this explains the critical impulse to 'narrativize' them; but I will also argue that these works preclude the construction of any particular narrative, thus demonstrating the artist's point. By shifting the issue from the search for a (thematic) narrative content to a reflection on narrative as a process, I will suggest that the particular narrative quality of the works resides in their power to set in motion a process of looking that is itself dramatic enough to produce a narrative interaction between the work and the viewer. The sensation that the works are narrative is therefore rightly felt, and it provokes the attempt to 'read' the narrative, which is, however, wrongly pursued.

This narrative process is effectively imposed upon the viewer because of a coincidence between the scene on the canvas and the interaction between canvas and viewer. While interacting with the viewer, the figures also stand in for the viewer, representing a role, if not a role-model, of a particular

way of looking. Thus, the figures propose for the viewer a narrative model which accepts the task of being part of a narrative without being able to know its content. The figures are behaving *like*, as well as being engaged *with*, the viewer. This first chapter, then, will develop Bacon's theory of affective narrative.

Having argued that the central narrative in Bacon is about looking, I will explore in Chapter Two the particular kind of looking that is at stake. The role of the viewer is a painful one, I will argue, because all the deceptive certainties of the visual regime we are used to are challenged; all the relationships between looking and what (we think) we see are cancelled; and all the positive constructions of bits of reality are questioned, wiped out, unmade. Bacon's works, as a self-conscious intervention in the history of art, respond to the conventions that have dominated Western art for centuries. Issues such as light and shadow, representation and reflection, substance and transparency, are not givens but topics of discussion in Bacon's art. Bacon's paintings form part of the insight, current in the postmodern era, that far from reflecting reality, language – in this case the language of art – constitutes it; that the subject is the product rather than the producer of representation, and that paint does not stand in but stands before the figure, not uncovering but hiding it. In some of his paintings, Bacon characteristically literalizes his propositions, wiping away the paint that would otherwise give substance to bodies, and that gesture, the trace of which constitutes the work, must be taken seriously, 'literally', as a sign proposing a statement.

This statement often takes the form of an ironic commentary on the idea of mirroring. To be sure, as in the most famous works of the canon of Western art, there are mirrors represented in Bacon's work. But this device for reliable reflection and realistic representation is a means to turn the table on the viewer trapped in this conventional illusion. Instead of reality or the subject, looking itself is reflected in the works, and this has consequences for the position and activity of the viewer. Bacon represents that which he means to cause in the viewer. The eye, Bacon suggests, does not reveal but instead dissolves, does not produce but instead destroys, does not make but instead unmakes the object of looking. This is the violence of the painting, represented while happening. This, then, is Bacon's theory of affective vision.

Hence, we might say, using a variation of Derrida's phrase, that there is no life outside representation. Again, Bacon literalizes this statement. In Chapter Three I will explore Bacon's particularly threatening play with life and death. In this remarkably self-confident body of art, a game with death presents the crucial importance of representation – the site where life is constructed – as specifically *visual*. Many of Bacon's early paintings, in which he responds to Velázquez's portrait of Pope Innocent X, represent pain, screaming, dying, and violent death. But these paintings are by no means 'life-like' representations of death; such a realistic account would completely undo the effect of the paintings, and although one can sympathize with a suffering pope, there is no reason for the viewer to worry when seeing his death staged. Yet, the viewer worries. And for good reason: I will argue that these paintings undermine the most basic assumptions we hold, consciously or unconsciously, about the reassuring effect of representation as a stronghold against inevitable death, 'eternalizing' at least the image of the subject who will have to die. Again, Bacon deprives us of such illusions. Representation is not life, instead life is shown to be sheer representation.

Representation, then, cannot preserve life but can only expose its undoing. Nor can representation reveal the essence of life. Representation which attempts to uncover life, to find its true essence, can only reveal death. Literalizing again, Bacon demonstrates that 'behind' the paint there is nothing: that it is 'death' that is represented in the paintings. The only life is *in* the representation; for representation is all there is. Hence, not only are Bacon's figures themselves represented as lacking substance, overflowing as well as hollowed out, skinless and shapeless, but also the representation of them, the paint itself, has holes in it, if it is not wiped out, effaced, or simply absent. For the viewer, then, there is no escape through a conventional catharsis. The viewer cannot sympathize with the threatened victim of violence, and then breathe again once the execution has taken place. The suspense of looking, the excitement of looking behind the curtain of representation, is not relaxed but violently brought to an end at the moment the viewer realizes that there is ultimately nothing to see. This narrative of perception has no happy ending. This is Bacon's theory of affective representation.

Locked up in a perpetual conflict, the viewer is not released

but mortified, and this mortification is so inevitably *relevant* that it is impossible for the viewer to disentangle her- or himself from it. This is so because the paintings convey a sense of the conflict between two discourses and conventions that constitute the culture we live in. They 'look back': they make one feel that the self depends on them for its existence. The issue here, the issue which will be discussed in Chapter Four, is the construction of the self through the gaze of the other. The paintings constitute such a gaze. But, rather than benignly bestowing form upon the viewer's self, rather than providing a sense of wholeness, for which the self is dependent on the gaze of the other, the paintings *are* that gaze while also exposing its mortifying power of withholding the wholeness one needs so badly. They do not shed the light of creation – the light that clarifies, integrates, secures – as when 'God said: let there be light, and there was light'. Instead, they lay bare a lack of substance, of form, of boundaries – elements that the viewer's self should be made up of, but is not.

The final chapter pulls all these themes together in an exploration of Bacon's position vis-à-vis perhaps the most crucial issue concerning the construction of the self in Western art: the representation of the gendered body. In two distinct ways the paintings respond to the cliché of the female body, and offer an alternative to the passive, colonizing convention of identifying woman with beauty and beauty with woman. The first way that they respond is by shifting the focus: female bodies are rare and marginal, while male bodies are frequent and central. Whenever female figures are represented, the paintings reverse and deconstruct the conventional forms and meanings. By offering female nudes, lying on beds, but actively desiring and objectifying the viewer (that is, transforming the viewer into the object) rather than being objectified by him, Bacon makes the viewer aware of the pain of 'objectification'. The second way that they respond to the cliché of the female body is by making the viewer reflect upon, and then offering a term by term deconstruction of, the standard constructions of masculinity. The analysis of masculinity as a cultural construction of gender is the more acute as masculinity is so rarely taken at its word, and its most basic assumptions are so rarely examined. Bacon's representation and subsequent undermining of the masculine self is probably the most affectively striking – and the word 'striking' needs to

be taken literally here – of his ongoing attempts to unsettle fixed discourses. It is in this analysis that the effect of reading his work is the most painful: there where the conventions of the history of art and its audiences are the most obviously imperialistic, at the site of genderization, the paintings strike back with an extraordinary force. This theory about Bacon, wherein all five issues, previously separated, join forces, may best be called a theory of affective embodiment.

This book, then, is an exercise in affective reading. But if, as I contend, Bacon's work is all about challenging, complicating, and undermining representation, then the attempt to write about this process will be caught in a paradox. For writing about art is also a representation of it. This is the main reason why, in my view, most of Bacon's critics fail to account for the 'affect' to which at the same time they are subjected. 'Affect' is a process of interaction. And interaction requires the equal contribution of all participants. But most criticism belies this equality. Affective reading requires that the usual hierarchies, pervasive if implicit in criticism, be suspended as much as possible. There can be no a priori certainties about superiority, fixity, or self-evidence. There can also be no certainty about 'who' is 'right' in the debate: the work of art or the critic, the painting or the theory, language or visuality. And unless one is self-conscious of the necessity of engaging the work of art in as egalitarian a manner as possible, affective criticism is doomed from the start. While I do, of course, have some claims to make and contentions to argue for, I realize that the discourse laid down in this book has no secure status. This, one can imagine, will have some consequences for method. My method is best characterized by the term *obliquity*.

In the first place, I do not believe in an absolute difference, let alone an opposition or hierarchy, between language and visuality. As the preceding description of the five key issues in Bacon has suggested, I consider Bacon's art to be a discourse: it has something to say, it has propositional content. By no means should this be taken to suggest that I think Bacon's work is art 'à thèse', illustrative of a statement independent of, or alien to it. On the contrary, like any discourse, this body of visual art embodies what it says and says what it is; it makes its points by its very visuality. The most appropriate set of tools for analysing this visual discursivity is therefore semiotic. I will

consider the paintings as meaningful and as consisting of signs that produce meanings in interaction with the responsive viewer. I will 'read' the paintings, that is, I will attribute meaning to elements (signs) that provoke in me as viewer certain meanings. These signs are often details, including representational elements (body-parts, dress, gazes, or hands), but also devices (impasto, distortion, erasure, drawing), and elements (arrows, light bulbs, shadows, holes, structures, landscapes) that mediate between these two categories. The convergence of details that support and reinforce each other increases the striking force of the works; Bacon's works have not been analysed 'affectively' so far, because Bacon's critics, scared away by the affective qualities of the works, tend to jump immediately to thematic or art historical conclusions. But the talk about violence as some sort of existential, dramatic theme, does violence to the paintings, and I wish to oppose this tendency toward escapism by analysing the function of the tiniest details in the pictures. Hence, the semiotic perspective, obliquely brought to bear on an interaction that partakes of language and of visuality, is pulled toward its pragmatic dimension.

My method of enquiry must also be conceived in terms of the oblique relationship between the paintings, the artist, and the critic. Bacon is a self-conscious and vocal artist who has not refrained from strong and repeated statements about his work. Critics tend to quote Bacon's statements as true, authoritative accounts of his works and, as good students, they proceed to do their homework and point out how Bacon's views are substantiated in the works. But in their zeal to substantiate their mentor's views, the critics have not done their homework correctly. For example, while endorsing Bacon's resistance against narrative, critics continue to read the works in such a way that the inevitable result is a narrative after all. While I consider such contradictions evidence of the affect of the paintings, the critics themselves seem happily unaware of the paradox. In contrast, I will entertain an 'oblique' relationship between the three of us – myself, Bacon, and his works. I will not attempt to 'fit' his statements to his works, but instead consider the two as possibly involved in a conflict that poses a challenge to the third party in this enquiry – myself.

Another consequence of the method necessitated by my

approach is that I must try to write 'about' art that is not 'about' anything but, instead, is *doing* things. To do this I will constantly emphasize throughout this book the obliqueness of my account by drawing in other discourses, by welcoming these intellectual intruders and letting them speak, and by taking them no less seriously than I take Bacon, the paintings, or indeed myself. These other discourses may be theoretical, like the discourse of narrative theory in Chapter One, or the theory of schizophrenia invited in at a relevant juncture in Chapter Two or, again, the theories on masculinity in Chapter Five. Or they may be literary, like the postmodern mystery novel and the modernist classic discussed in Chapters Three and Four. The first, Willem Brakman's *The Fatherkillers*, is a novel that responds to Bacon's works; we will see it step into the argument in Chapter Three to transgress the generic discourse of artistic convention by commenting upon the portrait as genre. This novel is a case of productive reception, a creative and responsive reading and rewriting comparable to Bacon's reworking of Velázquez's paintings. Thus, Brakman-on-Bacon helps to assess the importance of Bacon-on-Velázquez as a means to gain insight into historical change of artistic practice outside of the narrow bond between one master and one disciple. This emancipation from the more traditional type of study of influence is crucial, as it entails a view of cultural history that avoids the traps of individualism and authoritarianism. Instead, Bacon-with-Brakman offers a theory of art history in terms of production – the production of pain.

The second literary discourse brought into dialogue with Bacon's works is not a response; it is a co-text rather than a post-text. Djuna Barnes's famous modernist novel *Nightwood* has always had the same disabling effect on me as Bacon's paintings, and like those paintings it is both about, and causes, loss of self. I will confront Barnes's novel and its affective quality in Chapter Four. Last but not least, I will consider the major conventions of Western visual art that are addressed by the paintings, such as the convention of the nude, and certain cultural traits, such as the tradition of body-building, in Chapter Five. I will assume that the conventions have meaning, and I will suggest that Bacon does more than merely counter and displace them as traditional modes of representation. I will contend that he contradicts the propositional content of the conventions. His changing of the conventional representa-

tions of the gendered body, to quote just one obvious example, also counters the ideology of gender so perniciously produced and confirmed by these representations.

My invitation to other discourses to participate is not only a means of saying things that are hard to say otherwise. It is also a way to place the art and its maker within a culture: as participants and discussants, not as elite, untouchable master-pieces at which we can only gaze in wonder, saying 'how beautiful' when we like them, or 'how painful' when they hurt. The awe we traditionally offer up before works of art will be made to yield to dialogue, the objectification of the work will yield to self-exploration, and the obedience to authority will yield to serious interest in what all the participants have to say. This, it seems to me, is a more promising starting point for an enquiry which attempts to understand not what the mes-sage, theme, or content of a work of art is, but what really happens when reading hurts.

This book was already in press when I heard of Francis Bacon's sudden death on April 29th, 1992. His death brought to completion an extraordinary oeuvre in which death is a constant active presence. No body of painting of our time presents death's vital concerns in such close connection to both what precedes and surrounds it.

# 1 Narrative

*And the moment the story is elaborated, the boredom sets in;*
*the story talks louder than the paint.*
FRANCIS BACON[6]

Is Bacon's painting usefully characterized as narrative or, conversely, is denying its narrativity an illuminating gesture? Take his *Triptych May-June 1973* (illus. 2, 3, 4), a quite typical work in regard to the problem of narration. The work seems to be set in one space, and this space might be occupied by a single figure, reappearing in different scenes or episodes. It might, or it might not. Is the question of whether this is a narrative work relevant at all to an understanding of Bacon's painting?

Francis Bacon is deeply suspicious of narrative. For him, narrative seems to be the natural enemy of vision; it blinds. Narrative is boring because it precludes the direct actualization of a painting via the viewer's perception. Story-tellers are seducers, diverting the audience's attention from what there is to see.

A similar charge can be alleged against the theory of narrative – narratology. Indeed, the most serious challenge to narratology in the past ten years has been the one posed by the postmodernist aesthetic and its special attitude toward history. Theorists of narratology have been blamed for having constructed narratological concepts on the model of nineteenth-century realism, and for being fundamentally ahistorical, and thus incapable of addressing the historical specificity of the paintings studied.

Postmodernism has challenged narrative as well as narrative theory. First of all, postmodernists do not believe in what has traditionally been one of the main functions of narrative: to lend meaning to life, to our place in the world. As Lyotard has argued, the 'master plots' of Western culture ('métarécits de legitimation') have lost their explanatory and legitimizing function. They can no longer provide us with ontological certainties.[7] Yet this loss has caused a resurgence of, rather

than a decrease in, the production of narratives. Narrative genres like the historical novel are back, displaying their narrativity more openly and abundantly than ever. Furthermore, paradoxically, some postmodernists continue to use multiple narratives in an attempt to undermine the force of narrative by play. Others, and Bacon is among these, have chosen to oppose, close off, and block narrative.

Postmodern narrative not only involves a change of the function of narrative; it also requires a change in its forms. Distinctions between external and internal narrators, focalizers and characters, which are usually sharply delineated in realist and modernist texts, are mixed up in many postmodernist works. A similar mix-up occurs in the external functions of reader and author. The author and the reader are usually excluded from the analysis of narrative because they are the subjects not of narrative but of the situation of communication in which narratives are exchanged. In postmodernist narratives, however, author and reader are introduced *into* the narrative, and either their roles are emphasized or the meaning of those roles is addressed. By doing this, postmodernist narratives pose a challenge to many narrative theories, especially those theories based on taxonomic efforts that form typologies of narratives (e.g. Stanzel and Genette), rather than those that focus on aspects of the narrative text (e.g. Pavel and Bal).[8] Postmodern narratives show that narrative typologies offer too limited a conception of narrative, a conception that can only deal with the particular narrative texts on which the typologies were founded.

In this chapter I will explore the problematic status of narrative in the paintings by Francis Bacon. I will examine how these paintings can be read as narrative, if at all, and how narratology can help us decide this question. I will use narratological concepts, especially focalization, to show in which sense Bacon's paintings *are not* narrative and in which sense they *are*. The question, then, will not be *whether* his works are narrative, but *how*, and in what sense, they can be read as narrative.

Although narrative is not solely the purview of verbal texts, until now narratology has been developed mainly within literary studies. It is not self-evident that literary narratological categories can be applied to the analysis of visual texts. Therefore I will first try to show to what extent narratological

categories can be used for the analysis of visual works, and then I will show how they can be applied. This application will require a reversal: I will take Bacon's works as a theoretical perspective on the text called 'theory of narrative', so that 'work' and 'theory' change places.[9] Thus the presentation will take the form of a confrontation between three 'discourses', the first produced by Bacon (his paintings as well as his views), the second by literary scholarship, and the third by an oddly placed mediator, the critic.

## THE ILLUSION OF NARRATIVITY

The question of the narrative interpretation of paintings is especially relevant here because the paintings of Francis Bacon have given rise to quite a few narrative readings while, equally frequently, the artist has objected to that kind of reading. The fact that his work is read narratively should not have surprised the artist because Bacon's works display at least three elements which are traditionally seen as signs of narrativity.

Firstly, in many of Bacon's paintings two or more characters, or figures, are placed in the same space, suggesting a kind of interaction between them. It seems as if something is going on, as if characters are caught in the middle of an act. Even when the act involves a non-movement, like sleeping, lying down, waiting or sitting, the figures always have a strong dramatic charge. The characters seem as if they are not just there to be exhibited and exposed to the viewer.

Secondly, many of Bacon's works are composed as triptychs, a genre that traditionally displays temporal continuity spatially. The work will depict three scenes from the same fabula, with the first event on the left panel, the next on the central panel, and the last on the right panel. For instance, the crucifixion of Christ, frequently depicted in triptychs, will have Christ carrying the Cross in the first panel, the crucifixion itself in the next panel, and the descent from the Cross in the last.

This type of triptych is a plain representation of a story. Its narrativity is obvious. But even when the viewer does not know the story 'behind' the representation, the mere fact that the main character returns in different scenes on all three panels makes it quite obvious that the viewer is intended to postulate a coherent development in time between the

scenes.[10] But even when the temporal sequence is down-played, one can argue for its narrativity. Although the three panels may only represent different parts of one space at the same moment, the triptych as a whole can still be read as representing a narrative. The theme of the crucifixion again makes a convenient example: Christ may be depicted on the Cross on the centre panel, with the two criminals on their crosses in the left and right panels. Still, the pre-history (the way of the Cross) and the immediate future (the descent from the Cross), are implicated without being represented, as parts of the same story.[11]

Some of Bacon's triptychs suggest a temporal continuity, others a spatial one; in still other cases it is not clear which continuity can be postulated. Nevertheless, although there is much variety and ambiguity in the ways in which the panels of Bacon's triptychs cohere, narrativity can always be sensed and experienced as a key to the triptych's coherence.[12]

The third element that provides Bacon's works with a strong sense of narrativity is the application of the paint itself. In representing figures or characters, Bacon's handling of paint is much 'rougher' than when he paints the space around these figures. This rough style of painting seems to evoke or imply movement. Even in his portraits, there tends to be a sugges-tion of movement. The heads or bodies appear to be in motion, or the bodies are afflicted by movement of some kind. Move-ment, seen as a development in time, or as a sequence of events, is a crucial characteristic of narrative. Without move-ment in time there is no narrative.[13] This explains why the marked presence of movement in Bacon's works creates the illusion of narrativity. *Something* seems to be going on there, even in the portraits. And it is the paint which produces that narrative feeling.

These three characteristics, then, stimulate the viewer to-ward narrative reading. This compulsion to narrativize feeds upon several sources for complementary information: histor-ical knowledge, or the projection of the historical plot; fictional imagination, or the projection of a plot of the viewer's making; and biographical knowledge, or the projection of the life of the artist onto the artefact. These three sources can be combined in one narrative reading.

Hugh M. Davies's article 'Bacon's Black Triptychs'[14] offers an illustrative example of how Bacon's paintings tend to be

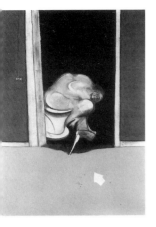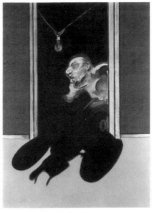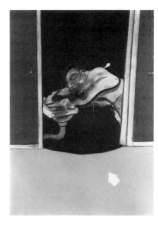

read narratively. He reads two triptychs, *Three Portraits, 1973* and *Triptych, August 1972,* as comparable because of the shared triple doorway setting and because they were painted within the same year. With their comparability established, he assigns to these triptychs a spatial continuity: they can be seen as either a panoramic view of a room with three doors spaced evenly along a continuous wall, or as three separate images of figures viewed from slightly different angles before the same doorway. In contrast, he reads a third triptych, *Triptych May-June 1973* (above, and illus. 5, 6, 7), again with the same doorway setting, as an illustration of a sequence of events. Thus he assigns temporal continuity to this triptych. It shows, according to Davies, a single subject performing sequential actions, just like still shots from a film. This would imply that Bacon violates two conventions of the triptych: the left-right progression,[15] and the consistency of viewpoint. Here is Davies's report on this triptych:

> The space occupied by the subject is a bathroom with two doorways situated in opposite walls. In the left-hand panel our vantage point is through one doorway, while in the center and right panels we look through the second, facing doorway. Very simply stated, the three panels – reading from right to left – depict a naked man vomiting into the bathroom sink then crossing the room, then dying on the toilet.[16]

Clearly, this reading interpolates biographical knowledge into the work's plot. The claim that the man on the toilet is dying, instead of merely defecating, can only be made plausible by

inserting some information on Bacon's private life. Two years before painting this triptych his friend George Dyer had died suddenly on the toilet on the eve of the opening of Bacon's retrospective in Paris. Davies does not give this biographical information, so the unexpected closure of his narrative reading – 'then dying on the toilet' – turns the story into a burlesque tragedy.

But how relevant is Bacon's biography to the reading of his paintings? And if it is not relevant – after all, Davies does not mention Dyer's death in this context – to what extent does this kind of narrative reading, this projection of a life-plot with an ending, account for the painting as a visual work? These questions may be assessed by approaching the work first from a non-narrative perspective. What does the visual composition of the triptych itself say or do? The symmetrical composition of the setting is striking. The light switch at the left of the doorway in the left-hand panel is repeated at the right of the doorway in the right-hand panel. The doorjamb in the central panel is seen frontally, while that in the left-hand panel is seen from a perspective that is more to the right, and that in the right-hand panel from a perspective that is more to the left. Consequently the position of the viewer moves neither from left to right, nor from right to left, as Davies claims, but is fixed in front of the central panel.

Davies's reading – and any narrative reading of this kind – rests on the assumption that the painting *illustrates*. It is a representation of a sequence of events, fictional or not. But the work does nothing to encourage this assumption. It is very hard to see the space in this triptych as an illustration of a different, referential space, for such a reading would have to be able to explain all the details of such a referential space by the space that is 'illustrated'. But Davies ignores many of these details in his narrative, illustrative reading. Where, for example, is the bulb of the central panel in the right-hand panel? Where is the light-switch of the right-hand panel in the central panel? Rather than answering such questions of realism, the space in the three panels seems to undermine such an illustrative reading. Instead it emphasizes its own symmetricality. This emphatic symmetry can be taken as a direction for reading: the reader must not see the actions in the several panels as a sequence or development, but as symmetrical or comparable. The reading, then, would be pushed away from narrativity.

The bodies in pain on the left-hand and right-hand panels may be assumed to excrete bodily fluids: vomit and faeces. But the central panel is different. Here, what strikes the viewer is the shadow coming out of the doorway. This shadow is not at all the natural, realistic representation of the man behind the doorway; rather, it is amorphous and has the visual qualities of a bat-like vampire. And the shadow looks as thick and substantial as a bodily fluid. The figure of the man, by contrast, is bony rather than substantial. He looks like a ghost rather than like a physical, corporeal man. He is air-like, as shadows normally are. Confronting the strange shadow and the equally strange man-figure, we might say that the body seems to dissolve into the shadow, to lose its bodily features to its shadow. The dissolution of body into shadow is a loss that emanates from the body itself. Something in the body is afflicting the body. In this respect it is similar to the figures that painfully excrete bodily fluids in the left-hand and right-hand panels.

This reading does not produce a narrative coherence between the panels. It does not postulate a sequence of events. Yet narrativity has not completely disappeared. All three panels are assumed to be about certain comparable events. There is similarity between the events, instead of the continuity postulated in a narrative reading such as that by Davies. For the events remain ambiguous: whether the body is subject or object of the event, or both at the same time, is not clear. The reversal between substantiality and void in the representation of body and shadow in the central panel also informs the reading of the side-panels, and thus the reading of the triptych as a whole.

AGAINST STORY CONVEYANCE

As I have suggested before, Bacon himself opposes narrative readings of his works. In the famous interviews with David Sylvester he explained several times why he does not like narrative in painting:

> In the complicated stage in which painting is now, the moment there are several figures – at any rate several figures on the same canvas – the story begins to be elaborated. And

the moment the story is elaborated, the boredom sets in; the story talks louder than the paint.[17]

I think that the moment a number of figures become involved, you immediately come on to the story-telling aspect of the relationships between figures. And that immediately sets up a kind of narrative. I always hope to be able to make a great number of figures without a narrative.[18]

Further on in the interviews he makes a meaningful distinction between telling a story and conveying a story. And again, the link is established between narrative and boredom. When Sylvester asks him why it is he wants to avoid telling a story, Bacon answers:

I do not want to avoid telling a story, but I want very, very much to do the thing that Valéry said – to give the sensation without the boredom of its conveyance. And the moment the story enters, the boredom comes upon you.[19]

Bacon seems to propose an opposition between narrative as a product that can be endlessly reproduced, as re-presentation – the 'boredom' is inspired by the *déjà vu* of repetition – and narrative as process, as sensation. Conveying a story implies that a pre-existing story, fictional or not, is transferred to an addressee. Narrative is then reduced to a kind of transferable message. Opposed to this 'conveying of a story', 'telling a story' focuses on the activity or process of narrative. This process is not repeatable; it cannot be iterative because it takes place, it *happens*, whenever 'story' happens. I wish to argue that Bacon's hostility toward narrative is directed against narrative as product, as re-presentation, not against narrative as process.

In his *Logique de la sensation*,[20] Giles Deleuze analyses the means by which Bacon undermines the narrative coherence of his paintings. To that aim, Deleuze proposes to differentiate between the *figural* and the *figurative* (or *figuration*). The figurative is illustrative just as narrative is illustrative by definition. It illustrates and re-presents a sequence of events. Bacon does not pursue the figurative in his work. He does not paint characters, but *figures*. Figures, unlike characters, do not imply a relationship between an object outside the painting and the figure in the painting that supposedly illustrates that object. The figure *is*, and refers only to itself.

Many recurrent aspects of Bacon's works are explained by his interest in the figural and his resistance against the figurative. Interestingly, these aspects also refer polemically to the features of the traditional narrative triptych. First, the figures in Bacon's paintings are often locked in by means of circles, parallelepipeds, or frames within the canvas. These inner frames isolate the figures from one another, blocking the spatial continuity so characteristic of the traditional triptych. Thus, Christ and the two criminals would appear to be separated rather than connected.

Second, in the case of Bacon's triptychs the outer frames of the three panels isolate the figures in each panel from each other. They cut off the story that is predicated upon the relationship between them. Bacon himself explains this use of the triptych as follows: 'It helps to avoid storytelling if the figures are painted on three different canvases'.[21] Of course, this is not how the panels of triptychs traditionally function. But Bacon avoids the expected, because conventional, temporal or spatial continuities between the panels by depicting isolated figures or figural events on the panels.

Third, in terms of a fabula, there is never a clear interaction *between* figures in Bacon's triptychs. Although the figures are felt to be involved in some sort of event, this event resists the connecting links of narrative. Andrew Forge describes this lack of intersubjectivity as follows: 'If one pair of eyes met another, if one pose slid into its next stage, if one gesture had a consequence, if Oedipus had only lifted his head to address the Sphinx, then something could have been felt to have happened that we could watch from the outside. But the homely boundaries of a story are refused.'[22]

Fourth, the figures are isolated in their space by the fact that they have been painted differently. As I indicated before, in the case of the figures the paint handling is much rougher than in the case of the space, or indeed than in the case of objects, such as furniture, within that space. Thus, in most of Bacon's paintings, the space functions not as a neutral environment, but as painterly, brightly coloured fields that enclose the figures.

Because of these aspects of Bacon's works, the figures never fully become characters, while the figural events are never explained by being embedded in a sequence of events. The figures interact neither with each other nor with their environ-

ment. Although Bacon's paintings display many signs which traditionally signify narrativity, and thus stimulate a narrative reading, by the same token any attempt to postulate narratives based on the paintings is countered.

The statement that no narrative can be postulated from these paintings does not imply that narrative is irrelevant to Bacon's paintings, however. Such a conclusion would surely indicate a facile, binary way of thinking. Even if it is not possible to postulate a story of which the painting is an illustration, this does not mean that narrativity is simply denied or undermined by the paintings, let alone simply ignored. For, as I suggested before, the paintings are nevertheless experienced as intensely narrative, because they appear to be in motion. Perhaps, then, we should look for the narrative somewhere else, at another level. Perhaps narrativity is in this case of a different order, and has a different status. The hypothesis I will develop here is that Bacon's narrativity, the illusion of narrative his work arouses, does not so much involve the representation of a perceived sequence of events, but the representation of perceiving as a sequence of events, which are embodied, not illustrated, by the figures. Sequentiality characterizes not the object of perception, but its subject. The narrative is not the content of perception, but defines the structure of perception itself.

Deleuze's study can help us to develop this hypothesis. It pursues the question of what the implications are of certain key expressions that Bacon has often used in interviews: 'orders of sensation', 'levels of sensation', 'domains of sensation' and 'moving sequences'.[23] Sensation is not being used here in the sense of a stirring of the emotions of many people, but in the sense of *consciousness of perceiving*, or 'seeming to perceive some state or condition of one's body or its parts or senses or of one's mind or its emotions.'[24] Deleuze gives four possible interpretations of Bacon's enigmatic expressions. First, he suggests that each order, level or domain corresponds to some specific sensation. This would imply that each sensation is a term in a sequence and that each painting depicts one sensation. This would apply not only to the three panels of the triptychs, but also to the series of popes, of crucifixions, and portraits, which must then be read as sequences of sensations.

Yet Deleuze renounces this idea of a plurality of sensations of different orders because it is not true that a Bacon painting is a term in a series. Each painting and each figure is itself a moving sequence.

His second suggestion is that each unique sensation has different orders. It envelops a difference of constitutive levels, a plurality of constituent domains. Deleuze writes: 'Every sensation and every figure is always an "accumulated" or "coagulated" sensation like a figure made of limestone.'[25] The problem I have with this idea is that there is no explanation for the synthetic character of the plurality of levels or domains.

Third, Deleuze suggests that levels of sensation are like arrests or snapshots of movement that when recomposed act to restore the synthetic movement in all its continuity, violence, and speed. The levels of sensation, then, would be the paralysed moments of a moving object. Deleuze alleges that Synthetic Cubism, Futurism, and Duchamp's *Nude Descending a Staircase* are examples of depictions of such levels of sensation. I would like to add to these examples the series of pictures by the photographer Muybridge (e.g. illus. 119). Muybridge tried to decompose movement by means of serial photography. But although Muybridge's pictures have been one of Bacon's main sources of inspiration, his fascination for these pictures is not necessarily a repetition of Muybridge's fascination with the analysis of movement. Andrew Forge has noted the difference between them quite acutely:

> What Bacon has learned from Muybridge – from his sequences as distinct from the individual frames that have contributed so crucially to his imagery – is the opposite of what one might expect – less a matter of time captured than of time ruptured.[26]

When we read the 'levels of sensation' as snapshots of movement, the movement defines the object of perception, rather than the subject or process of perceiving. To show the relevance of this third interpretation, Deleuze argues that Bacon's figures are indeed often caught in the midst of some movement like walking. I would say that this is true only for a minority of his paintings. It does not account for the impression of movement in the portraits, or in the many 'paralysed' figures who are sitting, lying, or standing.

Fourth, Deleuze suggests that levels of sensation would be

tantamount to the domains of sensation that refer to each of the different sense organs. A colour, a taste, a touch, a smell, a sound, or a weight constitute together the different levels of sensation. In this phenomenological explanation of the levels of sensation, the sensation is a cumulative sum of responses by the several sense organs. This would imply that Bacon is attempting to give visibility to a kind of unity of the senses: 'he is putting a multisensible figure into the visual range of the eye'.[27]

This fourth interpretation of 'levels of sensation' acknowledges the fact that in Bacon's oeuvre the body is central. For the body in Bacon's paintings becomes one integrated sense organ. It is the space whereto the sense stimuli are directed, and the place where the sense responses are made tangible. Bacon expresses the bodily tangibility of the responses of the senses in an extreme way as deformations of the body. It is as if the body is tortured by its abundance of sense organs and sense experiences. This deformation of the body can then be read as a sign of the bodily response of the senses, of the bodily experiences of the outside world via the senses. With this in mind it makes sense that in many of Bacon's paintings the heads of the figures are even more deformed than the rest of their bodies. Most of the senses are concentrated in the head: sight, smell, hearing and taste. The head becomes a *mise en abyme* for the body as sense organ.[28]

The body as sense organ: this is not only a relevant definition of the body in Bacon's paintings, but also of the effect his paintings have on the viewer. Bacon himself, at least, aims for such an effect. In interviews Bacon has declared several times that he does not want to address the viewer via her/his brains but via her/his nervous system. He rejects illustrative and narrative, as well as abstract, art because they work upon the brain and not upon the nervous system. This would mean that the figures in Bacon's paintings can be seen as representations of viewers: the bodies in the paintings exhibit the kind of responses that the viewer also should have. But this interpretation can only hold if we take Bacon's figures as having been deformed by what they sense – as if they have been *hit* by sense perception. John Berger does not read Bacon's works this way. He reads Bacon's bodies not as representations of deformed bodies, but as distorted representations of bodies. He claims that this representation is distorted in order to establish a more direct contact with the viewer.

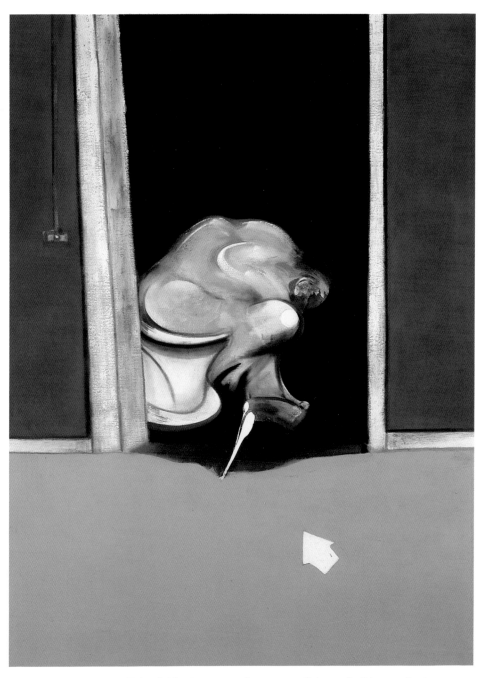

5 *Triptych May-June 1973*, oil on canvas (left panel). Private collection, Switzerland.

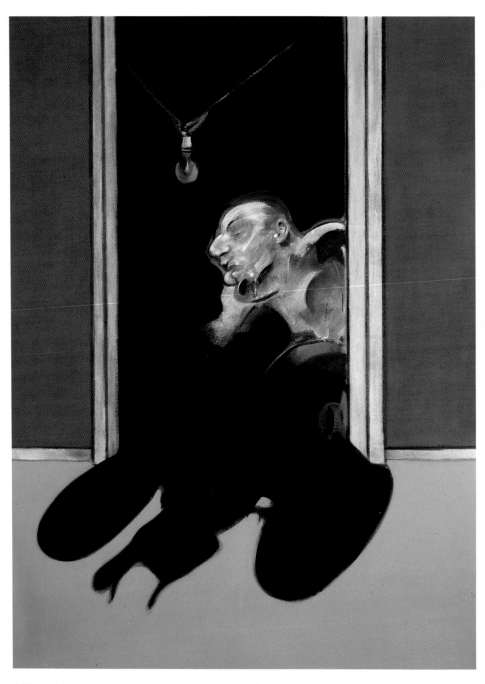

6 *Triptych May-June 1973*, oil on canvas (centre panel). Private collection, Switzerland.

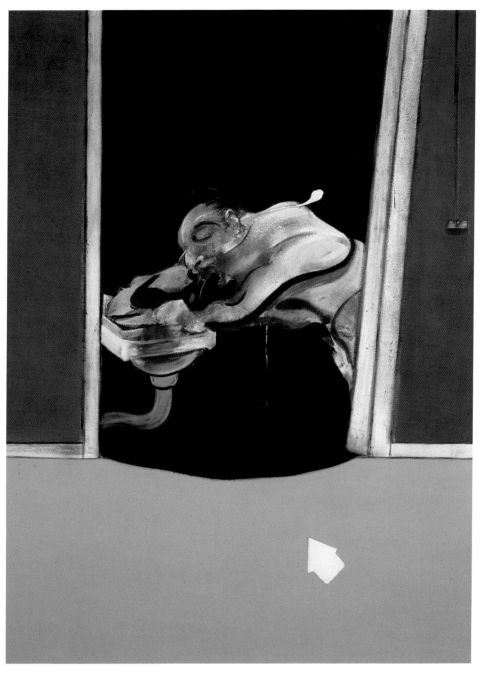

7 *Triptych May-June 1973*, oil on canvas (right panel). Private collection, Switzerland.

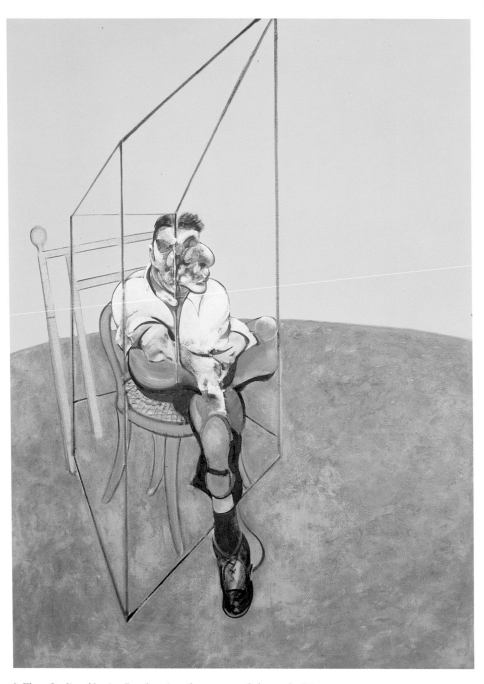

8 *Three Studies of Lucian Freud*, 1969, oil on canvas (left panel). Private collection.

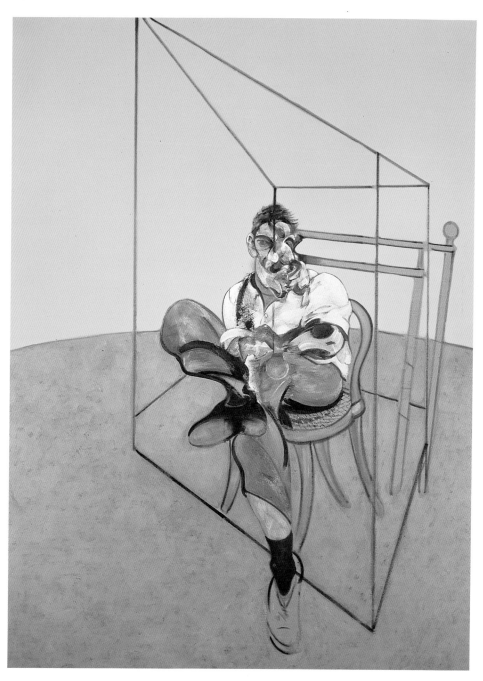

9 *Three Studies of Lucian Freud*, 1969, oil on canvas (centre panel). Private collection.

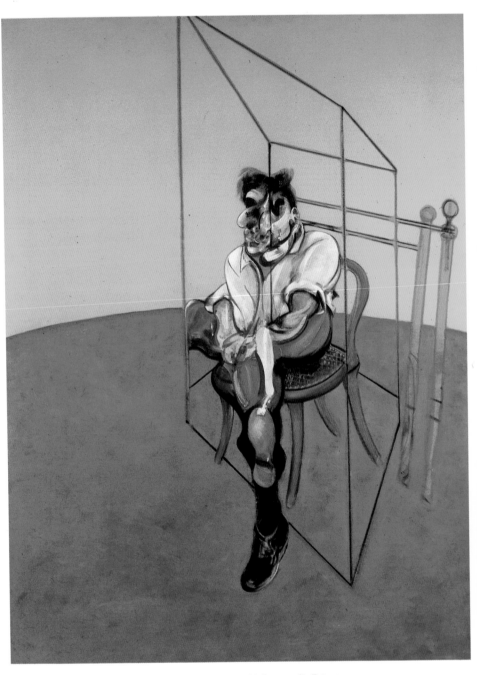

10 *Three Studies of Lucian Freud*, 1969, oil on canvas (right panel). Private collection.

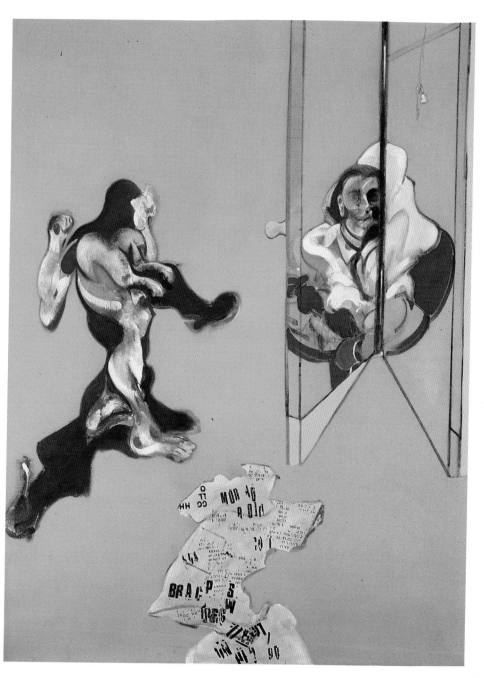

11 *Triptych – Studies from the Human Body,* 1970, oil on canvas (left panel).
Collection of Jacques Hachuel.

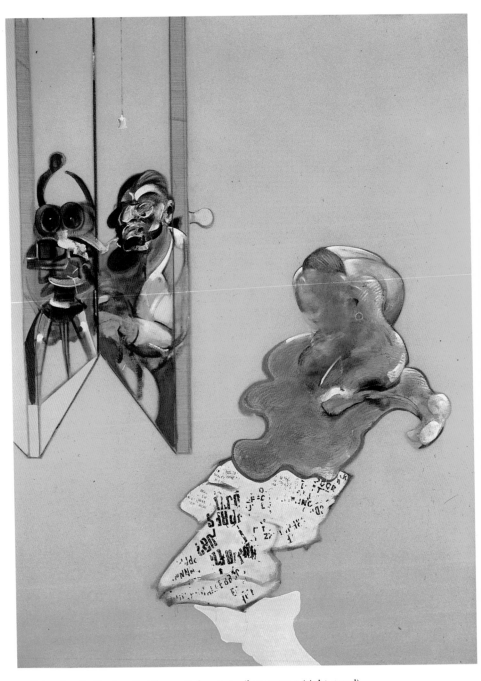

12 *Triptych – Studies from the Human Body*, 1970, oil on canvas (right panel).
Collection of Jacques Hachuel.

Deformation and distortion are, then, like Brechtian strategies that work to change the usual way of perceiving. Yet if Brecht pursued a more critical, distanced perception, Bacon pursues a more direct perception:

> The appearance of a body suffers the accident of involuntary marks being made upon it. Its distorted image then comes across directly onto the nervous system of the viewer (or painter), who rediscovers the appearance of the body through or beneath the marks it bears.[29]

The problem I have with this reading is the opposition it entails between form (the distorted image) and meaning (the appearance of the body). This opposition is the basic structure of the 'aesthetics of illustration' that Bacon opposes.

The depiction of sense experiences as body deformation is a radical undermining of the traditional idea of how the sense organs work. They are usually seen as reflecting the stimulus, or as representing the stimulus proportionally. The sense response is automatic, controlled, and singular. Bacon's body organ, on the contrary, works as a kind of chain reaction. The response of one sense works as a stimulus for the other senses. The unity of the senses in one body, as one sense organ, causes the senses to go off the rails. They can run wild because the several sense organs are not independent of each other, but integrated into one organ: the body.

When we see the levels of sensation as the plurality of senses, however, we lose sight of the movement in Bacon's paintings. Precisely this movement was central in Deleuze's third reading of Bacon's expression 'the levels of sensation'. Moreover, although the notions of 'sense' and 'sense organ' seem to me important for an understanding of Bacon's paintings, the differentiation of sensation according to levels does not seem to be very relevant to these paintings. Arguably, the opposite is at stake. I see in Bacon's tormented figures the neutralization of the differences between the senses in order to emphasize their unity, through the acceptance of their responses, as an uncontrolled force or power within the body.

THE NARRATIVE OF PERCEPTION

Although Deleuze's four conjectures regarding the meaning of the 'levels or domains of sensation' can each shed light on

some of Bacon's paintings, no one definition is entirely satis-
factory. Deleuze seems to be more cautious with the first and
the second conjecture, and formulates some objections against
them. But the other two seem to pass without criticism. Both
seem equally acceptable; it is not clear whether he prefers the
fourth, the phenomenological reading, over the third, which
reads the levels as snapshots of movement.

But his list of possible interpretations is not exhaustive. I
would like to add a fifth which would integrate the third and
fourth and take the issue to a level of greater complexity.
Levels, orders, or domains of sensation, I would contend, are
moments or snapshots of the narrative of perception. Percep-
tion, then, would not be limited to the eye, but it would be the
function of all the senses. It would mediate in the first place the
relationship between a subject's outerworld and innerworld.
But, as indicated above concerning Bacon's focalization of
perception, perception would not only be susceptible to outer
stimuli, but would also be susceptible to the inner responses of
other senses. Sense responses, then, could function as inner
stimuli.

This interiority of stimuli seems to be at stake in the triptych
*Three Studies of Lucian Freud* (illus. 8, 9, 10). The same figure,
who according to the title represents the painter Lucian Freud,
is represented in each panel as sitting on a chair. Behind the
figure we see the head of an iron bed. In the left-hand panel the
figure is seen at some distance from the left edge of the canvas,
while in the other two panels the figure is placed slightly away
from the right side. In the right-hand panel the external
focalizer is further away from the figure than in the other two
panels. In terms of the representation of looking, in the central
panel the figure confronts the viewer with his gaze, while in
the side panels the figures seem  to look at the figure in the
central panel. This representation of looking appears to be
decisive for the present enquiry.

At first sight the figures in all three panels are just sitting,
like models who pose for an artist. Nothing seems to go on in
the space of the representation, so the figures do not seem to
be characters in a story. But the gaze of the figures creates
confusion in this respect. The gazes of the two side figures
(toward the figure in the middle panel) suggest that the
triptych is not composed as a representation three times over
of the same figure in the same space, but as a representation of

three similar figures in one continuous space that is divided by the frames of the three panels. Such a composition would be akin to a crucifixion triptych, with Christ on the Cross in the central panel and the two criminals in the left-hand and right-hand panels. Such a reading of the triptych is based on the illusion of narrativity caused by the active gaze of the side figures.

The illusion of narrativity is undermined, however, by the 'imprisonment' of the figures. Each figure, in each panel, is isolated in space by a cage structure in cube form. But it is not only the cage that isolates. The indefinable space in which the cage is located is not a neutral environment; it is ambiguous to the point of total uncanniness. It is at once completely unrestricted, like the sight of the ocean, and totally confining, like a dungeon. In addition to the isolating function of the space in this triptych, the space is also in the first place *dividing*. The figure's body is inside the cage, while his legs are outside. The head of the bed is partly inside, partly outside. Yet the most remarkable division is caused by the cage *within* the figure's head. In each panel one of the back edges of the cage splits the head of the figure exactly between the eyes. According to the rules of classical, realistic perspective such a thing is not possible. The edge of the cage 'should be', like the other back edge, behind the man, not in front of him or cutting through him. The same thing happens in *Three Studies of the Male Back* (illus. 13, 14, 15). In the side panels of that triptych the edge of a cage structure divides the back of a figure's head. What does this Escher-like artifice mean and how does it function?

Beside the direction of the gaze of the side figures in *Three*

13, 14, 15 *Three Studies of the Male Back*, 1970, oil on canvas. Kunsthaus Zürich.

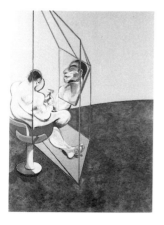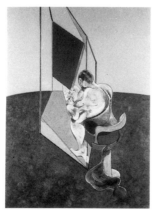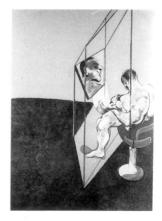

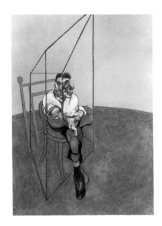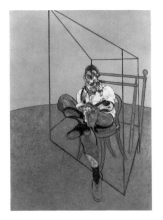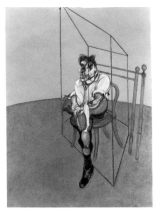

*Studies of Lucian Freud* (illus. 16, 17, 18), the only other parts of the panels that create the illusion of narrativity, the idea that a story is being represented, are the heads of the figures and the middle figure's hands. These are represented as if in an overriding turmoil of movement and deformation. This turmoil gets a different expression in each panel. Either no mouth, ears, or eyes can be distinguished, or several can be discerned within one head. The only exception is the central figure, which has a recognizable eye that gazes towards the viewer. This gaze does not suggest that the figure is involved in an event of the outside world; instead, there is a violent, deforming event going on *in* the head and the hands, which form the main locations of the senses.

16, 17, 18 *Three Studies of Lucian Freud*, 1969, oil on canvas. Private collection.

The head is, as I argued earlier, a *mise en abyme* of the 'body organ', because most senses are localized there. The head of the central figure is precisely divided. Of course, this split can be read as a formal, symbolic expression of the deformation that is at the same time expressed more literally as turmoil. But this artifice also has a more complex function. When we look more carefully at the figure in the left and right panels, we see that the division of the heads also splits the direction of their eyes. This can be seen more clearly when we cover one half of each head. The part of the head facing towards the centre panel looks unambiguously at the figure in the middle panel. The outer parts on the contrary have a more passive gaze; they are exposed to the gaze of the viewer, without actively looking themselves. This 'difference within' is a key to the understanding of Bacon's narrative of perception.[30]

The split gaze suggests two alternative readings – one

narrative and one non-narrative. When we emphasize those parts of the figures that are directed towards the figure in the central panel, a narrative emerges. There is an interaction between three figures, something goes on between them. This narrative is diegetic: the event takes place between the figures, who thus play out a *fabula*. It is also visual: the event they act out is looking. This narrative precludes identification of the figures as one and the same. The event requires their autonomous existence, an existence that is indispensable to the differentiation of subjects from objects of the look. When we emphasize the outer parts of the figures' heads, directed toward the viewer, a narrative reading seems to be cancelled out. We then see, three times over, the same figure in the same position. Only the position of the viewer is slightly different each time. The mode, now, is lyrical, in the sense that the lyric is defined through the structuring principle of apostrophe.[31] The viewer is not addressed by one gaze, but by three distinct gazes. Yet there is more to these gazes than meets the eye. Being directed, almost aggressively, straight toward the viewer opposite the canvas, each gaze proclaims its own viewer. There is no point of vision from which the viewer can embrace the entire image, directed by the interconnection of vantage point and vanishing point of classical perspective. Thus the viewer is split, just as the figure is. The triptych's reference to perspective, which is alluded to and undermined simultaneously, is also emphasized by the cages, which themselves look like drawing exercises badly done – failed attempts to 'do' perspective. In other words, the cages de-naturalize perspective.

The distinction between, and the juxtaposition of, the narrative and the non-narrative reading has important consequences for the identity of the figures. In the non-narrative reading the figures in the three panels have the same identity, while in the narrative reading the figures' identities are different. The active gaze of the side figures turns the central figure into an object of looking; hence this figure must be separate, different, non-identical. But the narrative undermines itself as soon as it emerges. Applying this narrative logic obliterates the fact that the three figures are represented as very similar, perhaps even as identical. The title confirms their single identity: *Three Studies of Lucian Freud*. The title works against the narrative reading. But choosing one reading over

another is not that easy. Why would the meaning of a title be more decisive than the signs within the work that signify narrativity? We can only conclude that several signs in this triptych suggest meanings that contradict each other, and that the site of this contradiction is the very notion of identity.

The division within the figure in the side panels is a division between being watched (by a viewer) and watching. But who watches whom in this figure? The side figures watch an identical figure, hence, they watch themselves. Thus we have here a 'split subject'.

The subject is split in two ways. Firstly it is split by the composition in three panels. This allows for the figure on one panel to be looking at himself on another panel. The framing and isolation in different panels – in other words, the structure of the triptych – produces this split, because it presents the split between/in the figure as radical, while at the same time the contiguity of the panels encourages a narrative reading that postulates continuity between them. Secondly, the subject is split by the back edge of the cage structure, which in each panel splits the head of the figure. In the side panels this split is at the same time a split in the direction of the figure's look.

These two ways of being split imply together that the *split between* panels signifies a *split within* the figure. The opposition between looking and being looked at, between narrative and non-narrative modes, can be read as a split experienced by the subject, the figure, and thus characterizes the inner world of that subject. But the direct stare of the other eye means also that the viewer is contaminated by this experience. The work, then, proposes a pragmatics of vision as the narrative of perception. This, I submit, is the sense in which Bacon's works are narrative.

PERCEPTION FOCALIZED

Once we have decided to read Bacon's paintings as representations of the narrative of perception, the next step is to analyse this narrative in order to see what kind of representation of the process or act of perception can be read in these works. In narratological terms the following questions arise: How is perception focalized?[32] Who are the characters in this narrative? Do the characters cause or undergo the events? To which 'goal' is the course of events directed?

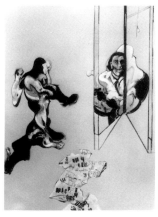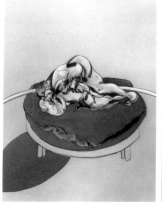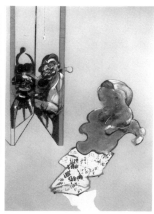

19, 20, 21 *Triptych –*
*Studies from the*
*Human Body*, 1970,
oil on canvas.
Collection of
Jacques Hachuel.

While it does not at all promote the projectionist or illustrative kind of narrative reading that I dismissed earlier (on Bacon's instigation), such a narratological approach immediately enlightens us with regard to the role of human figures in Bacon's work. It helps us to understand that what seemed to be a simple equation between figure and viewer is a much more complicated relationship. This role implies a commentary on traditional anthropocentrism. In the modern Western tradition, the subject who causes or undergoes a sequence of events is viewed as an individual human being. Bacon has dedicated his whole career to representing the human body.[33] But, strangely enough, the human figure is not the *subject* of Bacon's narrative of perception. The human figure is rather the *locus* of the events, the scene of action. Perception happens in and on the human figure.

This is particularly insistent in works where mirrors or other optical devices are represented. In, for instance, the right-hand panel of *Triptych – Studies from the Human Body* (illus. 12) we see two half-open reflecting doors mirroring each other. Normally, two mirrors placed face to face produce the effect of a *mise en abyme*. They each show a vertiginous abyss: the reflection of one mirror shows the reflection of the other mirror, which shows the reflection of the first mirror, and so on, endlessly. This self-referential device directs our reading of the reflections in Bacon's triptych. In one mirror we see a human figure, in the other a movie or still camera on a tripod. This camera is represented as a mechanical, beastly monster. It has the horns of a bull. Its 'eyes' are especially striking. They

are like the eyes of conventional caricatural representations of an octopus. The human figure does not see himself in the mirror. But the self-referentiality of the double-mirror device forces us to read the camera as a reflection of the figure. The figure, then, sees a representation of his sense of perception as violent and mechanical.

In the right-hand panel of *Triptych March 1974* (illus. 33) we see a man holding a very complex camera in front of his face. His face is almost completely covered by the mechanical apparatus. In both paintings the process of perception is represented by an extension of the human eye. Metonymically motivated, this extension device becomes a metaphor for the human eye and a *mise en abyme* for the narrative of perception. Perception, then, is not an activity directed by the human subject, but a mechanical process happening to the human figure.

But if the human figure is not the subject of perception, which agent or force is then its subject? The answer to this question is what I earlier called the stimuli of the senses. These stimuli can be seen as the subject of perception. This is not so striking in the case of the senses of hearing, taste, or touch. These senses are supposed to represent the stimuli proportionally and automatically. So when we taste sweetness, say, we think 'sweets'. These senses are directed by the stimuli. So the stimuli (sweets) can be said to act as the agent or subject of the process of perception (tasting sweetness). The situation is different in the case of sight. And the special case of sight illuminates not only Bacon's position as a painter – a visual artist – but also his historical position as a painter today.

Any attempt to position Bacon within cultural history will have to deal with the term 'modernism'. This term is used in two different, apparently conflicting, ways that need to be disentangled if we wish to understand Bacon's particular position. In the broad philosophical sense, modernism begins at the Renaissance, in particular with Descartes and the age of confidence in science. In this modernism the eye, the locus of vision, is the locus of the subject. The individual derives her/his subjectivity from her/his vision of the world. Positivism is an extreme manifestation of this 'arrogant' self-confidence in the human eye.

The conflation of the eye and the subject can be understood as an extreme manifestation of the Western modernist priv-

ileging of the visual as a source of knowledge. From the Renaissance through until the first half of the twentieth century, this confidence in perception has largely determined conceptions of science, art, and literature. This I/eye conflation is directly related to a belief in the existence, importance, and accessibility of truth. This optimistic modernism has been criticized by artists and philosophers alike, in the name of two different alternatives. On the one hand, artists and writers who have been identified as modernists in a narrower sense have challenged the existence and/or the importance of a truthfully representable reality outside the subject. On the other hand, opposition against the Cartesian paradigm has come from the so-called postmodernists who, largely inspired by Nietzsche, have challenged the confidence in knowledge and the belief in truth as a false appeal to 'masterstories'.[34] This philosophical postmodernism is not incompatible with aesthetic modernism. Bacon can be seen as modernist in the narrower, aesthetic sense, while he can also be placed with the postmodernist, philosophical opposition against modernism in the broader sense.

To phrase this in a slightly provocative manner: Bacon-as-modernist aesthetically focuses on perception while challenging its reliability, and Bacon-as-postmodernist philosophically continues to displace the locus of perception, so as to confuse its anchoring in the subject. As modernist, his paintings undermine the transparency of perception, and as postmodernist they decline to offer an alternative and to locate perception unambiguously in a stable body. His position in cultural history is therefore not so much unique, as double.[35] The modernists in the narrower sense, mainly identified with the first half of the twentieth century or, even narrower, with the period between the World Wars, were acutely aware of the problems inherent in the Cartesian view. Instead of claiming, with the Cartesian modernists, that the subject can master an objective and accessible exterior reality, they claimed that the subject constitutes the only reality. For writers, this conception led to a kind of writing which problematized language as a medium, and which focused on the subject by using extreme forms of subjective writing such as the 'stream of consciousness'. Language was regarded as both pervasively central and opaque, adhering to the subject of writing like a skin, rather than acting like a tool (such as a pair of glasses).

If language is understood to adhere to the subject like a skin, then a fascination with subjectivity is bound to become a matter of form. And this will involve, above all, the structure of subjectivity in the text. For visual artists, the de-emphasizing of outside reality has led to an almost exclusive attention to form. Disavowing the relevance of outside reality, they abide by what Jameson wrote about the modernist writers:

> The great modernists were . . . predicated on the invention of a personal, private style, as unmistakable as your finger-print, as incomparable as your own body.[36]

These two modernist reactions – in literature and in visual art – are therefore only apparently in tension. For the modernist writers – Joyce, Proust, Faulkner, Woolf – the opacity of language invited an exploration of its spatial substantiality, which in turn invited an investment in the visual metaphor that equates the eye with the self.[37] For the modernist painters, including the Cubists and Abstract Expressionists, the exploration of the purity of form and its subjective basis also maintained the centrality of vision, albeit in a less positivist spirit. These artists explored the problematics of vision without giving up visions' key position as a source of knowledge. Hence, what Rosalind Krauss wrote about Duchamp also holds for other modernist artists, and also for Bacon:

> There is no way to concentrate on the threshold of vision, to capture something . . . en tournant la tête, without siting vision in the body and positioning that body, in turn, within the grip of desire. Vision is then caught up within the meshes of projection and identification, within the spec-ularity of substitution that is also a search for an origin lost, Con, as they say, celui qui voit.[38]

As the preceding analyses have suggested, Bacon reacts critically to modernism in the broad philosophical sense, and in alliance with other artists identified with modernism in the narrower sense he inherits the centrality of vision while challenging certain positivist tenets. The narrative of perception outlined above tells the story of this struggle with the I/eye. The other side of this I/eye struggle, the bond between vision and the body of which Krauss speaks, will be further explored in Chapters Four and Five. The issue I am concerned with here

is the consequence of this modernist predicament for Bacon's narrative effect.

Whereas Bacon's implicit philosophical position can be aligned with postmodernists like Lyotard, his aesthetic position remains emphatically modernist: he is, before anything else, a *painter*, and he does not partake of the postmodernist doubt about the single medium. In a postmodernist aesthetic, the typical attitude is indifference and suspicion toward the 'nature' or 'essence' of a medium. Krauss formulates this as follows:

> Within the situation of postmodernism, practice is not defined in relation to a given medium . . . but rather in relation to the logical operations on a set of cultural terms, for which any medium – photography, books, lines on a wall, or sculpture . . . might be used.[39]

The medium is no longer the object or goal, as it is in modernist aesthetics, but a means by which the mechanisms of representation can be explored, shown, and challenged. The aspects of representations stressed in this 'project' are the role of the several subjects in the situation of communication; the role of the sender and the receiver; the relations between subject positions in the representations; the historical and spatial contexts in which representations circulate; and the role these contexts have in the production of meaning. Hence, this postmodernist aesthetics necessarily has a political edge to it, which Bacon's work largely avoids. For Bacon, perception is a philosophical problem, and the narrative effect of his paintings tell the story of that problem.

The issue dividing post/modernist art (that is, art that is philosophically postmodernist and aesthetically modernist) from modernism in the wider sense can best be understood in terms of depiction. Neoclassical, romantic and modernist writers all use the idea that they are to *depict* something in their writing. Allen Thiher shows that these visual metaphors of language can be understood as:

> the metaphysical axioms which declare that, since language clearly does offer knowledge, and since knowledge is ultimately vision, then language must be iconic in some way.[40]

The relationships between the object world and ideas or concepts, and between ideas and language, are seen as visual

relationships. The objects in the world are *mirrored* by elementary propositions in language. To relate to the world as a subject, to know the world, is, then, to see the world. Sight gets ontological primacy, and the subject and the eye get conflated.[41]

This conflation of the subject and the eye is undermined by Bacon's non-differentiation of the senses. The eye is not the master subject, but a mechanical apparatus like the other senses. It is put in its structural place as the focalizer's instrument. Thus Bacon's idiosyncratic narrativity becomes a device for a postmodern critique of modernism.

This critique is noticeable in the kinds of stimuli represented in Bacon's works. Earlier I argued that the inner responses of the senses are again stimuli for other senses. This dynamic takes the shape of a deformation of the body. In addition, we have the stimuli which are inflicted on the body from the outside. Significantly, it is the visual and tactile stimuli that are the most frequently thematized. They are either directly depicted or indirectly implied. Tactile stimuli are implied indirectly when the bodies suffer pain caused by something from the outer world. Many of Bacon's figures are literally wounded. (Again, note that we commonly use the word 'literally' to mean 'actually', showing how thoroughly implicated the idea of vision is in language.)

For example, the foot and lower leg of Oedipus in *Oedipus and the Sphinx after Ingres* (illus. 22) have been given a bandage, and there is blood on the bandage. Thus the work insists on an intertextual relationship with the literary source – Sophocles' Oedipus cycle – as well as on 'literality' (the name Oedipus means 'swollen foot'). There is the red slash, too, on the body in the left-hand panel of *Triptych – Studies of the Human Body* (illus. 23). The central panel of *Triptych Inspired by T. S. Eliot's Poem 'Sweeney Agonistes'* (illus. 37), which I will discuss in the next chapter, shows bloody clothes and sheets in a metonymical representation of violence, of pain inflicted on a figure's body. There are many paintings with mating/fighting figures, often inspired by Muybridge's pictures of wrestlers. Those entangled bodies express pain rather than pleasure, as for example in the central panel of *Triptych – Studies of the Human Body*. The open mouth showing all its teeth, the red film on the face, the red pupil in the eye – all represent pain.

In the case of tactile stimuli it is the effect of the stimulus, not

22 *Oedipus and the Sphinx after Ingres*, 1983, oil on canvas. Private collection, California.

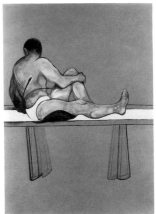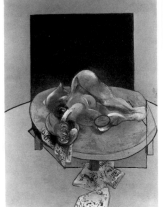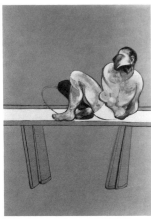

the stimulus itself, which is visual in nature: blood, a wound. The wound and the blood are metonymically motivated metaphors of the pain experienced by the bodies. In the case of a visual stimulus the stimulus itself, as well as its 'reception', can be directly represented visually. The event of perception of visual stimuli is represented in many of the portraits and self-portraits. The eyes of Bacon in all three panels of *Three Studies for Self Portrait* (illus. 26, 27, 28) express total susceptibility to visual stimuli. The figure's gaze is paralysed, reminiscent of the gaze of a rabbit caught in a band of light. The gaze is dictated by the stimulus, not by the holder of the eye. The writer Leiris in *Portrait of Michel Leiris* (illus. 29) seems to be under the spell of something he sees. He is in a kind of hypnotic trance. He is not the powerful observer of the outside world; rather, he is dominated by the visual. Thus the function

23, 24, 25 *Triptych – Studies of the Human Body*, 1979, oil on canvas. Private collection.

26, 27, 28 *Three Studies for Self Portrait*, 1979, oil on canvas. Private collection.

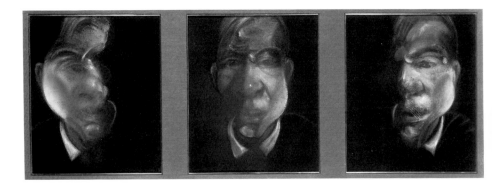

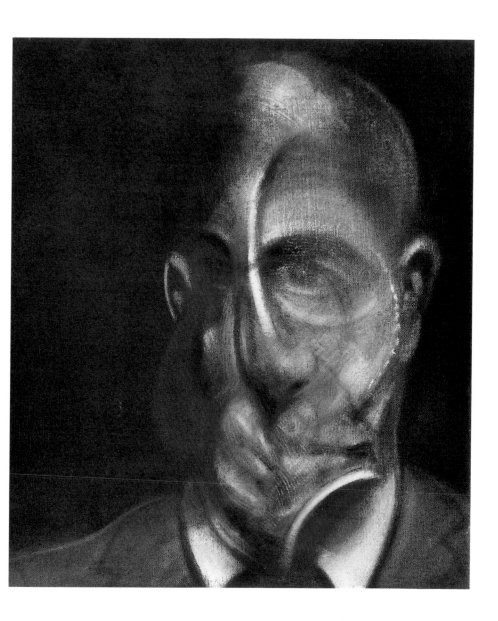

of focalizer is detached from perception: the focalizer's look is arrested.

What these two central senses – vision and touch – share, then, is the polemical opposition to the distanced mastery of the modernist and positivist gaze, which dominates the world while leaving the subject of looking uninvolved.[42] The sense of touch stands at the other end of the spectrum from sight: it cannot operate without the bodily involvement of the subject.

Touch, then, becomes the master trope of perception and contaminates even its opposite, sight. Sight is now proposed as a kind of touch, an act that is inflicted upon the body as a whole.

In my reading of these few works by Francis Bacon, narrativity was at stake. His works cancel out, as well as stimulate, narrative readings. I have used narratology and asked questions derived from narrative theory, not to decide *whether* Bacon's work is narrative, but to decide *how* it is, in what sense it can be *read as*, narrative. I have proposed a narrative reading in which Bacon's works represent a pragmatics of vision as the narrative of perception. This narrative would then have a double status. On the one hand it would be diegetic: the events acted out by the figures in the representations are events of perception. On the other hand this diegetic narrative *about* perception would be doubled in relation to the viewer. The narrative could be called apostrophic and metonymic: it touches the viewer.

We have encountered this double status of narrative in the triptych *Three Studies of Lucian Freud*. I have argued that two ways of looking are represented in that triptych by two sets of gazes, a diegetic and an apostrophic set. I called the reading based on the diegetic reading a narrative reading, the one based on the apostrophic gaze a non-narrative reading. But now, after I have shown how the viewer's perception is contaminated by the narrative of perception represented in the paintings, I would argue that the reading set in motion by the apostrophic gaze is narrative as well. Bacon's works do not allow a safe distance between the viewer and a unified image. They involve the viewer bodily and directly in the act of production. The resulting 'affect' is the event that constitutes the narrative. This is not a 'third person' narrative, which, according to Benveniste 'tells itself',[43] proclaiming the exclusion of the viewer. Rather it is a personalized narrative in which the roles of first and second person threaten constantly to be exchanged.

In the following chapter I will further pursue this analysis of Bacon's aesthetic position as a key to reading his painting, moving from the issue of narrative, so central in the history of Western culture, to other issues highlighted in the history of Western visual art. I will argue that Bacon's works propose a

modern aesthetic based on a postmodern philosophy, centring around contiguity instead of iconicity, repetition, or illustration. The recurrent motifs of mirrors that do not reflect literally, of lamps that do not project iconically, of shadows that are not projections but extensions of the body, all seem to fight against an aesthetics of reproduction, in favour of an aesthetics of procreation.

Bacon's aesthetics of procreation can explain his aversion to narrative, as he has confessed in interviews. In his conception of narrative, a narrative representation is always an illustration of a pre-existing fabula. But as I have argued in this chapter, his work displays another kind of narrative: narrative that is contiguous with the reader, that touches the reader by its focus on the performative 'affect' of narrative.

The narrative dimension that thus constitutes the basis of the post/modern aesthetics was foregrounded by a narratological analysis, paradoxically effective because it did not quite work. Narratological concepts, then, more than narratological typologies, are useful instruments of analysis, even in an era that displays a contempt for the realist narratives for which these concepts were initially conceived. Or rather, because of this suspicion, these concepts have been liberated from their deceptive status as automata: from 'tool' for 'application' they became discussants in a debate. In the following chapter we will see that it is not their origin in verbal discourse but, on the contrary, their detachment, their abstraction, from discursive specificity that seems to make them so objectionable. For that is precisely the problem with *all* analytic concepts, be they verbal in origin (like narrative) or visual (like perspective, reflection and duplication). Bacon's works theorize the need for the specific: for the sensational that is no other than itself, for a process in which the viewer must participate, for a participation that hurts, deforms, but *happens*; they theorize the need for narrative.

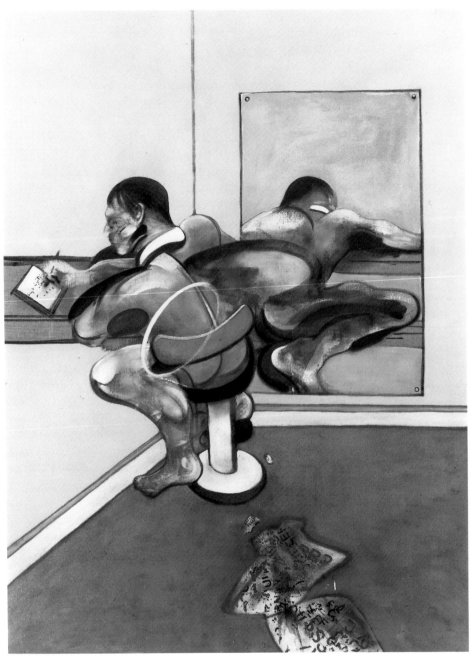

30 *Figure Writing Reflected in a Mirror*, 1976, oil on canvas. Private collection.

# 2 Perception

Certain pictures, whether modern or ancient, transform the map of the
human body and thereby get lost amongst the surreal platitudes of the
beliefs the spectator holds concerning his own image. Thus, these
works force him to reinvent understanding for just one moment,
through the aesthetic momentum produced by their visual subversion
of banal perception – in other words they force the spectator to
reinvent his intimate discourse about himself and about his world of
objects.

J. GUILLAUMIN[44]

The painting *Figure Writing Reflected in a Mirror* (illus. 30) shows
a figure sitting in front of a mirror. In contrast to traditional
representations of this motif, however, the figure is not looking
in the mirror. Instead, he turns his side and back to the mirror,
and is thus incapable of, or uninterested in, seeing himself.
Rather than being preoccupied with looking, he is busy writing.
Is this specific, unexpected occupation in front of a mirror a hint
at a polemic between language and vision, between narrative
and perception? If the particular activity represented might
suggest as much, the presence of the mirror undermines the
simple dichotomy, for it symbolizes the issue of vision just as
much as the act of writing hints at story-telling. And in case we
overlook this dual theme, the title states the equal importance of
both events, the writing and the reflecting.

Bacon's attitude toward narrative constitutes an important
aspect of the philosophical-aesthetic position which I have
characterized above as both modernist and postmodernist.
This particular post/modernism, the combination of a
postmodern philosophy with a modernist aesthetic, receives
an especially illuminating treatment in a specific set of repres-
entational motifs that are frequently present in Bacon's paint-
ings: the tools of vision. These tools most often take the shape
of two common, at first sight even banal, elements, which
have been, however, loaded with meaning throughout the
history of Western aesthetics: the mirror and the lamp. An
elucidation of these motifs and their possible meanings may
provide insight into Bacon's art and its historical position.

In Bacon's work the significance of the mirror and the lamp differs radically from the special value these have held in the history of Western culture, where they have acted as metaphors for the revealing role of visuality and the human eye. In his influential book, *The Mirror and the Lamp: Romantic Theory and the Critical Tradition*, M. H. Abrahms takes the mirror and the lamp as metaphors for two antithetical conceptions of the poetic mind. In the mirror image the mind is compared to a reflector of external objects. In the lamp image the mind is compared to a radical projector that makes a contribution to the objects it perceives.[45] In the history of aesthetics the mirror metaphor characterizes much of the thinking from Plato up until the eighteenth century, while the lamp metaphor typifies the prevailing motif during the Romantic period.[46]

Although initially Bacon appears to place himself within the Western tradition by taking the human body as his favourite subject of representation, he distances himself from that tradition by subverting the role of the mirror and the lamp. His mirrors do not reflect or reproduce adequately, nor do his lamps project or highlight adequately. The bodies of his figures are not reflected or elucidated by these visual devices; instead they are dissolved by them. In this chapter I will argue that the role of the lamp and the mirror in Bacon's work elicits a reading of his work as a response to the dominant tradition of Western aesthetics. If the classical and the modernist traditions of Western aesthetics can be summarized as looking to art for a reflection of the body and an illumination of the body, in other words, the 'reflected body' and the 'illuminated body' respectively, then the metaphor of Bacon's post/modernist aesthetics would be 'the body unbound'. I will first examine the implications of this metaphor for Bacon's aesthetic position in the history of art. In the last chapter I will revert to the semiotic and ideological consequences of this unbinding of the body.

THE MIRROR IMAGE: DECEPTIVE AND DECEIVED

The motif of the mirror marks vision as the theme. The visible (the object of looking) as well as the visual (the act and experience of looking) are both framed by the mirror's reflection. Theoretically, the representation we see in the mirror should reflect our act of looking. The stimulus of sight, as well

as the response to it, are framed at the same place and moment. Only the sense of sight is susceptible to the mirror effect. The law of the mirror prescribes an absolute, mimetic representation of the object in front of the mirror. Although distorting mirrors exist, the conventional expectation of a mirror or of a representation of a mirror is absolute mimesis.[47] Hence, if the viewer who looks into a mirror does not see what is in front of the mirror, that is her or himself, a phenomenon has occurred that is at odds with the act of looking.

Some of Bacon's works that contain representations of mirrors are cases, in varying degrees, of mimetic mirror reflections.[48] In the painting *Figure Writing Reflected in a Mirror* (illus. 30), we see exactly what the title promises. The representation on the framed level can be supposed to be a mimetic mirror reflection. We notice, however, that the focalizer of this reflection is not the mirrored figure. This figure directs his face to the paper on the table on which he is writing. His side and back are reflected in the mirror, not his face. The focalizer of the mirroring effect is outside the painting.[49]

In *Three Studies of the Male Back* we see in the left- and right-hand panels (illus. 13, 15) a man shaving himself in front of a mirror. In the central panel the man is reading a paper. Although he is sitting in front of the same mirror as in the other panels, we do not see his reflection. The reflection in the other panels appear as 'normal', suggesting mimesis. The focalization hovers between the internal and the external. Although we are inclined to look with the man into the mirror, and see his reflection with him, this reflection is represented slightly from the side, implying that we do not see the same reflection that he sees, as he must see his reflection frontally.

A significant painting in this respect is *Study of Nude with Figure in a Mirror* (illus. 34). We see a female nude classically exposed to the gaze of the viewer. The mirror is not turned toward the woman, but rather toward the viewer who is in front of the painting. In the mirror we see a dressed man on a bar stool apparently watching the naked woman. It may be illuminating to read the painting as a commentary on Manet's *Un Bar aux Folies-Bergère* (illus. 31).[50] Bacon's painting seems to be both an explicit embodiment and a critique of those views according to which the object of Western representation is traditionally female, and the subject is a male voyeur. (I will return to this in more detail in the last chapter.) Manet's

31 Edouard Manet, *Un Bar aux Folies-Bergère*, 1882, oil on canvas. Courtauld Institute Galleries, London.

painting, however, can hardly be accused of unambiguously accepting this ideology of vision; indeed, it presents the mirror as a distorting element, bringing about an uneasy identification between the voyeur on the right and the viewer in front, both of whom are addressed by the woman. Yet the embarrassing directness of the woman's gaze in the Manet painting only just begins to undermine the power of the louche voyeur, a bourgeois gentleman who seems out of place in the bar, but who is nevertheless still, along with the viewer, the master. The self-confident pose of the gangster-like man in the Bacon painting embodies a double critique of this situation. First, his look turns the woman into an ape; her total objecthood is not softened by a smile or a complying or subordinate look, but sharpened by animal-like features (mouth and hair). But at the same time, the woman's body is distorted: her legs replicate the posture of the man's legs. This similarity of pose suggests that the voyeur shares the animal features of the woman. And, by analogy, so does the viewer, whose function is represented by this man. Thus, the onlooker is contaminated, his looking 'touches' his body as it touches her. This contamination threatens his identity, as he becomes like his subject.

In some other paintings the visual stimulus is framed in even more radically problematic ways. In *Figure in Movement* (illus. 32) a diving, falling figure at first appears to be reflected on a black panel behind him. The scene is presented through

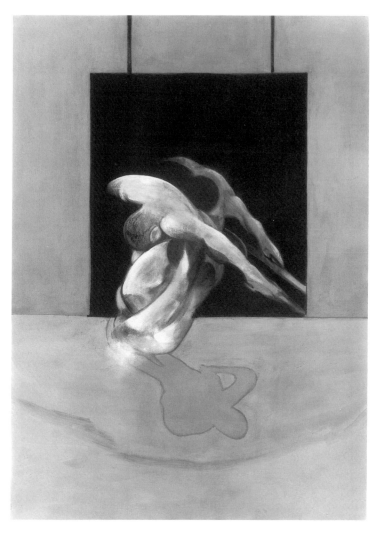

an external focalizer. Yet we see not a mirrored reflection of the figure, but its exact repetition. Neither do we see the back of the figure, which we would see in a 'normal' mirror; instead we see its front. The figure is not reflected in the mirror; our gaze at the figure is repeated, not mirrored, in the mirror. Looking itself, not the object in front of the mirror, is reflected.

*Portrait of George Dyer in a Mirror* (illus. 35) can be read in a similar way. In that work we see a figure with his back toward a mirror, turning his head over his shoulder towards the same mirror. Part of this figure's head is missing, so only the back part of his head is visible. Yet, in the mirror the figure sees the missing front part, as well as the back part, of his head, as do

we. But the two parts are divided: the head is split exactly between the eyes.

How are we to understand such an oblique relation to mirroring as mimesis? For a better understanding of this disturbing image, the concept of 'negative hallucination' may be of help. In an interview about the works of Francis Bacon, René Major introduces this concept:

> Sometimes a person looking at himself in a mirror does not manage to see himself. That phenomenon is called negative hallucination. I am thinking of a specific case of someone who retrieves his image from the mirror after having broken its surface by throwing a glass at it. The image first appears fractured before the fragments find their usual unity. The fracturing here turns out to be linked to the temporal impossibility of display – a fixed and repetitive definition of his image. This negative hallucination is an early experience, for it may also be held responsible for the cry of the infant at the moment he does not perceive the presence of his mother, while at that very moment she is at his side.[51]

The applicability of the concept of negative hallucination to *Portrait of George Dyer in a Mirror* depends on the way we analyse the focalization in this painting. This structure hovers between external and embedded internal focalization. The viewer is inclined to look along the same axis as the sitting man, and to see, as he does, his reflection in the mirror. His gaze, more restricted than the gaze of the outside viewer, is embedded in the focalization of the viewer.

The figure sees a split face, which could imply either that the model's real face is also split or that he sees (or hallucinates) his face as split. But it is not really clear that the viewer sees in the mirror the same thing that the figure sees, for the focalization is ambiguous. It could be the case that the focalization is solely external, and that there is no embedded internal focalization. This would mean that we do not see what the figure sees, that, instead, we watch the figure looking into a mirror. We see his mirrored reflection, but from a different angle. The non-identity between the figure's head and its reflection in the mirror does not necessarily imply, then, a split in the face/gaze of the figure; instead, it may imply a split in the gaze of the external focalizer. And while we do not see half of the figure's face, that part is surely there, given its reflection in the mirror.

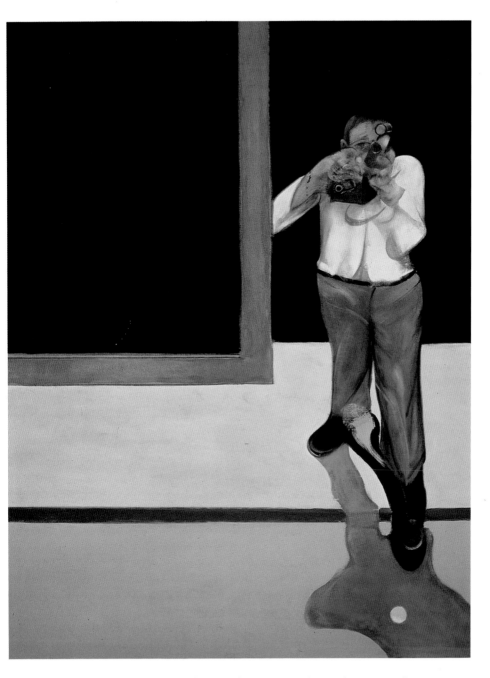

33 *Triptych March 1974*, oil on canvas (right panel). Private collection.

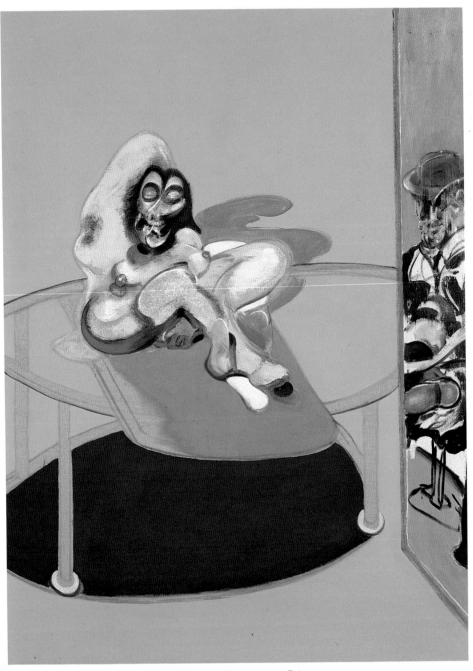

34 *Study of Nude with Figure in a Mirror*, 1969, oil on canvas. Private collection.

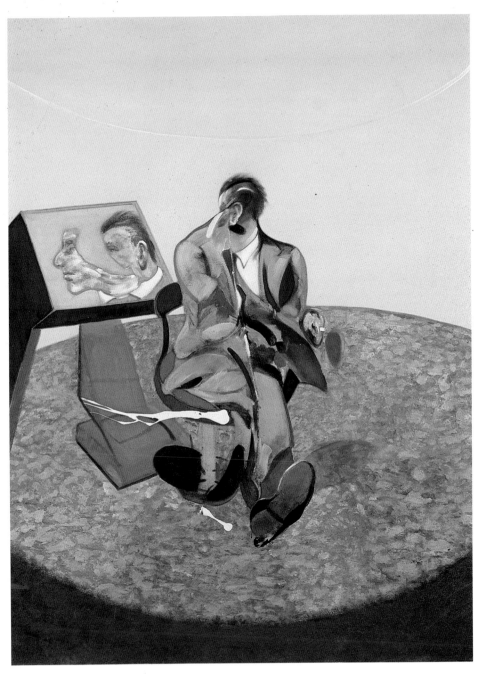

35 *Portrait of George Dyer in a Mirror*, 1967–68, oil on canvas. Thyssen-Bornemisza Collection, Lugano, Switzerland.

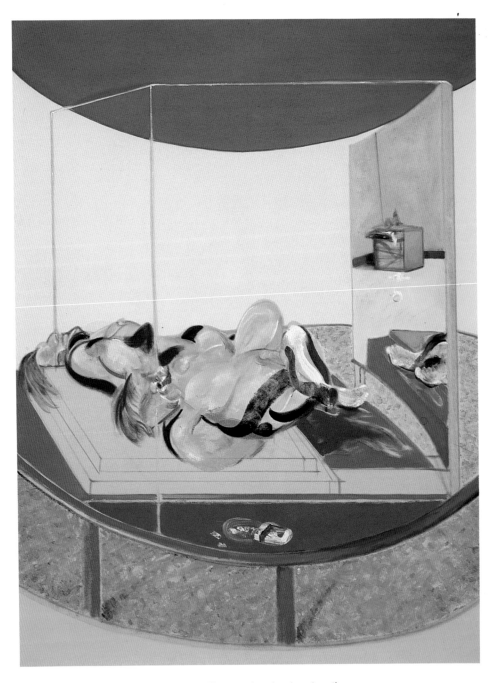

36 *Triptych Inspired by T. S. Eliot's Poem 'Sweeney Agonistes'*, 1967, oil on canvas (left panel). Hirshhorn Museum & Sculpture Garden, Smithsonian Institution, Washington DC.

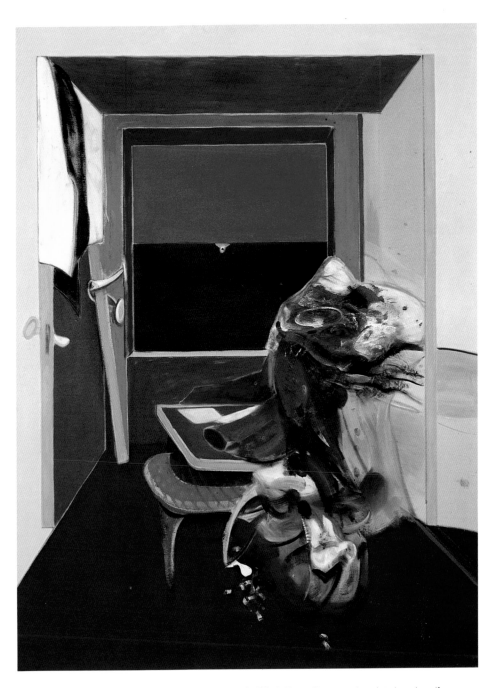

37 *Triptych Inspired by T. S. Eliot's Poem 'Sweeney Agonistes'*, 1967, oil on canvas (centre panel). Hirshhorn Museum & Sculpture Garden, Smithsonian Institution, Washington DC.

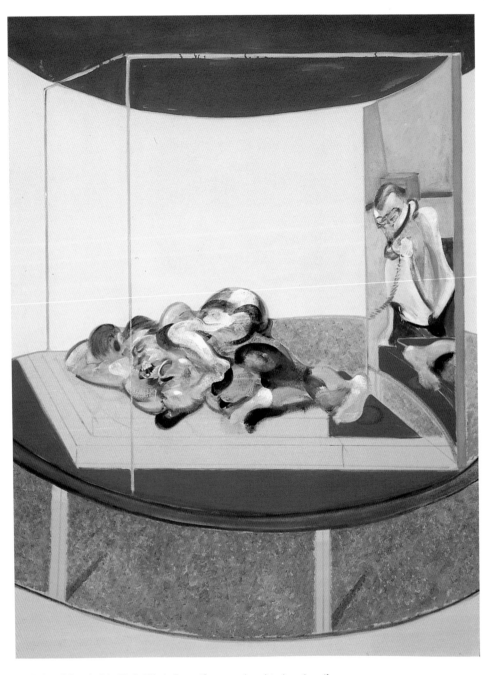

38 *Triptych Inspired by T. S. Eliot's Poem 'Sweeney Agonistes'*, 1967, oil on
canvas (right panel). Hirshhorn Museum & Sculpture Garden, Smithsonian
Institution, Washington DC.

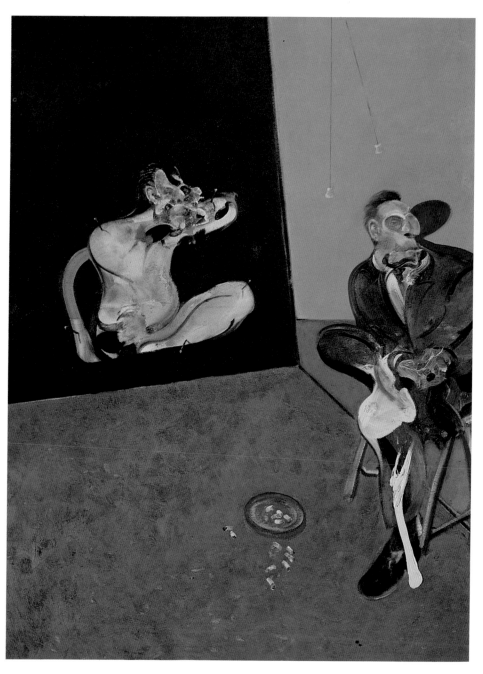

39 *Two Studies for a Portrait of George Dyer*, 1968, oil on canvas. Sara Hildén
Art Museum, Tampere, Finland.

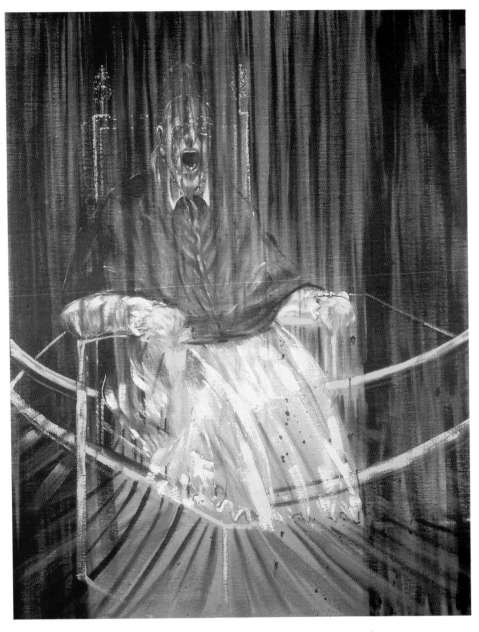

40 *Study after Velázquez's Portrait of Pope Innocent X*, 1953, oil on canvas. Des Moines Art Center, Des Moines.

This would constitute a clear case of negative hallucination by the external focalizer. Unless, of course, this agent sees too much. Does it see things in the mirror that are not present in the primary space of the representation? This would be a case of 'normal', positive hallucination.

The focalization in this painting is totally ambiguous with regard to both its object and its subject. It is impossible to detect where the defect in looking originates, or whose defect it is. Is it the external focalizer (the inscribed viewer), the internal focalizer (the figure), or the mirror that defeats the representation of the visual experience? Is the sense of sight deceived, or does the sense of sight deceive us? Do *we* see what we see, or does vision (the mirror) make us see?[52]

## THE MIRROR IMAGE AS DOUBLE AND AS OTHER

The work *Triptych Inspired by T. S. Eliot's Poem 'Sweeney Agonistes'* (illus. 36, 37, 38) can shed further light on this problem of the deconstruction of the visual realm through its investigation of the problematics of sight – to the extent that it weaves this problem into the problem of identity. Thus, this work demonstrates both the central importance of vision for the construction of the subject's sense of self, as well as the way vision and subjectivity undermine each other. The three panels of this triptych are all representations of interiors. The settings of the outer panels are similar, and provide a view of a semicircular room. On the floor there is a grass-green carpet on which a round, red platform rests. On this round platform there is another two-part square platform. The space above the two platforms is demarcated by the open cage-structure that we find in so many of Bacon's works. The right side of the cage contains a mirror, indirectly representing the left side of the room. In the reflected part of the room we see in the background a chest of drawers.

So far, this description accounts for the left, as well as the right, panels. Yet, the two outer panels differ in their representation of two figures on the platform and in the mirror reflection. In the left-hand panel two nude figures lie on their backs on the top platform, where they seem to be asleep or simply relaxing. An ashtray and cigarettes beside them on the red platform underscore the idea of relaxation. The long hair of both figures, and the breast in profile of the back figure,

indicate that they are women; male figures in Bacon's works consistently have short hair.

The two female figures in this representation are strikingly similar. They lie in the same position, they have the same kind and length of hair, they both have their left leg crossed and their right arm in a curve beside their body. The two bodies are so similar that one could claim that they each constitute the other's double: they are *doppelgänger*. This sameness is not only suggested by the explicit repetition of bodily features in their representation, but also in the mirror image of this scene. Although we see only a fragment (that is, the feet) in the mirror, this fragment is enough to establish again the motif of sameness of identity. The identity of these figures are not only fixed by their mirror-like image in one another, but also by their reflections in the mirror.

In the right panel we see wrestling or mating figures, probably men since their hair is much shorter than that of the figures in the left panel. The entire scene expresses violence. The bodies cannot be distinguished from each other. We see legs, arms, a mouth and hair, but it is not easy to decide which legs belong to which body. The entangled bodies have lost their separateness through this aggressive, sexual violence. In this panel's mirror, in the meantime, we also see the reflection of a foot. But there is something more reflected; we also see in the mirror a dressed man making a phone call. This man is not present in the primary space of this panel's representation. Nor is the scene at and around the platform identical to its reflected mirror image.

Although the telephoning man is problematic in the visual representation, the intertextual relationship to Eliot's poem is quite clear. The man is the only direct reference to Eliot's 'Sweeney Agonistes'. Rolf Laessøe has pointed out how Bacon's triptych relates to Eliot's poem, which is subtitled 'Fragments of an Aristophanic Melodrama'. The two women in the left panel can be seen as Dusty and Doris, the two women who discuss their male acquaintances in the section entitled 'Fragment of a Prologue'. Yet the lesbian connotations of Bacon's representation are lacking in Eliot's poem. Their conversation is interrupted by a telephone call from Pereia, one of their male acquaintances, who is clearly the literary source for the man telephoning in the mirror of the right-hand panel.[53]

The relationship with Eliot's text, as pointed out by Laessøe,

is not truly indispensable for a better understanding of Bacon's visual representation, although it may have some relevance.[54] Moreover, Laessøe misses one significant point. Although he quotes the epigraph of Eliot's poem, he does not read the triptych from the perspective of this epigraph. The epigraph comes from Aeschylus's *Choephoroe*, the central part of the *Oresteia*. The words are spoken by Orestes when he realizes that the Erinyes are pursuing him for matricide. The motto is:

You do not see them, you don't – but I see them.

Isolated as an epigraph, these words characterize the problematics of focalization in Bacon's works. The epigraph is ambiguous because it does not make clear whose vision is 'normal' and whose is deviant. Is there someone who sees too much, or somebody who sees too little? Are the eyes of the second person ('you') or of the first person ('I') deceived or deceiving? In Bacon's case, is the external focalizer, or the embedded focalizer (the figure), hallucinating negatively or not? Precisely because these questions are unanswerable, it becomes plausible that the problem of the instability of vision is related to the problem of the instability of identity. Identity, selfhood, seems to depend on who sees what. When the mirror image is stable, the figure has a demarcated identity. Identity gets blurred when the mirror image cannot be identified as a mirror reflection. The left- and right-hand panels of the triptych inspired by Eliot's poem respectively embody these two extremes of the production of identity.

That no 'real' stability can be produced by a mirror is shown in the middle panel, where the subject is entirely void. Doubly undone, the open window of a train compartment suggests that the subject has fled the assigned space, while the blood on the clothes suggests that the dissolution of the subject was violent. That the space where this violence took place was a train (a site of travelling) only underlines in yet another mode the instability of identity.

The central problematic of identity in Bacon's work manifests itself not only in the motif of the mirror, but also in the motif of the double. In fact *doppelgänger* were already present in the triptych responding to Eliot's poem; there are the two resting women and the two wrestling men. In the right-hand panel of *Crucifixion, 1965* (illus. 109) we see two 'gangsters', and the central panel of *Triptych – Two Figures Lying on a Bed*

*with Attendants* (illus. 82), which I will discuss more fully in Chapter 4, has its pair of men as well. In opposition to the lack of identity between mirror reflection and mirrored object, and to the eroded identities of the deformed and dissolving bodies, the motif of the double can be read as an artificial strategy for establishing or reinstating identity. Clearly, there is a conflict concerning identity. In the previous chapter I have suggested that the stimuli of the senses constitute a threat to the stability of identity. Here we can conclude that vision is the locus of that conflict.

### REFLEXIVITY AND THE LOSS OF SELF

Given the problematics of identity examined in the previous section, an analysis of schizophrenia may prove relevant. Louis Sass proposes to approach schizophrenia from the perspective of theories of selfhood and introspection.[55] In medical psychiatry the 'self-disturbances' of schizophrenia are usually understood as a regression toward early infantile experience and to a primitive state. In this view, a normal, mature, healthy condition is presupposed as the standard, and schizophrenia is regarded as a movement away from that healthy condition. In the 'mature' condition, perceptions, thoughts and actions are lived as if from within, with an implicit or semiconscious sense of intention and control. In contrast, in the schizophrenic condition, thoughts, perception and movements of the body are felt to be imposed from without. Similarly, the psychoanalytic view interprets schizophrenia as a loss of ego boundaries, where the schizophrenic distortions of the 'normal' sense of self are seen as a deep regression to the original infantile consciousness, in which experience is dominated by primary process thinking, by hallucinatory wish fulfilment, and by the absence of an observing ego.

The regression-into-primitivity interpretation has several implications, as Sass points out. The first is that schizophrenic forms of experience and expression lack complexity, sophistication, and validity; second, that psychological health and psychological maturity are virtually synonymous; third, that the Cartesian subject-object distinction and the Western conception of discrete and integral selfhood represent a universal, objective truth; and finally that the achievement of these conceptions is the goal of normal development.

The romanticized view taken by antipsychiatrists and critics of psychoanalysis such as Norman O. Brown, and Gilles Deleuze and Félix Guattari, is ultimately similar to the orthodox view. Only the value judgments are reversed. From the antipsychiatric perspective the primitive, infantile condition is to be preferred over and above the mature condition of self-control. For the primitive condition would be characterized by unrestrained desire. Schizophrenia stands, then, for life, instinct, the freedom of 'nomad thought' (Deleuze and Guattari) as against the mind, which provokes oppressive self-consciousness, the illusions of logic, and the belief in self-control. Post-structuralist notions of 'the split subject' and of a 'decentred existence', if idealized, would fit within the same radical, romanticized concept. These key-notions of the 'split subject' and a 'decentred existence' may indeed stand for a more authentic and vital mode of being than those of the humanist subject in control of its perceptions, thoughts, and actions. But the traditional analysts and their radical poststructural critics share the assumption that the schizophrenic lacks the self-control, the awareness of social convention, and the reflexivity of 'civilized' consciousness. In both accounts schizophrenia is a lack or a regression. It seems hardly attractive to suggest a relation between such a sorry state and Bacon's paintings.

Such a link might, however, make the mirror paintings more readable, so it seems worthwhile to look for an alternative view of schizophrenia as loss of self. As an inducement to an alternative genealogy of the loss of self, Sass proposes the idea set forth by William James in his 'The Consciousness of Self' in James's book *Principles of Psychology*.[56] Because perception and introspection are important notions in Bacon's interpretation of identity and the loss of self, as they are in 'The Consciousness of Self', James's ideas can shed new light on Bacon's works. James begins by asserting the classical conception of self, only to undermine it. According to the classical view, human consciousness is defined by the feeling of a 'central nucleus of the self'. This centre imbues one's thoughts and sensations with a sense of being unified rather than of 'flying about loose'. This unity of self stems from active intentionality. This active intentionality presides over the perception of sensations and is the source of effort and attention, as well as the place from which the fiats of the will appear to emanate. Not

satisfied with this rather vague description of the self, James takes a careful and more determined look. James observes:

> Whenever my introspective glance succeeds in turning round quickly enough to catch one of these manifestations of spontaneity in the act, all I can ever feel distinctively is some bodily process for the most part taking place within the head.

Volitional control turns out 'on close scrutiny' to be based on the feeling of a 'fluctuating play of pressures, convergences, divergences and accommodations in my eyeballs'. These observations would imply that our innermost centre, the inner sanctuary of identity and intentionality, is merely an imaginary entity or an ideological construct.

But James unwittingly undermines this conclusion in a later chapter, 'The Stream of Thought', where he discusses the observational method of introspection. He points out that the method of observation and introspection over-emphasizes the 'substantive' parts of the stream of experience and neglects what he calls the 'transitive' parts, such as feelings of relationship or of activity. To see and specify the 'transitive' is as impossible a task as to see darkness by switching off a lamp very quickly. This view might be pertinent to issues raised by Bacon's paintings, in which light switches play a key role.

Sass indicates that James's insights into the paradox of observing the 'transitive' can be applied to his analysis of the consciousness of self. For Sass argues that the experience of the self is carried by transitive rather than by substantive parts of the stream of consciousness. So the loss of self observed by James could be caused by his use of introspection as a method of observation. Sass does what James did not do: he turns James's analysis of the method of self-reflective introspection around upon James's analysis of the consciousness of self. This results in an *explanation* of the loss of self which is the opposite of the classical interpretation of the loss of self as experienced and expressed by schizophrenics. Sass writes:

> The loss of self may develop *not* from a weakening of the observing ego or a lowering of the level of consciousness, but to the contrary, from a hypertrophy of attentive, self-reflexive awareness.[57]

The loss of self seems to be embedded in modes of conscious-ness that are not 'primitive' or 'infantile', but that are ex-tremely self-reflexive. It derives not from a lowering but from a hypertrophy of consciousness.[58]

Sass briefly points out that hypertrophied reflexivity is also characteristic of certain strains of the modernist and postmodernist sensibility. In modernism hyper-reflexivity manifests itself mostly as an *externalization* of selfhood. He cites the novels of Nathalie Sarraute as an example. The protagonist/narrator of her novel *Between Life and Death* seems to look so hard at his subjective stream of experience that his feeling of selfhood dissipates. 'The harder he looks, the more the objects of his awareness come to seem to be all that exists, the more the sense of a self transcending this flux disap-pears.'[59]

The distinction felt to exist between subject and object-world disappears, leaving only sense data. The self of the subject is so externalized that the subject is no longer experi-enced as an inner and active observer, but merely as the locus at which the external world is experienced. Without sense stimuli there is no longer the feeling of self or subjectivity. But the externalization of the self also implies a subjectivization of the external world: the external world can only be represented by a subject's experience of that world.

In the case of postmodernism, hyper-reflexivity does not result in externalization of the subject, but in *internalization of the object*. What is usually seen as internal and subjective is now expressed as the product of the object-world or of the language by which the object world is signified. This tendency results in the conviction that language, and the object world as signified by language, constitute the subject's subjectivity.

From this perspective it is not surprising that the hyper-reflexivity of modernism focuses mainly on the character's relationship to the outside world. The character constitutes her/his subjectivity in her/his focalization of the external world. The hyper-reflexivity of postmodernism, on the con-trary, focuses mainly on the power of language to produce subjects, a power on the basis of which the text and the consciousnesses of artist and audience exist. Postmodernism suggests that language and the world of meanings depicted by language constitute the consciousness of the subject.

The relevance of the notion of hyper-reflexivity for the

understanding of Bacon's works is obvious. Some of Bacon's paintings gain depth when confronted with Sass's descriptions of the schizophrenic's loss of self. In the preceding chapter I concluded that Bacon's figures are never in control of the perception of sensations, which is represented as a mechanical process. In turn, the deformations of the figure's body can be read as the figure's alienation from this mechanical and violent process, which seems to victimize the figure. In the cases of schizophrenia that Sass describes, bodily sensations are experienced as having their original locus in another version of one's body. His patient Natalja A. experienced her body as an influencing machine not under her own control. According to Sass's interpretation of this case, this influencing machine symbolizes Natalja's tactile awareness of her own body as lived in the mode of intense introspection. The machine, then, is not the projected image of the physical body, but of the (lost) subjective experience of self.

I should emphasize, at this point, that I do not want to suggest that Bacon's works represent schizophrenics, nor that they are painted by a schizophrenic. I use Sass's interpretation of schizophrenia as 'caused' by hyper-reflection as a subtext in order to understand further the status of Bacon's 'reflections' on the stimuli of perceptions, and the loss of identity that seems to accompany it. I do not want to read Bacon as a representation of the postmodern condition, of 'man in postmodern society'. I want to argue, instead, that it is not the depicted world which is 'postmodern',[60] but that it is the process of perception and representation that the work reflects on and stimulates that deserves this description. This is what I meant earlier with the qualification of Bacon as post/modernist: a modernist aesthetic combined with, or perhaps even in the service of, a postmodern philosophy.

The narrative of perception that Bacon's works represent is not about perception in a 'primitive' postmodern condition in which the subject of perception is cancelled out; such an interpretation of postmodernism would endorse a description of postmodernism that equates to the understanding of schizophrenia as an infantile state. It would be the product of a hyper-reflexive awareness of the process of perception. At the same time one could argue that modernism encourages a reflection upon perception; it thematizes the subjective perspective on the world, and the way that perspective constructs

the world, and the identity of the subject, through the metaphor of vision as insight. Yet Bacon's 'hyper-reflexivity' leads to a notion of perception that is thoroughly de-subjectivized and de-visualized. It de-emphasizes the constituting role of the human subject in the narrative of perception. The subject is reduced to the role of scene of action. This devaluation of the subject also.undermines the role of vision as the privileged sense of perception. It renders senseless the modernist conflation of the subject with the eye. Sight is no longer the sense that constitutes the subject as master subject in control of the world.[61] Instead, it becomes only as significant as the other senses, and may be regarded as simply the mechanical process of stimuli and responses that converts the human subject into an object. Sight is no longer to be conflated with the 'mind's eye', but rather with the 'body's spasm'. The agents of the narrative of perception, the stimuli, are like an invasion of the subject by the object-world. According to this analysis of postmodernism, perception becomes the internalization of the object.

In this process, perception is closely linked to representation. Representation is not followed by perception – the perception of a representation; instead the reverse occurs: the process of perception concludes with representation. The figures, not in control of their perceptions as observers of the sense stimuli, nor in control of the responses of their bodies to the stimuli, are left deformed. These deformed bodies can be read as souvenirs, as representations of a forlorn idea of identity. The difference between the idea of an originating identity and that of a deformed identity provides the opportunity for a temporal re-establishment of identity. The deformed body is the only representation left of the missing identity. This representation of the deformed body is not only the logical result of the violent process of perception, it is also the only signifier which keeps the idea of identity alive.

THE CLOSURE OF PERCEPTION AND
THE OPENING OF THE BODY

In order to understand how perception and representation interact, I propose that we scrutinize the closure of Bacon's narrative of perception, which constitutes the focus of the painter's works: the deformed bodies. In the preceding chap-

ter I read the deformations of the figures' bodies as representations of the self-regulating chain reaction of stimuli and responses of the senses on and in the body. This mutilation, this deformation of the body, is the culmination of the process of perception. But this culmination is not expressed only as deformation of the body. There are other motifs which intensify the meaning of the deformed body.

For example, if the figures are in movement, they are usually in a downward movement, in the middle of a fall. The most striking example of this is *Figure in Movement* (illus. 32). This figure is falling down, diving headlong towards the ground.[62] Deleuze, noticing the downward movement of many of Bacon's figures, does not read this as a simple movement in space; he considers it a passage in the perception of sensation, with decline in the intensity of sensation manifesting itself usually as a precipitous fall.[63] Deleuze goes on to see in the deformation of the body a downward movement, and links this to the way the deformed body also suggests a decaying body:

> The flesh falls away from the bones, the body drops away from the upright arms or thighs. The sensation is developed through falling, sinking from one level to the next.[64]

Another motif that intensifies the meaning of the deformed body is the excretion of bodily fluids or other substances. The turmoil of sensation in the body makes the body 'overflow': we see the figures vomiting and defecating, as in the left and right panels of *Triptych May-June 1973* (illus. 5, 7), or the man on a toilet bowl in the left panel of *Three Figures in a Room, 1964.*

These two motifs culminate in the over-substantial shadows that I discussed earlier, which themselves suggest downward movement, as well as giving a sense of the fluidity to the figures. These shadows are never clear-cut, realistic projections of the figure, and this contrasts with the traditional artistic use of shadows as a kind of mirror image of a subject, a repetition of a subject's profile. There is a long symbolic tradition surrounding the phenomenon of the shadow. Shadows have been seen in relation to identity. They are supposed to confirm the identity of the subject; having a shadow substantiates subjectivity. Having a shadow has been, in fact, synonymous to being alive; whereas being a shadow means being dead, not having a shadow means being fictional.

The projection of a shadow presupposes a source of light. Such sources of light are also a recurrent motif in Bacon's works, invariably in the form of a bare bulb hanging at the end of a cord from the ceiling. Just as the cage structures and the direct gazes in Bacon's work undermine classical perspective, so the sources of light undermine the related conventions of the distribution of light, especially that of chiaroscuro. The convention of chiaroscuro culminated in the work of Rembrandt, whose paintings are commonly seen as *the* major achievement of visual art.[65] But the centres of light in Bacon's work, unlike those of Rembrandt, never create a division between light and dark areas. They never illuminate some area of the represented space. What does the bulb in Bacon's works do instead? What is the relationship between the source of light, the figure and its shadow?

In *Study for a Human Body (Man Turning on the Light)* (illus. 41) a bare bulb, a naked figure and its shadow are depicted. As the title tells us, this figure turns on the light. The figure is entangled in a cage structure that renders the space of the representation confusing. If one starts looking from the bottom of the painting, the figure looks like half a reflection in a mirror – at the left side – and half a figure against a green wall. The foot which seems to stand on the green wall, as if on a floor, cancels out this view, however, and shifts the work to another level of reading. This second reading is suggested by the upper part of the representation. If we focus on the figure's head, it is almost as if we are looking into a box, or into a small room, on the floor of which the man is falling down. But this reading is, in turn, undermined by the lower part of the representation, where the figure's left leg disappears behind the green floor/wall. Every reading of the space is overturned; Gestalt shift turns the space inside out or outside in. The flatness of a mirror becomes the content of a box, or the hollow inside of a room becomes the impenetrability of a wall. The undermining of the classical distribution of light is thus woven into a critique of perspective.

The turned-on light and the shadow are both outside this contradictory space. The shadow on the left side of the painting resembles a puddle, and is perceived as a shadow only because it takes the form of a thin curve projected below the figure's arm as it turns on the light. The shadow is not 'airlike'; it is substantial, like a body or like paint. The bulb and the

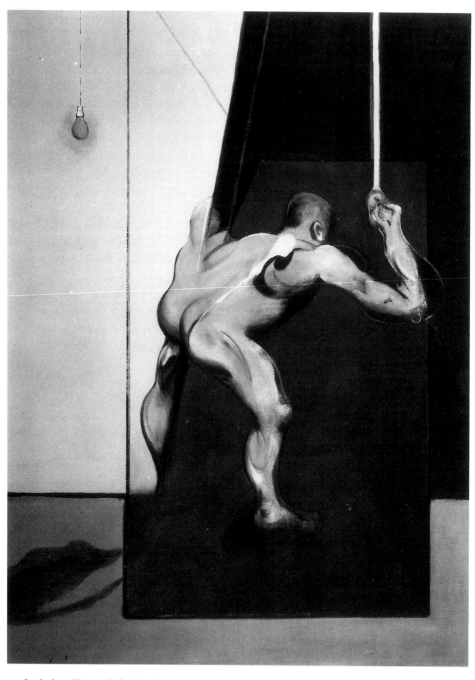

41 *Study for a Human Body (Man Turning on the Light)*, 1973–74, oil and acrylic on canvas. Royal College of Art, London.

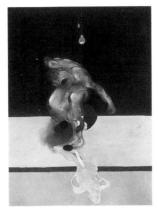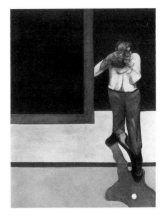

42, 43, 44 *Triptych March 1974*, oil on canvas. Private collection, Madrid.

shadow are both on the left side of the figure, so that the figure is not situated neatly between them; this, in turn, implies that the shadow is not produced by the represented light. For there is no causal relationship between the shadow and the light, though there may seem to be a relationship between the light and the figure, as well as between the figure and the shadow.

The figure seems to be forced down by the light. The relationship between light and figure, and between shadow and figure, is even clearer in the central panel of *Triptych March 1974* (illus. 43). While in the side panels the hanging bulb is absent and the figures are upright, in the central panel it is as if the naked figure is literally pushed down by the light. The shadow on the floor not only has the substance, but also the colour, of a body. In this painting it is the figure in the left panel, wearing an apron with blood stains, like a butcher, who seems to turn on the light. His right arm is in the same posture as the figure in *Man Turning on the Light*. The arm reaches for the doorpost, the usual place for a light switch. Although there is no source of light represented in this panel, the figure has a 'thick' shadow, resembling a bodily organ. We would need to postulate a spatial continuity between these two panels to find a source for the shadow and to see it as a projection by the bulb in the central panel.

In the right panel we see a figure with a complex camera. This figure also has a thick shadow, again despite the lack of any light source. And the shadow, curiously, contains a striking detail. There is a spot in the shadow, partly yellow, partly white, which repeats the characteristics of the bulb in the central panel. The source of light is misplaced within the

shadow, and this dislocation can be read as an index[66] of the conflict between two modes of reading the shadow; the 'wrong' one, according to which a shadow is just a projection of something by a source of light, and the alternative, according to which the shadow is not a projection, but an extension of the figure – not a metaphor, but a metonymy or synecdoche of it. When we read the shadow metaphorically as a realistic projection, the identity of the figure is captured and represented by its shadow. But this possibility is undermined, because the shadow is emphatically *not* a projection. When we read the shadow as an extension of the body, the identity of the figure is co-determined by the shadow. We recognize that the shadow is not a representation of the figure, but a part of its reality. Or rather, the figure is no more real than its shadow.

How do the three panels cohere? The figure in the left panel is represented as a cruel individual: he looks like a butcher with blood on his apron, which suggests that his act of switching on the light is cruel and destructive. The negativity of light is confirmed in the centre panel, in which a figure is crouching as if forced down by the light. The light thus figures as an aggressive, negative entity or agent. If we use the symmetricality of the composition as a reading device, as I have already argued we should, then the act of taking a picture in the right panel would also become a negative act. Such a reading is confirmed by the threatening appearance of the camera. Another implication would be that the act of taking a picture has to do with light, the light that forces down the figure in the central panel. And indeed, both shadows produced by a source of light and those produced in photography are based on the mechanism of projection by light. Photographs as well as shadows are *re-productions*, mimetical illustrations, and the precondition for both sorts of illustrations is light. This reproducing light is represented as destructive in Bacon's work. It pushes down the figure in the central panel, and it pierces and wounds the shadow (not a body-projection but a body-extension) in the form of lightning, as a photographic flash can do. It is clear that these scenes of deconstruction display a negative attitude towards reproduction, seen as projection and illustration.[67]

*Three Portraits* (illus. 45, 46, 47) displays the negativity of reproduction in a similar way. According to Davies the left panel of this triptych is a portrait of George Dyer, Bacon's

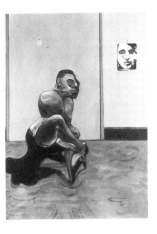
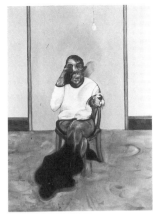
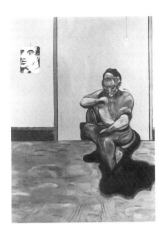

45, 46, 47 *Three Portraits: Posthumous Portrait of George Dyer, Self Portrait, Portrait of Lucian Freud,* 1973, oil on canvas. Private collection.

deceased lover;[68] the central panel is a self-portrait; and the right panel is a portrait of Lucian Freud. In the left panel a black-and-white photograph of Bacon is shown pinned to the wall; in the right panel a photograph of Dyer is on the wall. In each panel a bare bulb is depicted hanging from the ceiling. All three figures have a shadow. And while Bacon's shadow in the central panel is more like an extension of his body 'streaming' out of, and dissolving, his legs, this shadow can be read as a 'realistic' projection made by the bulb behind him. Yet, in the case of the side panels, the shadows cannot be so easily explained. Realistically speaking, the shadows should have been on the other side of the figures. If we persist in reading realistically, and read the triptych as one space with three doors, we could argue that the shadows in the side panels are projections created by the light in the central panel. The yellow stroke on that central bulb would indicate, then, that this light is switched on, while the other, all-white, bulbs are not lit. Yet such a reading is contradicted by the title: the triptych would become a group portrait, instead of a combination of 'three portraits'.

The relationship between light and shadow lies elsewhere – in another insistent reflection on representation. If we persist in representational logic, and read the triptych as three separate images of figures viewed from slightly different angles before the same doorway, the source of the shadows in the side panels must 'logically' be located in the black-and-white photographs. The photographic reproduction of a figure in the representation thus produces the figure's shadow, as the light

87

does in the central panel. The image of the other person is the precondition of the figure's shadow image, as a lightbulb is the precondition of a projection. But it is not so much the shadows themselves that are produced by the pictures and the light. For these shadows are not projections, but extensions. Instead it seems that the 'producer' of the shadow is the body; the body's inducement to extend itself lies in the light or picture of the other. The producer of reproductions (light, camera) seems to call for the production of extensions. How is that possible?

Reproductions produced by cameras and mirrors, with light as the precondition for this production, are seen as creating visual identity at a distance. They externalize identity within framed visuality. As such, they offer themselves as stimuli to the senses. According to Bacon, these stimuli do not lead to a recognition of identity by observing subjects in control of their perspectives, as realism would have it; nor do they allow for constructions of the subject as modernism would have it. Rather, they create the setting for the alienation and distortion of the idea of subjectivity. As the stimulus of sight, the visual leads to an internalization of the object world. This invasion of the subject by the external, and the loss of self it causes, is signified by the deformation of the body. The body is deformed into extensions. The shadow is one of these extensions.

It would be a mistake to see the extension of the body as an unhappy close to a cruel story. In fact, the bodily extensions offer an alternative, a critical response, to a specific conception of representation. They respond to the view of representation modelled on the ideologeme of reproduction from an Aristotelian perspective. From this perspective, males produce replicas of themselves. But while these reproductions, these replicas, claim sameness with their model, they are experienced as alienating and distorting. Lacan's well-known protostory about the child and the mirror makes this point most clearly. Representation seen as extension, in contrast, claims not sameness but contiguity. It emphasizes spatial or temporal contiguity in the *process* of representation, while it acknowledges difference between the *model* and the *product* of the representation. In other words, this view proposes representation as extension, that is, not as reproduction, but as procreation.

Bacon's work seems to display the conflict between two

aesthetic theories. These aesthetic theories can be charac-
terized in Peircean terms: the reproduction theory is based on
the primacy of iconicity, whereas the procreation theory is
based on the primacy of indexicality. If we read Bacon's work
discursively, it proposes the aesthetic theory of procreation
through indexicality as an answer to the alienating effects of
the aesthetic theory of reproduction through iconicity. The
shadows of his figures are not icons, but indexes of their
bodies.

Sometimes the 'feeling for the index' is displayed in a
provocative way in Bacon's work.[69] For example, his use of
arrows in many of his works undermines the belief in the
iconicity of visual images. The right panel of *Three Portraits*
(illus. 47) displays such an arrow. This arrow parallels the gaze
of the figure that represents Lucian Freud. Although this
figure's face is turned towards the viewer, his eyes move away
towards Bacon in the central panel, and the arrow above his
shoulder also points emphatically in that direction.

The arrow is *the* symbol for indexicality. It is based on the
spatial contiguity between the locus of the sign and the place
towards which it points. In Bacon's work the arrow is not part
of the represented world, but functions as a device for reading.
The reader, not the figure, is directed by it.[70] The arrow
indicates that Freud's gaze is moving towards Bacon in the
central panel. Dyer, in the left panel, already has his gaze
focused on Bacon. As a result, Bacon's gaze becomes signifi-
cant; for it addresses the viewer in front of the triptych and can
thus be read as *apostrophic*. As I mentioned in Chapter One,
this device, common in lyric, consists of the rhetorical address
to 'you'. The common denominator between the apostrophe
and the index (in this case an arrow) is one of contiguity and
directionality. The apostrophe foregrounds the contiguity be-
tween the figure in the painting and the viewer in front of the
painting.

The act of addressing the viewer in the central panel blocks
the narrative of looking that is represented in the side panels.
It turns the act of looking at this triptych, as well as the act of
looking represented in this triptych, away from the perception
of a narrative into a narrative of perception. Touching the gaze
of the viewer through his apostrophic gaze, Bacon acts out his
aesthetic theory of contiguity as a ground, and indexicality as a
mode of semiosis. His mode of representation strengthens his

polemical response to the aesthetics of reproduction. His aesthetic of procreation is not simply displayed in his works, but, more effectively, it is set in motion between the works and the viewers.

## THE MIRROR AND THE LAMP REVISITED

I started this chapter by claiming that Bacon's work could be read as a response to the 'mirror' and the 'lamp' – the metaphors for two Western conceptions of the poetic mind as distinguished by Abrahms. Bacon's response to Western aesthetics is even more specific than my reading of the deconstructed lamps and mirrors in his works has suggested so far. These works not only comment on the general metaphors of that tradition, they also comment on the tradition's most famous painterly devices. His cage-structures, in addition to other functions they simultaneously fulfill, also evoke quite explicitly the convention of perspective 'discovered' in the Italian Renaissance, while at the same time renouncing it provocatively. These cage-structures display an exaggeration, or misapplication, of the principles of that convention, thus emphasizing the conventional nature of perspective. The confining, isolating cages represent the convention of perspective, as they also represent perspective as a confining cage. Bacon pokes fun at a device which has often been considered 'proof' of the superiority of Western culture.

Similarly, the bare bulbs which fail to project light, and the shadows which are extensions of the body instead of projections caused by light, evoke and provide distance from the convention of *chiaroscuro*. Space is not illuminated realistically, but represented ambiguously as the *idea* of walls and floors or confining colour fields. Finally, Bacon also evokes and responds to the *impasto* technique, which is prominent in the later work of Rembrandt. Yet, in the case of Bacon, it is not so much the thickness of the paint that creates the effect of impasto, but rather the processing or 'belabouring' of the paint that creates the impression of impasto. This leaves the traces of the construction of the image within the image. Traditionally, this device has been read as realistic, and more recently as self-reflexive:[71] impasto creates a realistic illusion because it gives the image 'body' or substance; it is self-reflexive because the hand of the painter, her or his labour, is still visible in the

product of her or his work. The constructedness of the image is made manifest: the painter and the act of painting are metonymically represented *in* the image.

These two readings of the impasto technique are not sufficient for an understanding of Bacon's works. The self-reflexive reading, which points to the work done by the painter, cannot explain why only the figures' bodies are painted using this technique. The realistic reading makes even less sense. The effect of Bacon's figures is not produced by thickness of paint; the technique does not give the bodies body. In Bacon's case the constructedness of the bodies does not signify the making, but rather the unmaking, of the body. The painter's hand is metonymically present in the textures of cloths and in the imprints of tools he has used to wipe away the paint that would have given substance to the bodies. These traces unmake the bodies. And this unmaking of the body by the painter results in the unbinding and dissolution of the body, and so parallels the effect of the stimuli of the senses. The painting *of* the body coincides with perception *by* the body: they both unmake the body. Representation and perception are ultimately conflated.[72]

The deconstructive effect of painting – its un-representational quality – is perhaps most explicitly thematized in a series of works which evoke one of the central themes in Western art, the crucifixion. In *Fragment of a Crucifixion* (illus. 48) only the raised arms of the mortified creature obliquely remind us of Christ, the main character of the crucifixion story which Bacon here appropriates for his own aesthetic statement. Apparently, Christ-the-character is less important, here, than the imagery of crucifixion itself. The immense cross is disproportionate compared to the figure; the cars in the background are indices of contemporary culture, detaching the theme from its mythological tradition; and the piece of flesh on top of the cross, reminiscent of Rembrandt's *Slaughtered Ox* (which is more explicitly evoked elsewhere in Bacon), is there to insist on the issue of representation. In connection with Bacon's resistance to iconicity, discussed in this chapter, this ostensively iconoclastic appropriation of the sacred theme signifies the mortifying effect of representation itself.

This is confirmed by the other crucifixion paintings, such as *Three Studies for a Crucifixion* (illus. 49, 50, 51). On the left-hand panel of this triptych, the motif of the 'slaughtered ox' is bound

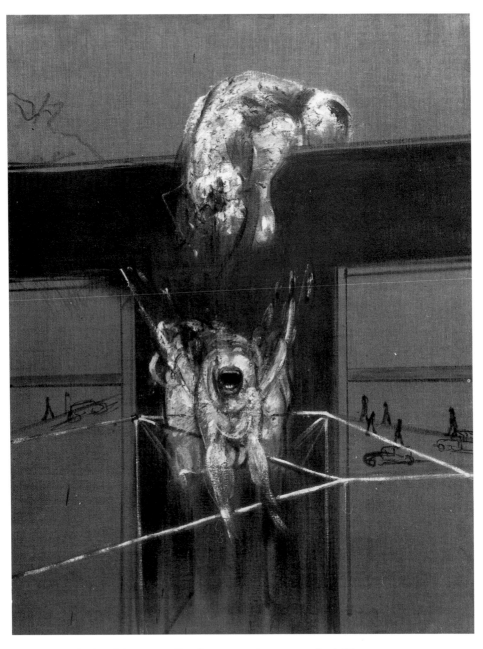

48 *Fragment of a Crucifixion*, 1950, oil and cotton wool on canvas. Stedelijk
van Abbemuseum, Eindhoven.

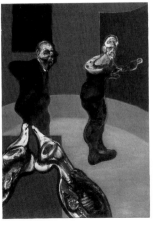
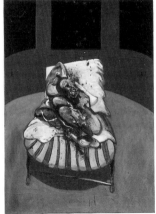
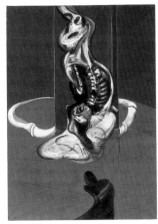

49, 50, 51 *Three
Studies for a
Crucifixion*, 1962, oil
and sand on
canvas. Solomon R.
Guggenheim
Museum, New
York.

up with the crucified figure upside down. And this happens
again in what is perhaps Bacon's most discussed work, *Cru-
cifixion 1965* (illus. 53). The motif of the crucifixion is not
merely the token of bodily suffering and sacrifice. In the
context of Bacon's polemic with the Western tradition of iconic
representation, it is the inevitable consequence of representa-
tion, the tearing apart of the body, the destructive effect of
reproductive mimesis, which the crucifixion betokens. And
this is even more obvious in those works where the crucifixion
is not represented by the cross or by slaughter, but subtly and
microscopically by nails. As indexes of the immense suffering
and the total mortification of the body, the nails suggest that
any attempt to represent iconically may be regarded literally as
an attempt to *nail the body down*.

52, 53, 54
*Crucifixion 1965*, oil
on canvas.
Staatsgalerie
Moderner Kunst,
Munich.

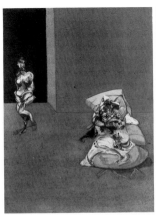
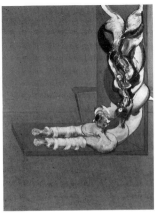
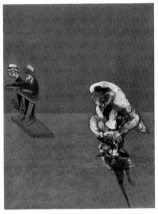

The most detailed version of this literal statement can be seen in *Two Studies For a Portrait of George Dyer* (illus. 39). The scene is clearly one of iconic representation, bound up in a vicious circle as the title suggests. Whereas Dyer is obviously sitting for the portraitist – his pose is a pose, again literally – according to the title he is already merely a portrait, and has been sacrificed to representation. And the sacrificial nature of portraiture is hinted at indexically by the nails that penetrate his body in the painted portrait, his mirror. The two light bulbs, one for each portrait, provide the sitting Dyer with substantial shadow and body extension, and the (doubly) painted Dyer with a clear-cut black-and-white: black background, white body. The embedded portrait is both emphatically iconic – it replicates Dyer's pose – and absurdly different: naked, nailed down.

Although there is no such emphasis on this nailing down of iconic representation in *Study for a Portrait* (illus. 107), discussed in Chapter Five, the insistent presence of nails that nail down – or pin up – the images of the reclining woman is not without reference to Dyer's double mortification. The unbinding of the body causes the work to contaminate both the painter and the viewer. It touches both and establishes contiguity between them. First evoking and then rejecting the aesthetics of reproduction, these works propose an aesthetics of procreation. This is a further meaning of the particular kind of narrative that was discussed in Chapter One – narrative that does not allow for a safe distance between the viewer and a unified image, but that implicates the viewer, in an almost bodily way, in the act of production. These works *touch* the viewer. The resulting 'affect' is the event that constitutes the narrative.

# 3 Death

*Death is the sanction of everything the narrator can report.*
*He derives his authority from death.*
WALTER BENJAMIN[73]

*Do you see the story? Do you see anything?*
JOSEPH CONRAD *Heart of Darkness*[74]

Bacon's *Study for Portrait III (after the Life Mask of William Blake)* (illus. 58) explicitly alludes to death, not just in the way it seems to show a dead face, but also in certain details, such as the noose-like collar. Yet the painting does not simply evoke death; it also challenges it. *Study after Velázquez's Portrait of Pope Innocent X* (illus. 40) challenges death not as a state but as a moment. This painting is filled with blood and pain, with violence and horror, and refers to death as a moment of transition. Yet, the story of this death, the mystery of how it happened, is not there for us to read. This work from the series of 'screaming popes', just like the painting of the 'life mask', raises questions about the relationship between represent-ability and subjectivity, and it is no coincidence that death provides the thematic venue for those questions.

It is easy to represent death objectively: as somebody else's death, as a dead body, as the fear of our future death. In those cases death is outside or in front of us. The object of represent-ation is not the experience of death itself, but the confronta-tion with a person who has died. Representing the experience of death, however, seems impossible. Being dead, or even being in the process of dying, cancels out the possibility of participating in the act of representation. We cannot narrate or describe death in the first person, present tense. Bacon's paintings about death, I will argue here, are an attempt to challenge that limit of representability.

Although representing the experience of one's own death is impossible, this inability seems to be compensated for by another paradoxical representational situation: when we rep-resent the living body, or bodily experiences, death is always lurking. I do not simply mean to say that death is always

metonymically implicated in the representation of a living body (that is, that this body will soon be dead; it is going to die.) Rather, I mean that the intense, concentrated representation of bodily experiences evokes simultaneously the situation of death. Death, then, is not an event which comes after life; it is a situation which lurks within the experience of the body.

This uncanny conflation of the living body with death is particularly acute in the works of Francis Bacon. His representations of the human body, mainly the male body, are unnerving because they depict bodily experiences as violent and deadly. Being absorbed by the intensity of bodily experiences, Bacon ends up in the situation of death: that is, his paintings suggest that in moments of pain and ecstasy a loss of self is inflicted on the body as a prefiguration of death.

The difficulty of representing the experience of death may be clarified by examining the interaction between visual representation and looking. The responses of the viewer may also help us to understand what *happens* in representation, and so in this chapter I will make a detour through a particular literary work. In order to discuss how Bacon's representations of bodily experiences attain their 'deadly effect', and to understand which representational strategies address death, even while depicting life, I will present a reading of a reading of Bacon's works about death. The reading in question is itself representational, while also exploring the limits of representation. Indeed, even in its title the modern novel *De vadermoorders* (*The Fatherkillers*), by the Dutch writer Willem Brakman,[75] proposes the terms by which the problem of representation can best be elaborated. The novel explicitly engages with Bacon's work, and recalls the procreation-reproduction distinction broached in my previous chapter. Just as Bacon used Velázquez's painting of Pope Innocent X as a model,[76] Brakman models his novel upon Bacon's 'pope paintings'. Again and again these famous paintings of screaming popes are evoked in the novel. This explicit intertextual relationship between Bacon's paintings and Brakman's novel is too obvious to be interesting in itself. There is, however, more to say about the relationship between these two artists, for both are concerned with the problem of narrative. At first sight, Bacon's explicit resistance to narrative contrasts with the way Brakman crowds his novels with exuberant narrators. In fact, Brakman's main characters are always excessive talkers, talkers who

cannot stop telling stories. But strangely, Brakman's narrators never convey a true story, that is, a coherent sequence of events. For Brakman's narrators, narration is an intransitive activity; it has no object. These obsessive narrators tell, but they tell no stories.

As discussed in Chapter One, Bacon's paintings contain several narrative signs that stimulate a narrative reading. But these signs have an effect like that of Brakman's compulsive story-tellers – they push the viewer toward a narrative reading that turns out to be impossible, or at least reductive as an account of the work.

In this chapter I will argue that it is exactly this conflict between narrativity and non-narrativity that situates death in the living body, rather than as a final event after life. Using *The Fatherkillers* as a heuristic tool, I will concentrate my attention on Bacon's early portraits, especially the portraits of the Pope, to make this point.

### THE VISUALIZATION OF DEATH

Brakman's novel is about a murder in the Vatican. One morning Pope Innocent X is found murdered in his chair. Inspector Duck of Scotland Yard is sent to solve the mystery of this murder. Inspector Duck plays the attentive listener while various cardinals tell of jealous plots in the Vatican. Bacon's famous 'screaming pope' paintings are frequently evoked in these conversations – although no painting is mentioned by name, the descriptions are unmistakable. Here is one example:

> 'Well', said the voice, 'His Holiness was sitting against a black background and of his chair only a few carved lines were visible, pink and red. Strangely, it was as if He was sitting in a glass cube, and that impression was reinforced by the sense that His Holiness was suddenly very inaccessible, out of reach to the ear. For the sake of clarity I wish to mention that He was wearing the well-known purple skull-cap and, furthermore, a purple dress to which a white ribbon lent an unpleasantly merry tone.
>
> I am sorry to say that His Holiness made an infantile impression: in spite of my warning a blissful smile was immobile on His face, the upper teeth were unnaturally bare, and He seemed entirely absorbed in the bell-cord He moved with tiny pulls. Suddenly I saw how ugly He was,

how unappealing with that hard white flesh, that seemed so obscenely naked.'[77]

While several scenes in Brakman's novel have clearly been modelled on Bacon's 'pope paintings', it is not this direct quoting that has led me to compare these two oeuvres. On the contrary, this type of borrowing is too often used the other way around, so as to show that the relationship between literature and visual art is illustrative. The logic of illustration, however, inevitably supposes a hierarchy between the arts in which the image is considered at best an interpretation, at worst an imperfect rendering, of the literary text.[78] In addition, another hierarchy is superimposed on this one, whereby the older work (the 'source') is presumed to have influenced the newer one, which is then considered a passive recipient of influence. Michael Baxandall[79] has rightly proposed a reversal of this view. According to him, the later work *actively* produces the 'influence' by choosing to respond to the older work. I propose yet another view of this intertextual relationship, a view that avoids the trap of both these hierarchies, while it is applicable both to cases where the text precedes the image, as in traditional history-painting, and to cases where the image precedes the text, as in Brakman's response to Bacon. I suggest that both artists shape their work through an active intervention in the assumptions and conventions of theories about the arts, and that understanding these interventions helps us to understand their works in relation to the historical process in which art and literature are shaped.

This approach helps to account for the use I have made of the conventional portrait, specifically one portrait by Veláz-quez, as well as the use I am about to make of the canon of mystery or murder novels, in this reflection on theory in different artistic traditions. Moreover, this approach allows insight into the change of artistic practice through history without confining explanation to a 'one master – one disciple' structure, which is invariably based on the principle of author-ity.[80] An additional advantage of this approach lies in the role it accords theory. Theory is no longer regarded as a body of discourse that is laterally, if not hierarchically, related to art, and instead becomes another intertext, a discussant participat-ing in the debate between the works of art and literature. Or, put another way, theory becomes an aspect of art.

Brakman wrote his novel within the conventions of the detective story or mystery novel genre. But he did this in a provocative way. Some of the traditional, substantive elements of the detective novel are present, but only as clichés. There is, for example, Brakman's detective, an Inspector of Scotland Yard, albeit provided with the name of a Walt Disney character: 'Duck'. Other traditional elements are, however, provocatively missing. The novel has no conclusion, for example. The mystery of the murder is never solved.

Brakman's treatment of the mystery novel genre suggests that well-considered reflections on narrativity underlie his work. First, the mystery novel as a form is considered to exemplify literary narrative. Todorov has argued, in *The Poetics of Prose*, that it is the narrative of narratives.[81] The 'whodunnit?' question dramatizes the role of the story; using the terminology of the Russian formalists, it makes manifest the relationship between the *fabula*, the chronological sequence of events, and the *sujet*, the way the plurality of events are presented in the narrative text.

The reader of a narrative is traditionally expected to reconstruct the chronological sequence of events on the basis of the story as told. In the mystery novel the activity of reconstruction is done by the detective or inspector for the benefit of the reader. The detective leads the way. Drawing out the events as they have been caused by his/her predecessor, the criminal, the detective follows in the criminal's footsteps. From this perspective the story of reconstruction is a repetition of the story of the crime.

In the classic mystery novel the criminal events – events that stimulate reconstruction but are at the same time unknown – are revealed by the inspector in the presence of the reader. S/he makes the crime into an intelligible story and thereby makes her/himself into a narrator. As a consequence of this narrative situation, the mystery novel in fact contains two stories. First, we can distinguish the story we do not have: the crime, the true facts of the case. But the story that the audience reads does not consist of all the ins and outs of the affair; it is made up only of certain crucial data. The criminal story is *formed* by the story about the detective who poses questions and takes note, who tracks, traces, and reveals. The paradox of narrativity is dramatized in the mystery novel: the story of detection told in the mystery novel *consists of* a criminal story,

and the story of detection *shapes* the criminal events into a story.

In the beginning of a traditional mystery novel there is a death. But initially this death is not an event; it is merely a situation. The death has to be embedded as a crime into a sequence of events, which are in turn caused by agents with motivations that give the events direction and meaning. It is the task of the detective to transmute the criminal death from a situation into an event. This work of detection transforms death as an unacceptable, because unintelligible, situation into an event that is explained through its context in a sequence of events: through the work of the detective the empty signifier, 'death', is provided with a metonymical signified.

This differentiation between death as situation and death as event implies a reversal of the relationship between the criminal events and the reconstructing events produced by the detective. I started out by asserting that the story of detection is presented as a *repetition* of something that has already happened. Yet I have to conclude that the crime story is actually *produced* by the detective; that is why mystery exemplifies narrative in general. Hence, death, the beginning and instigation of the story of detection, is not repeated in the closure of that story; the story's closure is the birth of death as event. The death-event is not repeated, but it is shaped and produced by the mystery novel.[82]

Brakman's novel *The Fatherkillers* is different from this model in certain crucial respects. It deviates from the genre by giving its story an open ending. At the end of the novel the facts of the criminal events are still unknown. The criminal is not unmasked. In this regard, the novel has an ambivalent relationship to another semi-mystery text to which the title of the book clearly alludes, Freud's *Totem and Taboo* of 1913. In that work the criminal is de-individualized. In this mythical narrative Freud attempts to provide his psychoanalytic theory with a narrative beginning. He recounts the 'historical' event – the murder of the arch-father by the herd of sons – that supposedly initiated religion and civilization. The father's death is the beginning of an endless repetition of hatred (as motive for the murder), identification (with the father), and fear (of the consequences). This creation of an event as explanation demonstrates neatly the narrative mechanism in which the works of both Brakman and Bacon find their starting-points. Death

does not produce coherence as the end-point of life, but as its beginning. The story of death is not a 'becoming' from beginning to end, but a repetition of what already has been.

Because the criminal in *The Fatherkillers* is not identified, the pope's death has not been transformed from situation into event. In the middle of the mystery novel Inspector Duck predicts that his desire to unmask the murderer is going to fade:

> If my policeman's instinct and fingertips do not deceive me, then I suspect that this is one of those cases in which the complicated tracking and tracing vanquishes the desire to apprehend the culprit.[83]

In fact, Inspector Duck confirms here the supposition that the mystery novel contains two stories and is motivated by two desires: the desire to transform death from situation into event by unmasking the criminal; and the desire for unmasking and revelation as simple activities, independent of their result. In Brakman's novel the second desire becomes an end in itself, and the criminal story that motivated this second desire is never told. The novel does not form or shape the criminal events; the novel is formed only by detection, listening and telling as intransitive activities.

This intransitive emphasis on detection results in an unsettling representation of death. The death of the pope is not made intelligible by embedding it into a sequence of events. So death, denied the status of event, is consistently represented as a situation. Thus, death is not depicted as an event that has happened to somebody else and will someday happen to us. Instead we are surrounded by death, we are in the situation of death. Brakman does not tell the story of death; he tells a story from within the situation of death, a situation that is, by definition, unnarratable. He does not tell about death; he tries to tell from the position of being dead.

Brakman's repeated evocations of Bacon's paintings of the screaming pope represent this situation of death most effectively. Here is one example:

> If he had to verbalize his sufferings, he would, while stressing the incompleteness of it, appeal to a vision of slaughter, to a situation of being totally enclosed by cleaving, hacking and creaking, by lots of screaming red, yelling holes.[84]

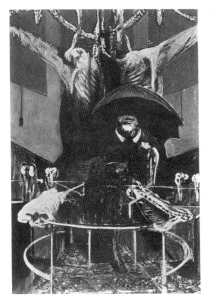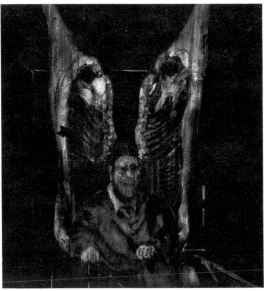

Reading this, one cannot help visualizing the scene through the agency of Bacon's *Painting 1946* (illus. 55) or, even more obviously, *Figure with Meat* (illus. 56)'. Though the situation of death is represented, no story is produced. The basis of this representation of death is visual; we *see* the pope telling us 'I am dead', but we do not *hear* the story:

> The gap of the wide-opened mouth into which the scream had been returned was very striking, a sorry sight because everybody knows how much a scream softens the pain.[85]

55 *Painting 1946*, oil on canvas. The Museum of Modern Art, New York.

56 *Figure with Meat*, 1954, oil on canvas. Art Institute of Chicago.

## MYSTERY PORTRAITS

In the history of art there seems to be no visual equivalent for the literary genre of the mystery novel. Still, one of Francis Bacon's triptychs could provide a convincing case that there is something like 'mystery painting'. In the central panel of *Triptych Inspired by T. S. Eliot's Poem 'Sweeney Agonistes'* (illus. 37), already discussed in Chapter Two, we see what might be a criminal scene. We see bloody clothes and sheets that could be the representation of the kind of violent death that triggers a detective story – a first cause.

Putting to one side for a moment this obvious *thematic*

connection, we can also find a genre in Bacon's work that is *semiotically* comparable to the mystery novel: the portrait. In fact, the majority of Bacon's paintings can be seen as variations on this classical genre. Many titles of his paintings refer to this genre: *Portrait of Lucian Freud, Study for Portrait of John Edwards*, and the like. And within his works references to this genre also abound: the figures in his paintings are on display. They are quite often literally staged in a kind of arena, as if to foreground the idea of display. In addition to the way they mock linear perspective, as discussed in Chapter One, the boxes in which many of Bacon's figures are enclosed can also be seen as signs, as an artifice that stresses the idea that the figures are portrayed in order to be watched by the viewer. The boxes are like showcases or show windows in a museum. The figures are not involved in a fictional world in which the viewer is ignored, and from which the viewer is excluded; rather, the figures inhabit a world of and about representation and its relationship to display.

With the dominant characteristics of all of Bacon's portraits – death and violence – shared by the mystery novel, it is tempting to approach Bacon's portraits as if they were visual examples of the mystery genre. In fact, I will use the hypothetical genre of *mystery portraits* as a heuristic tool by which to understand Bacon's portraits. Now the question becomes: how is the meaning of Bacon's mystery portraits produced by the conventions of the mystery genre? Do these portraits follow the conventions or do they distance themselves from them in a provocative, polemical way as Brakman's mystery novel does?

To see the portrait as an instance of the mystery story implies that we must distinguish two stories in the representation: the story of the crime and the story of detection. In the case of the portrait the history of the sitter's life can be seen as the 'story of the crime'. It is the task of the portraitist to represent a whole life-story at one moment of that life, by means of condensation. The description of that one moment becomes a metaphor of the life-story in which this depicted moment is embedded, a metaphor of this single moment's past as well as of its future.

The second story of the mystery genre, the story of detection, can be seen in the case of the portrait as the process of representing the figure – as the attempt to portray. The act of

painting and of representing by means of condensation is, then, the act which must challenge the death that is going to happen. Death is made intelligible and acceptable by portraying, and thus fixing, the life-story which will have preceded the sitter's death. Death is challenged by this act of representation. The object of detection is thus the story of life, the story that still has to be formed and shaped by the representation of it. Without the detecting act of representation, life will not have been shaped, and so will not have been distinguished from death. Without the detecting act of representing the life story, we are left in the situation of death. From this perspective, then, the motivation for the act of representation is the desire to transform the unacceptable and dominating situation of death into an event – an event in which death is acceptable because it is represented as absence: the death-to-come is only indirectly represented as the opposite of the life-story portrayed.

## MASKING DEATH

In this regard a most significant effort to transform the situation of death by differentiating it from life is the tradition of the death mask. Semiotically speaking, the death mask is an index of death. Because of its concrete, existential proximity to its meaning, the indexical sign can be unnerving, if not uncanny. Such a frightening index is domesticated in the death mask; it is displayed in order to make it into an *icon* of the life that has passed away.

What can we make, in this respect, of Bacon's use of the phrase 'life mask', as in his work *Study for Portrait II (after the Life Mask of William Blake)* (illus. 57)? According to the logic of opposition, we are led to suppose that life masks are, semiotically speaking, the opposite of death masks; they are indices of life, not of death. But instead of working with the opposition between an index of death and an icon of life, as we have it in the death mask, we are now faced with a competition between two equally strong signs: the evoked but implicit index of death in the traditional death mask, and the explicit index of life in the life mask. Because of the existential, contiguous relationship between an index and its meaning, the indexical life mask would be more successful in representing life than the iconic death mask. While the reference to life in the death

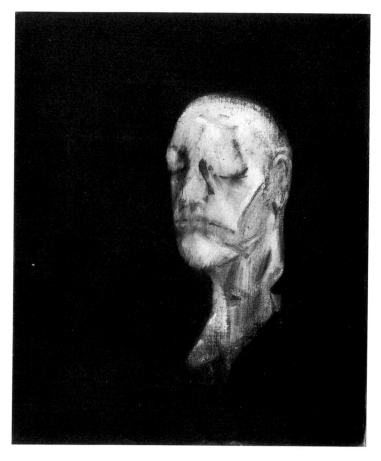

57 *Study for Portrait II (after the Life Mask of William Blake)*, 1955, oil on canvas. Tate Gallery, London.

mask is 'only' based on similarity, in the case of the life mask it is based on contiguity.

But things are even more complicated than that in Bacon's painting. Symmetrically opposed to the convention of the genre, Bacon's portrait after Blake's life mask does not represent the life mask as an index of life, but as an icon of death. Nevertheless, while the figure evokes death by its bleak pallor, closed eyes, and black surroundings, it stands upright, in contrast with the traditional death mask; it has volume, while a death mask is hollow; and, most significantly, it has details – a slit in the mouth, and eyelashes, for example – that a death mask lacks. All of these attributes seem to make it signify as a non-death-mask. The index of death is no longer the imprint of the face in the wax of the mask, based on spatial contiguity. Instead, the index is now temporal: after death, there is life again. The death mask has been *on top of* the dead face; the life

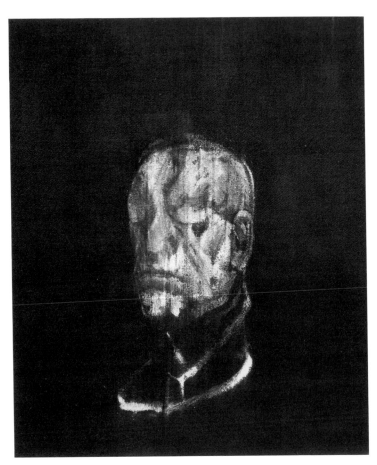

58 *Study for Portrait III (after the Life Mask of William Blake)*, 1955, oil on canvas. Capricorn Art International SA, Panama.

mask was dead *before* being formed on the living face. Representing life, we are in the situation of death. From inside death, the figure is resurrected. The imprint of life is indistinct from the ghost of death.

Blurring the difference between life and death, this portrait avoids the mystery portrait genre at the same time as it evokes it. It is impossible to see this portrait as a detected, represented life-story. Like Brakman's mystery novel, Bacon's portrait tantalizes us with the promise of turning death into an unthreatening event, but leaves us within the situation of death. Seen in this light, the noose-like circle (or is it a priest's collar?) in a similar work, *Study for Portrait III (after the Life Mask of William Blake)* (illus. 58), does not so much refer to violent death as to the imprisonment in the situation of death that life entails.

Something similar can be said of the painting *Study after Velázquez's Portrait of Pope Innocent X* (illus. 40). The pope's scream of horror, the cramped hands that cling convulsively to the elbow-rests, the red dots of paint which suggest blood, join together to form a violent situation of death. Although the narrativity of this representation of a screaming pope stimulates the compulsion to detect or reconstruct a story of a crime, all our efforts to do so are frustrated. There is no clue about what kind of crime has happened or is happening, nor can we hazard a guess regarding the identity of the criminal or the motive of the crime. Transforming this situation of death into an intelligible event is impossible.

The second story of the mystery genre, 'the story of detection', is foregrounded, however, in a very self-conscious way. The painting itself seems to be overlain with a curtain of paint strokes, so that the space in which the pope is situated is covered by a haze of paint. The upper half of the canvas is covered by this layer, with the vertical strokes in this portion of the painting alternating with stripes of canvas that have been left bare; the lower half of the painting is both less clearly vertically structured and brighter. The effect of the whole suggests that a 'curtain' is being removed upwards at the moment of depiction. We see this event of *revelation* happen.

All these features are highlighted even more extremely in another of Bacon's early paintings, the *Study for Portrait* (illus. 59). The screaming man is placed in an almost empty box, and he is surrounded by nearly naked canvas. The lack of paint in the box seems to be countered by the blue-black body of paint at the bottom of the painting. Is this the man's shadow? Is it the threatening force which causes the violence inscribed in his face? Or is it the result of some violence originating somewhere else? Is this dark concentration of paint a repository of paint *for* the empty box or paint taken *from* the box? A confrontation between two other 'pope paintings' provides a possible answer to this question.

In the painting *Pope I* (illus. 60) we see a relaxed pope, quietly sitting in his armchair. He is surrounded by a black space. There is no death or violence in this portrait. The black background is quiet, especially in comparison with the moving, uneven paint that overlies the pope in the *Study after Velázquez*. At the bottom of the painting we see a representation of a curtain – this time not a curtain of paint, but a painted

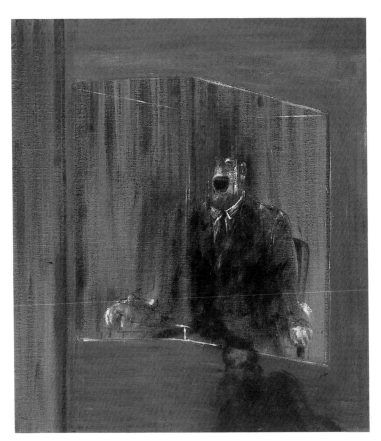

59 *Study for
Portrait*, 1949, oil on
canvas. Museum of
Contemporary Art,
Chicago.

curtain. This curtain is closed and the pope seems to be happy, or at least not in pain. This figurative representation of a closed curtain seems to have an effect on the pope that is the reverse of the effect of the moving curtain of paint in *Study After Velázquez*. But in the latter work it is not the curtains as props that are problematic; rather, the problem lies in the representation – the layer of paint – functioning *as* a curtain.

A moving curtain of paint appears again in *Head VI* (illus. 72). But there is another striking detail in this work. Between the covered eyes of the pope there is an object that can be seen as a hanging light switch or as the tassel of a curtain. This light switch or curtain tassel is a recurrent motif in Bacon's work. In his early work the motif is ambiguous: it seems to refer to the act of turning on the light as well as to the act of closing or opening a curtain. In his later work the second possibility disappears. The switch/tassel becomes an unambiguous light

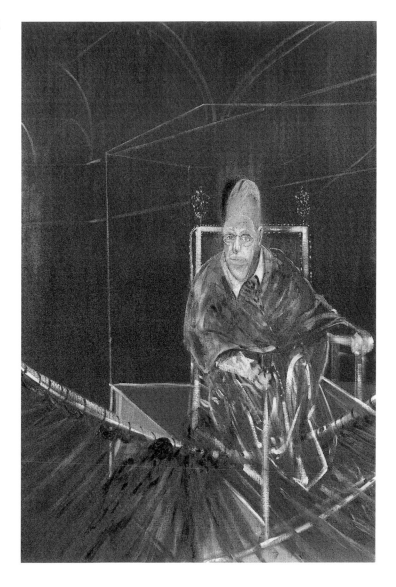

60 *Pope I*, 1951, oil
on canvas.
Aberdeen Art
Gallery and
Museums.

switch, sometimes hanging, sometimes fixed on the wall, and
most of the time associated with naked bulbs (*Self-Portrait,
1973; Triptych May-June 1973*). In the painting *Head VI* the light
switch/curtain tassel covers or replaces the figure's eyes. This
is striking because sight, as well as the idea of lamps that are
switched on or curtains that are opened, traditionally refers to
the idea of perception as detection and revelation. In fact
perception, as well as representation as revelation, is brought
to the fore in the convention of seventeenth-century Dutch

109

61 Rembrandt van
Rijn, *The Holy
Family with Painted
Frame and Curtain*,
1646, oil on canvas.
Gemäldegalerie,
Kassel.

painting in which half-opened curtains represented on the
canvas reveal a scene behind. Rembrandt's *The Holy Family
with Painted Frame and Curtain* (illus. 61) is a good example of
this tradition.[86] We can only see the represented object when
the curtain is removed, and this half-opened curtain reminds
us of the once-closed curtain, and so emphasizes the act of
revelation. In the case of Bacon's painting, however, the sight
of the pope seems to be blocked, even cancelled out, by this
index of detection and revelation.

In contrast to *Pope I*, *Head VI* does not have quiet, black-
painted space; instead there are strokes of paint on an almost
naked canvas, signifying movement. Taken together, the two
paintings give rise to a logic that seems to allegorize repres-
entation. In *Head VI* representation appears as an act of detec-
tion or revelation. The curtain is being opened, or the light is
being switched on, whereby the opaque haze disappears. This
act of detection is clearly presented as a violent, deforming act.
If the crime is not revealed by this act of detection, it is
precisely because the act of representation *as* detection *is* the
crime. This conception of representation is, Bacon seems to
suggest, the very source of the violence and death done to the
figure. The pope is screaming because of *how* he is being
represented: in the position of being detected and revealed.

The allegorical and metacritical meaning of these paintings
can thus be formulated as follows. Portraits in which the story
of a life is represented as a detection of the life, in the sense in

which detection in the mystery novel is the repetition of the crime, are violent portraits; they are literally *murderous*. These allegories of representation seem to say that death is not made acceptable by being made intelligible in portraits that reveal the life story. Instead, death is brought to life by this kind of portrait. How can this be possible?

## THE VIOLENCE OF NAKED LIFE

The detecting portrait pretends to be able to unravel a reality: the life story. The representation pretends to unmask naked reality – the truth about a person, and his or her life. Bacon, however, shows that representation, seen as an act of detection, does not unmask the figure; it forms, or better, it deforms, decomposes, and kills the figure. This kind of representation draws us into the situation of death.

In one of his latest paintings Bacon painted this allegory of representation in a way that recalls his early paintings. As in his early paintings, black is the dominant colour. *Study for Portrait of John Edwards* (illus. 73) shows a deformed body against a black background. The black areas on and against which the figure is situated are enclosed by fields of naked canvas. This bare canvas bring Bacon's practice of removing paint in the earlier works one step closer to its logical conclusion. What is the resulting state of the represented body? Let me address this question via a detour provoked by a detail.

The body is both dressed and naked, but is emphatically *not* in the process of undressing. The formal collar has no relationship whatsoever to the naked body; it is a *sign*, an index of 'dress', of decorum, not an icon of a particular piece of clothing.[87]

On a more fundamental level (to which this contrast between dressedness and nakedness refers as a sign), the body is depicted in the process of deformation. This moment of deformation stimulates the compulsion to read the work as a narrative. But what kind of narrative is supposed to be 'illustrated', then, by this portrait?

Reading this painting as part of a specific criminal story is obviously implausible. There may be a murder story here, but it is not a particular individual who turns out to be the criminal. Instead, it is the world of representation that is deforming and killing, and the violence is committed by the painting's de-

vices, projections, and signs. These agents of violence are the hit men of the main character 'non-representation', who has declared mob warfare against representation. Let me describe a few of 'his' gunmen.

While most of Bacon's figures in his later paintings have body extensions, caused by the force originating in the light of the naked bulbs (as in *Triptych March 1974*, illus. 43), this figure has *holes* in his body. At first sight, these holes are simply black areas that cover the body. But if we take the *forms* of these holes seriously, we can see a correlation between them and the surrounding bare canvas. These holes point exactly toward the corners of the naked areas of the canvas. The corners in the canvas, suggesting three-dimensional space, seem to be pro-jected into the black that cuts into the body. But this 'cutting' black is simply the background where it has become visible due to the incompleteness of the body. It is not that the black covers, but that the bare canvas cuts out, the missing body parts. In other words, the naked canvas represents a deform-ing force, directed at, attacking, the figure's body. These holes and cuts, then, serve as gunmen for the enemy of representa-tion. Although the very existence of the painting suggests that representation triumphs, as in most fights, the winner does not emerge unscathed. The assault on representation leaves scars that not do not fully heal, scars that cover over a naked truth that can never be quite eliminated again. These scars bear witness to the fact that representation cannot save life, and can only imperfectly mask death. This painting seems to suggest that if we look behind the curtain of representation, we will find death.

Like Brakman's novel, Bacon's portraits deconstruct the tradi-tional mystery plot in its very attempt to exemplify narrative. These works do not try to differentiate between death and life, by transforming death from a situation into an event. Bacon's portraits do not shape criminal events by repeating them in representation; instead, these portraits are themselves crimi-nal. If Bacon denounces representation as an act which de-tects, reveals, and repeats the life story outside representation, he is in fact denouncing representation as a transitive activity.

As I pointed out at the beginning of this chapter, this denunciation is one of the most characteristic features of his work, and is a feature with which Brakman shows a deep

affinity. Thus, the conversation between the theory of the mystery novel, Brakman's text, and Bacon's paintings yields an understanding of all three, based on similarity as well as difference, on affinity as well as polemic. If Bacon stands out particularly acutely in this debate, it is because his paintings are such radical explorations of the issues raised by contemporary art and literature. As we have seen in Chapter One, although his paintings contain many narrative signs that stimulate a narrative reading, they tell no story. His figurative paintings, paradoxically, have no object. Bacon's relationship to the narrativity of the mystery genre is exclusively on the second narrative level, where 'revelation' is attempted in the *act* of representation. The only narrative is the narrative of representation as an intransitive act. These intransitive narratives leave life undifferentiated from death. If there is life in representation, it is not in the represented object but in the act of representation. Hence, the representational act does not repeat an event that has already happened – the repetition of a dead event.

To avoid a misunderstanding at this juncture, let me make it clear that neither Brakman nor Bacon simply reduces the mystery novel to one story. The one that is pushed out, the repetition of past events, is replaced by an event taking place in the present. For instead of that repetition, these works enact a living relationship with the viewer.

Bacon's portraits have a 'performative' element that provokes an uncanny relationship with their viewers. When the differentiation between life and death is problematized by the blurring of the figure's position in either of these realms, the reader or viewer is contaminated. The 'life' of Bacon's mystery portraits and Brakman's mystery novel is produced by an address projected from within the situation of death. The painfulness of that projection provides the affective power of the paintings, which act both through and on the body. It is to the question of the body, which lies at the very core of the effect Bacon's paintings have, that we will now turn.

# 4 Bodyscapes

*The body is with the king, but the king is not with the body.*
SHAKESPEARE *Hamlet*

## BODY MATTERS

The body, indeed, is where it all begins: as soon as one wonders what, where, or who one is, one looks to the body for the answer. But if one looks to Bacon's representations of bodies to seek such an answer, to understand the relationship between body and being, bewilderment sets in. Bacon's bodies hinder any attempt to derive from them a sense of existence, identity, or solidity. Precisely because of this bewilderment, the body may well be the central element for an aesthetic and philosophical understanding of Bacon's painting. Here, as elsewhere, Bacon's conception cannot be regarded in isolation. It is a position partly affiliated to, and partly opposed to, current Western philosophies. Hence the need to assess traditional ideas in order to measure Bacon's difference.

The centrality of the body in reflections on being and identity does not imply that our concept of the body is in any way simple; on the contrary, it is the site of almost every conflict and insecurity, self-doubt and self-splitting desire, that one experiences. Attempts to understand the relationship between body and self are numerous. The body is treated as the site and focus of a whole variety of problems and conflicts. All those problems originate in the difference between the form in which a human subject experiences her/his body and the way in which it is perceived by others. Simply stated, one does not see oneself as one is seen by others. While others see the subject's body as object and as whole, the subject has only inner experiences or fragmented outer views of her or his body. As Jefferson formulates it:

> Since the body is what others see but what the subject does
> not, the subject becomes dependent upon the Other in a

way that ultimately makes the body the focus of a power struggle with far-reaching ramifications.[88]

This perspective is a radical reversal of the popular idea that the freedom and independence of an individual subject is a given, derived from the boundaries and demarcated wholeness of her/his body. It may be more correct to say that the subject depends for wholeness on the gaze of the other.

Bakhtin discusses these relationships of dependence between self and other in one of his first essays, written nearly twenty years before he wrote his well-known study on Rabelais and the carnivalesque.[89] In this essay he discusses these relationships in terms of the literary metaphors of 'author' and 'hero'. He sees the relationship between self and other as equivalent to the one between hero and author, because the self/hero is always 'authored', that is, created, by the other/author. Without the other the body has neither shape nor form because the self has no direct or coherent access to it. As Bakhtin writes:

> The body is not something self-sufficient: it needs *the other*, needs his recognition and form-giving activity. Only the inner body (the body experienced as heavy) is *given* to a human being himself; the other's outer body is not given but *set as a task*: I must actively produce it.[90]

'Others' create an external shape and form for the string of inner sensations of self: they create a perception of the body as 'whole'.

If we look at Bacon's images in light of this analysis of the self/other relationship, it becomes immediately clear that the subjects in Bacon's paintings are all represented as trapped in an entirely inner sensation of self. Again and again we see bodies as series of fragments, dangling on the string of the inner sensation of self. Bacon's subjects seem to lack the wholeness that the self/other relationship would produce. This lack is particularly apparent in *Three Studies for Portraits including Self Portrait* (illus. 62, 63, 64). While in most paintings the fragmented bodies are clearly distinguishable from the space that encircles them, in the three panels of this triptych it is not exactly clear where the body ends. The faces are fragmented in such a way that we cannot decide whether the formless appendices belong to the subjects' faces or not. Even

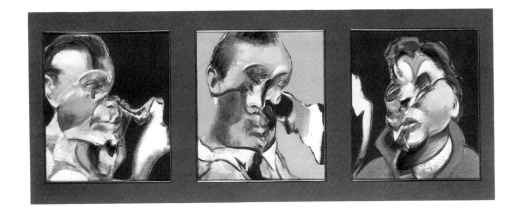

in the middle and left panel, in which the appendices are directly contiguous with their faces, differentiating the subject from its context is not easy. Subject and non-subject become one visual field constructed upon contiguity, making it impossible to speak of a subject or self.

Similarly, although in a less radical manner, the faces in *Studies of George Dyer and Isabel Rawsthorne* (illus. 65, 66) are not clearly delineated. This painting, which is unusual in that it takes the form of a diptych, shows two figures facing each other. Here Bacon is making ironic use of a genre from early capitalist Europe in which a bourgeois husband and wife, facing each other, were painted for posterity. While in the

62, 63, 64 *Three Studies for Portraits including Self Portrait*, 1969, oil on canvas. Private collection.

65, 66 *Studies of George Dyer and Isabel Rawsthorne*, 1970, oil on canvas. Private collection.

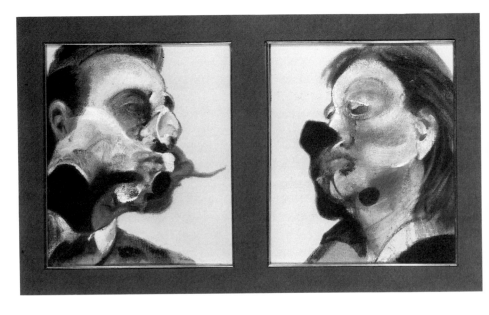

traditional pairing each partner derives his or her identity from the allegiance to the figure they face, in Bacon's diptych the visual relationship does not define, but undoes, the characters. Facing each other with blind eyes, these figures seem to lose their boundaries in the confrontation. Dyer's face is extended by a strange pointed element that seems to be reaching toward Rawsthorne; she, on the other hand, displays one of the characteristic substantial shadows. Here, again, Bacon's representation of the inner experience of self finishes by deconstructing the idea of self: if there is only an inner-self there is, in fact, no self at all.

The 'innerness' of Bacon's bodies throws a new light on the ambiguous, obstructed narrativity of his paintings. Mostly, Bacon avoids putting more than one figure on the same canvas because such togetherness would immediately suggest a story. Dramatic interaction would inevitably result. Perhaps he opposes the representation of stories so completely because the most elementary story, the one of becoming a self *through* the other, must be kept at bay. As I suggested in Chapter Two, the only representable activity that would remain for Bacon would be the shattering of the subject or the failure to become a unified self.

The absence in Bacon's paintings of an other who would be able, by her or his gaze, to transform the subject into a whole, is not overcome even in the relatively small number of paintings, like *Crucifixion 1965* or *Three Figures and a Portrait, 1975*, where there are several figures on the canvas. Deleuze has remarked that in these paintings Bacon obstructs even the slightest idea of spectacle.[91] The figures present are never spectators or viewers; there is never any sign that they are aware of the presence of other subjects; there is never a looking-relationship between the subjects. Therefore Deleuze calls the figures witnesses (*témoins*), rather than spectators. I would even prefer to call them bystanders, because the idea of the witness still presupposes the other's sensorial awareness of the subject. But whatever name one chooses to give these figures, it is clear that the mere presence of another figure in the same space is not sufficient to create an external shape for the subject's body. Without a gaze directed toward the subject, the form-bestowing effect of the look of the other is denied.

Bakhtin discusses another difference between the perspectives of the self and the other. This difference concerns the

relationship between the self and the rest of the world. It is also centred on the body. The subject's viewing-position in the world always coincides with the body. The body is the vantage point from which the subject sees the world. In Bakhtin's words:

> I am situated on the frontier of the horizon of my seeing; the visible world is disposed before me. By turning my head in all directions, I can succeed in seeing all of myself from all sides of the surrounding space in the centre of which I am situated, but I shall never be able to see myself as actually surrounded by this space.[92]

The other, in contrast, sees the subject always as part of the world. The self needs this perspective of the other in order to feel part of the world she or he inhabits.

The lack of a visual relationship between self and other can also explain the isolation of Bacon's subjects in terms of the space which surrounds them. The subject who lacks the support of the look of the other can see its body only as if from a frontier. Its body is its vantage point. Many critics have noticed the artifices in Bacon's paintings that isolate the subject in space: the boxes, platforms and cage structures. They are usually read as a means of short-circuiting the development of action, hence, of a story, and this is how I viewed them in Chapter One. The isolatedness of the figures can now also be read, first figuratively, as the confinement of the subject within his inner sensations, and second, more literally, as the demarcation of the subject's position, always alone on the

67, 68, 69 *Triptych – Studies of the Human Body*, 1970, oil on canvas. Marlborough Fine Art, London.

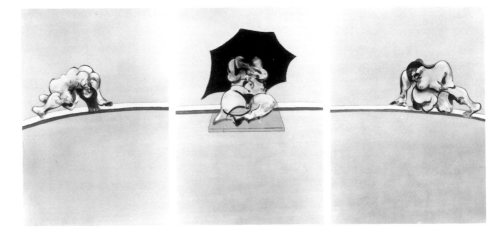

border of the world. The most extreme cases are those where Bacon used swings and ropes to make the figures cling like trapeze-performers to their limited space, leaving absolutely no alternative perspective on the world. In the left- and right-hand panels of *Triptych 1970* (illus. 116, 118) the figures are placed on swing-like objects; in *Triptych – Studies of the Human Body* (illus. 67, 68, 69) all three panels present a female figure on a kind of rope in a vacuum-like space. The figures in the outer panels are especially clearly imprisoned by their positions. There is no way for them to adopt another perspective on their place in the world. They are stuck in their border positions.

LACK OF SELF

This exploration of selfhood through space offers resonances with literature, notably with one of the key texts of modernism: one of the characters in Djuna Barnes's novel *Nightwood* can be seen as a typical Baconian character. For this reason I will dwell in some length on the role of the notion of self in this novel. This central figure, Robin Vote, is perhaps an even more extreme representation of a person who has solely inner experiences of self than even one of Bacon's figures. While at first sight Bacon's characters may seem to suffer from their condition, the question of whether they actually do is left open, in contrast to Barnes's treatment of Robin.

Robin seems to endorse her lack of self, her shatteredness. It is exactly this lack of desire for wholeness that makes her the love-object of three other characters of the novel: Felix, Nora, and Jenny. It may be illuminating to examine the relative positions of these characters, and then position Bacon's figures against the constellation of figures in Barnes's modernist novel.

Those three characters – Felix Volkbein, Nora Flood and Jenny Petherbridge – each suffer from a lack of 'self'. Felix, the wandering Jew, suffers as a consequence of self-hatred; Nora suffers because she is self-sacrifice incarnated; and Jenny suffers because she is a 'thief', that is, because she is convinced that she does not have what others have and therefore must provide herself with it.[93] They each traverse a moment of illusion, erroneously thinking that their lack will be filled by the love they feel for Robin Vote. Robin, however, time and

again, eludes the person who thinks that in Robin s/he has found her or his 'self'. She runs away from Felix (after having borne him a son, Guido), from Nora, and, in the end, from Jenny. Most of the novel consists of conversations these three abandoned characters have with the oppressive and depressive figure of Doctor Matthew O'Connor. Although in their despair they are hardly able to listen, the Doctor holds prophetic monologues in which their despair is not softened but, on the contrary, mirrored and aggrandized in a theatrical way. His soliloquies to Nora, in the chapters 'Watchman, what of the Night?' and 'Go Down, Matthew', are among the most impressive segments of the novel.

Robin is the object of desire of all three of these characters. But what kind of person is Robin? Which of her features make her desired by all these people who, each in a different way, suffer from an extreme lack of identity? One obvious but, I contend, ultimately partial answer is her gender. In an otherwise brilliant article Elisabeth Bronfen suggests this much when she writes:

> Their search in fact reveals how semiotics is always already gendered, since the sought for body is feminine. Yet as privileged object of both a narrative and an erotic search, the feminine is a construct, serving as the body onto which the others' sense of displacement comes to be inscribed.[94]

To the extent that Bronfen is doubtlessly right to stress the genderedness already inscribed in semiotics, we cannot ignore the fact that Bacon's bodies are predominantly masculine, and the next chapter will explore the consequences of that fact. But here, the problem of the relationship between body and subjectivity is, in a sense, even more elementary than that, and looking at Robin's narrative position is illuminating. Robin is called a born *somnambule*, a sleepwalker who lives in two worlds – a combination of child and desperado.[95] Her attitude is self-annihilating.[96] When pregnant, her reactions represent the reverse of all the clichés about that experience. She was 'strangely aware of some lost land in herself'.[97] She takes to travelling, always alone and self-absorbed, as if searching for her former condition. Her misgivings become reality immediately after the delivery. A sense of loss hits her; it is not the loss of the child within her, not of her wholeness, but rather the loss of her fractured auto-autonomy that she bewails:

Shuddering in the double pains of birth and fury, cursing like a sailor, she rose up on her elbow in her bloody gown, looking about her in the bed as if she had lost something. 'Oh for Christ's sake, for Christ's sake!' she kept crying like a child who has walked onto the commencement of a horror.

After a week out of bed she was lost, as if she had done something irreparable, as if this act had caught her attention for the first time.[98]

In contrast to the other characters who suffer from their lack of self, Robin longs to return to the condition she was in before she delivered her baby. The delivery was for her a moment of separation that transformed her shatteredness into wholeness. She becomes whole, a separate being, at the moment that she becomes able to see her child and to imagine how the child would be able to direct his gaze towards her.

But her wholeness is insufferable. Felix sees her 'standing in the centre of the floor holding the child high in her hand as if she were about to dash it down',[99] but she ends up running off, leaving the child with Felix. And after that, she is 'herself' again. Robin manages to recover her shattered condition. She returned, Lacan would say, to the imaginary stage; she knows no desire for wholeness because she coincides with herself. The doctor describes the difference between her and the other characters thus:

> You write and weep and think and plot, and all the time what is Robin doing? Chucking Jack Straws, or sitting on the floor playing soldiers; so don't cry to me, who have no one to write to, and only taking in a little light laundry known as the Wash of the World.[100]

The fact that Robin knows no desires also shows in her sense of time. She neither looks forward to what is to come, nor anticipates it: 'And Robin? I know where your mind is! She, the eternal momentary – Robin who was always the second person singular.'[101]

Robin is always the addressed – Benveniste's 'you' – but she does not speak herself. The word 'I' is of no use to her because she has no experience of a demarcated, whole self. The Lacanian perspective again demonstrates the implications of her position. The entrance into the symbolic order (the law, language) generate desire. The experience of complete identifica-

tion characteristic of the imaginary yields to a mediated experience through language. Meaning and unity are lost forever; they can only be promised by language in an indirect way. The desire that this permanent mediation produces is ultimately a desire to return to the unity of the imaginary stage, as fantasized in retrospect. Robin, then, knows of no desire, for she stands outside the symbolic order. She has no desire, and so she is the suitable object of the desire of others. She represents, for the other characters, the once-experienced unity of the imaginary stage.[102]

This view might be related to what we see in the left-hand panel of *Triptych Inspired by T. S. Eliot's Poem 'Sweeney Agonistes'* (illus. 36), which I discussed earlier in a different context. This panel represents, again, two identical figures, this time female. The figures lack substance. The precariousness of the balance of the foreground figure, who realistically speaking should lose her balance and tip over, indicates a lack of substance within. The outer delineation of the figures consists of curves only, thus emphasizing the fragility of lines as limits. But the most striking aspect of this image is the resemblance, in shape, pose, and precariousness, of the two figures, and to understand that similarity we will have to return to yet another motif of Barnes's novel.

## LOVE AND THE LOSS OF SELF

*Nightwood* proposes a view of love in which love is represented as entirely negative. Bakhtin's view of the relationship between self and other seems utterly idealistic in comparison. He stresses the fact that the self/other relationship is essentially active and productive. The other *transforms* the dispersedness of the subject's experience into the assembled whole that makes him a 'hero'. This productive act of the other/author is, according to Bakhtin, an aesthetic act because it is a construction of coherence and wholes.[103] But it is also an act of love. Jefferson argues that Bakhtin's view makes the self/other relationship into something extremely 'sweet' and 'happy':

> Relations between author and hero are conceived as entirely happy and loving relations in which the subject-hero receives the whole that the author makes of him as a gift offered by the (author)lover to his (hero)beloved. Love is the

culmination – or even the condition – for the aesthetic: only love can be aesthetically productive.[104]

In Bakhtin's view, however, love is a one-way process in which the author-lover is the active partner and the beloved-hero the passive counterpart. The non-dialectical nature of this self/other relationship, entailing the beloved's passivity, is absolutely essential for the success of the authorial activity and its construction of the physical form of the beloved. However, the happy, non-dialectic self/other relationship as described by Bakhtin can be threatened, although he only mentions these threats briefly as if to avoid disturbing the overall paradisiacal atmosphere he has created. One of those threats is that desire may bring the self and the other too close together. This seems to be the threat in many of Bacon's paintings.[105]

If desire brings self and other too close together, then the demarcation between active and passive roles may become blurred. And, according to Bakhtin's early writings, that demarcation is necessary if the aesthetic-loving system is to transform the self into a whole. If desire brings the two parties too close together, then the self may become indistinguishable from the other. The outer body of the self/hero would then disintegrate, becoming no more than an aspect of the body of the other. Jefferson has commented: 'Desire places the two parties on the same side of the boundary, or rather destroys the distance that makes it possible to construct boundaries in the first place.'[106]

This is exactly what happens in those paintings by Bacon that represent coupling or fighting figures, and that are mainly inspired by Muybridge's photographs of wrestlers. In his first paintings with coupling figures the two bodies can still easily be distinguished. In *Two Figures* (illus. 70) it is hard to make out whether the two naked men are making love or fighting. The white sheets on which they lie down suggest the former; the open mouth, with bared teeth expressing aggression, suggest the latter. The faces of the two men are especially blurred and shattered. One could also argue that there is a causal relationship between the love-making and destructive aggression. The sexual desire of the two men may destroy the distance between them, shattering their selves. Love-making, then, may here be representing an assault on the self's boundaries, with sexual desire leading to loss of self.

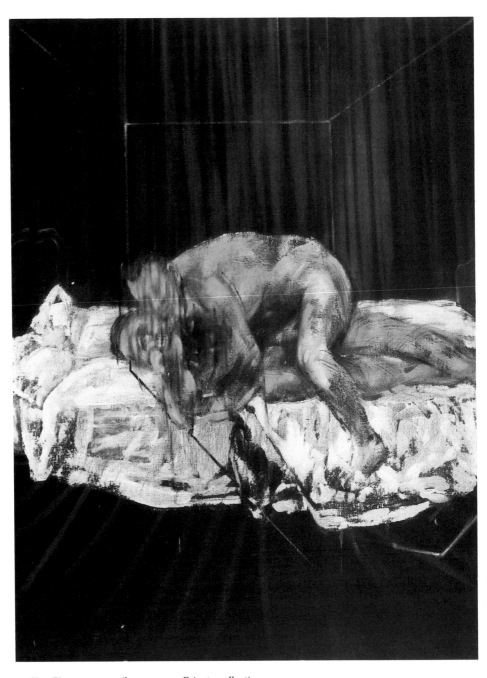

70  *Two Figures*, 1953, oil on canvas. Private collection.

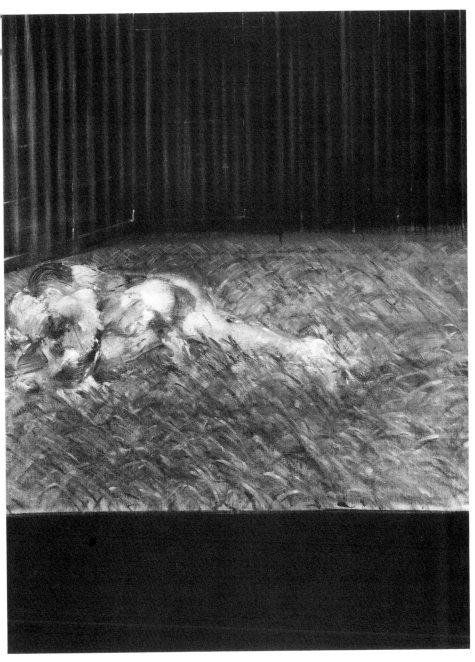

71 *Two Figures in the Grass*, 1954, oil on canvas. Private collection.

In *Two Figures in the Grass* (illus. 71) the two men are still distinguishable, but only with some effort. Their heads have not lost their boundaries. In *Three Studies of Figures on Beds, 1972*, however, the bodies in the left and middle panels are in such a state of turmoil and shattering that it becomes almost impossible to distinguish them. As in the common euphemism for love-making, the bodies 'have become one'; but they have not been transformed into a new whole as a romantic conception of love would have it; rather, they have been transformed into one field of shattered fragments. The middle panel of *Triptych August 1972* shows a similarly total disintegration of selves, caused, again, by the blurring of the self/other relationship.

If love-making leads to loss of self, as Bacon's coupling figures seem to suggest, then the implication is that sex is essentially masochistic.[107] This is exactly what Leo Bersani has argued in his re-readings of Freud's theory of sexuality.[108] Bersani's view of sex can perhaps foster a better understanding of the shatteredness of Bacon's subjects, as well as of the kind of sexual experience that, in *Nightwood*, is represented as a form of loss of self: homosexuality, specifically, lesbian love.

It is important to realize that Bersani arrives at a much more positive view of the loss of self and of masochism than is common in Western culture. For one thing masochism in Bersani's account does not have the common meaning of pleasure in pain. Bersani's positive view of the loss of self and the abandonment of control makes Robin's endorsement of her loss of self not only understandable, but also suggests its status as a *model*. Robin becomes an exemplary figure whose narrative wanderings embody her voluntary elusiveness. I would like to suggest that Bacon's figures represent a visual equivalent of that 'looseness', including, possibly, its positive connotations.

Bersani demonstrates how Freud, in *Three Essays on the Theory of Sexuality*, intertwines two views of sexuality that might appear to be incompatible. In the first place Freud presents a teleological view, in which infantile sexuality prepares the way for the goals of 'adult', post-Oedipal, genital heterosexuality. According to Freud, this 'adult' experience of sexuality is characterized by a hyperbolic experience of the self, a strengthening or aggrandizing of the ego. The sexual pleasure involved amounts to a discharge, a relaxation and a

disappearance of sexual excitement – the latter being seen as confusing, painful and unbearable. Sex is, in this view, a purely metonymic process wherein one state must lead quickly to the next, with no room for metaphoric identification. The problem with this view of sexuality is, however, that it does not explain why the subject not only aims for relaxation, for a discharge of the effect of sexual tension supposedly experienced as undermining and, therefore, unpleasant, but also aims for an increase and repetition of that tension. So Bersani argues for a view of sexual experience as a movement, an oscillation between a hyperbolic experience of self and a loss of any awareness of self.

According to Bersani, the limited view of sex as self-hyperbole represses the experience of sex as self-loss or self-destruction. In his seminal essay 'Is the Rectum a Grave?', Bersani suggests that such a repression is caused by the phallocentric order, in which power is respected and powerlessness is made a shameful taboo. By analogy to the male sexual organ, he calls the strong, tumescent hyperbolic experience of the ego a 'phallicizing of the ego'. But he does argue that this sexual experience as psychic tumescence is not the privilege of men only:

> If, as these words suggest, men are especially apt to 'choose' this version of sexual pleasure, because their sexual equipment appears to invite by analogy, or at least to facilitate, the phallicizing of the ego, neither sex has exclusive rights to the practice of sex as self-hyperbole. For it is perhaps primarily *the degeneration of the sexual into a relationship that condemns sexuality to becoming a struggle for power*. As soon as persons are posited, the war begins. It is the self that swells with excitement at the idea of being on top, the self that makes of the inevitable play of thrusts and relinquishments in sex an argument for the natural authority of one sex over the other.[109]

Bersani's gesture here is to disconnect the hyperbolic, phallic experience of sex from the possession of a penis and the capacity for erections (the literal swelling of what is conceived of as, but need not be, the metaphor for the ego) and from the privileges that a phallocentric society bestows on that possession. But the fact that the struggle between the sexes is often fought through sex explains why the experience of sex as loss

of self and destruction of self needs to be repressed. For Bersani, phallocentrism, therefore, should not be defined as the denial of power to women (although it is crystal clear that in practice that is invariably the form it has taken) but rather as the denial of the positive value of powerlessness and loss of self in both women and men.[110]

According to Bersani such a view of sexual experience as self-loss and self-destruction is not absent from Freud's work, although its presence is fragmented and incomplete. Time and again Freud reverts to a way of thinking about sexual experience in which the opposition between pleasure and pain is cancelled out. Sexual pleasure then becomes a *'jouissance* of exploded limits', an ecstatic suffering in which the human organism is temporarily suspended when 'it is pressed beyond a certain threshold of endurance'.[111] Masochism need not, therefore, take on the traditional negative meaning of passivity and submission, but instead takes on a positive value as powerlessness. This reversal of the standard valuation of masochism is possible because masochism is not, for Bersani, a perverse and exceptional deviation, but:

> an evolutionary conquest in the sense that it allows the infant to survive, indeed to find pleasure in, the painful and characteristically human period during which infants are shattered with stimuli for which they have not yet developed defensive or integrative ego structures.[112]

The sexual experience of children is not, in this view, the first step on the road toward adult, genital sex, but the model and foundation for all forms of sexual experience. The only way to survive the situation of powerlessness in which the infant lives is by drawing pleasure from it. From this perspective sexuality emerges as a typically human response to the number of stimuli to which the infant is exposed before ego-structures can develop sufficiently to withstand those stimuli, or to 'bind', or 'cathect' them, in Freudian terminology. Powerlessness, then, could not be tolerated by the structured self because, as a kind of psychic falling apart, it is a threat to the stability and integrity of the self. It is only through the masochistic nature of sexual pleasure that we are able to survive this threat.

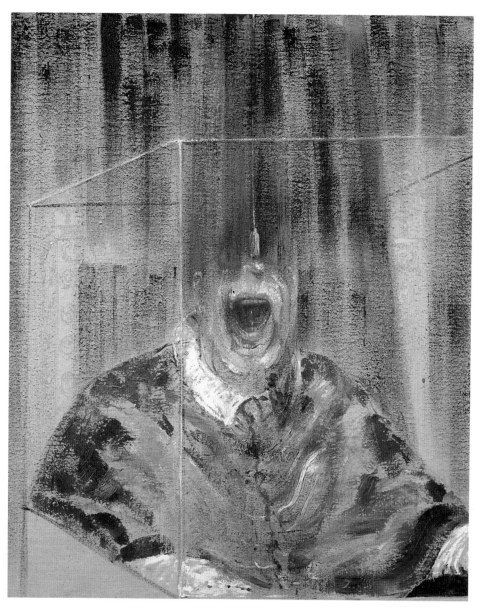

72 *Head VI*, 1949, oil on canvas. Arts Council Collection, London.

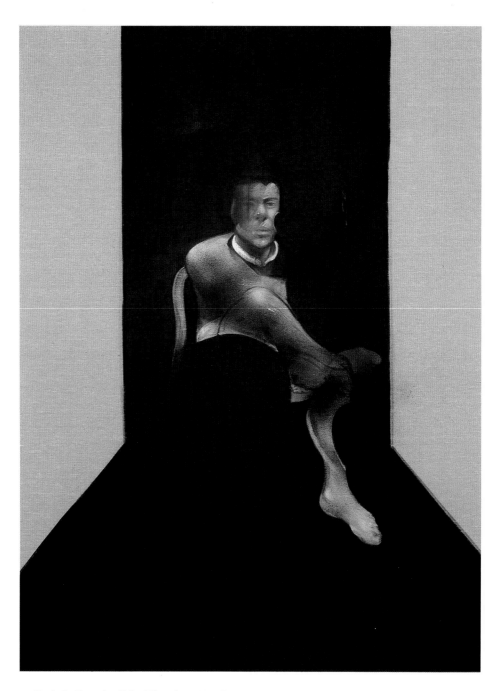

73 *Study for Portrait of John Edwards*, 1988, oil on canvas. Collection of
Richard Nagy.

74 *Study for Portrait of Van Gogh III*, 1957, oil and sand on canvas. Hirshhorn Museum and Sculpture Garden, Smithsonian Institution, Washington DC.

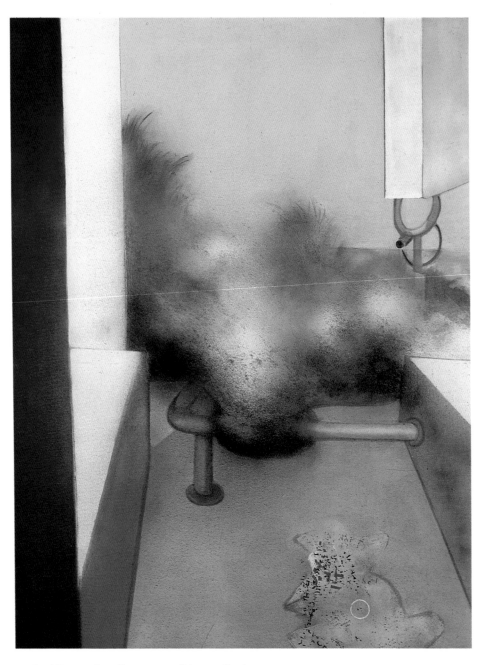

75 *Sand Dune*, 1981, oil on canvas. Private collection.

76 *Landscape near Malabata, Tangier,* 1963, oil on canvas. Ivor Braka Limited, London.

77 *In Memory of George Dyer*, 1971, oil on canvas (left panel). Beyeler collection, Basel.

78 *In Memory of George Dyer*, 1971, oil on canvas (centre panel). Beyeler collection, Basel.

79 *In Memory of George Dyer*, 1971, oil on canvas (right panel). Beyeler
collection, Basel.

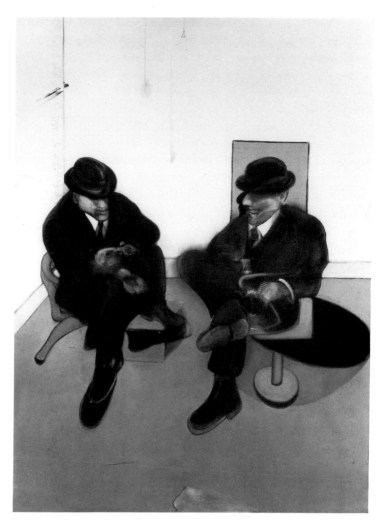

80 *Two Seated Figures*, 1979, oil on canvas. Beyeler collection, Basel.

### THE GAY BODY

The sameness of the two male figures in *Two Seated Figures* (illus. 80) is problematic, yet emphatic. Although not clearly enough delineated to be dubbed twins in any realistic sense, their identical clothing suggests the importance of their sameness; similarly, the clumsy pose of the left figure's legs seems to function as an indicator of one figure's effort to imitate the other figure's relaxed crossing of the legs. Our understanding of the way that these pictures engage current cultural views of subjecthood and sexuality is given yet another level of complexity by a reading of Barnes's novel.

In *Nightwood* homosexual love is one of the most significant images of the loss of self. With the exception of the marriage of Felix and Robin, all the relationships are homosexual. The doctor, Matthew O'Connor, is homosexual. The gay characters experience their loss of self, caused by their love, more intensely and violently than Felix does, who appears slightly naive and little given to self-reflection. The special significance of homosexuality in this novel becomes obvious as soon as we examine the terms by which this novel represents self, identity, and self-confirmation in a love relationship. However, *Nightwood* does not propose homosexuality in general, but specifically lesbian love,[113] as the experience most significant in terms of a loss of self.

How is the relation between lesbian love and loss of self conceptualized in this novel? The dummy or doll is the crucial motif in *Nightwood* that embodies this relation.[114] In certain passages the motif of the doll seems to subscribe to the standard homophobic link between lesbianism, sterility, corruption and death inherited from the nineteenth century.[115] Yet, to suppose that the doll is the symbol of the child that lesbian love cannot produce seems too easy an answer to the question of why lesbian love, specifically, should be experienced as death, as a total loss of self. In one of his oracular phrases the doctor seems to say that the unfulfillable desire for motherhood in lesbian love is not so much an untoward consequence, but, quite the contrary, that the desire for motherhood is the very motivation for that love:

> 'Love of woman for woman, what insane passion for unmitigated anguish and motherhood brought that into the mind?'[116]

Motherhood may seem comparable to lesbian love to the extent that it is an emotional bond *of a woman* with someone else who is maximally similar to her. That similarity can be symbolized by the blood shared between mother and child. The shared identity of mother and child, the same blood, thus becomes the image of the subjective experience in which the self is recognized in the other, is transferred onto the other, *becomes* the other. Motherhood is therefore the foundation of lesbian love in the doctor's view. That relationship of identification is realized in lesbian love in a manner that emphasizes maximally the other, child or lesbian lover, as the same, as self cleaved in two.

Motherhood in this view is in the first place splitting, cleaving, cloning. Fatherhood, in contrast, cannot be experienced in this way. There is no unmediated contiguity between father and child; fatherhood can only be established on the basis of metaphoric similarity. In contrast, motherhood, grounded in existential contiguity between mother and child, is not only a metaphorical relationship (of similarity) but also a metonymical one. The child, a clone of its mother, is thereby the lost self incarnated: the mother's identity is split.

Doctor Matthew, the homosexual who often calls himself a woman and dresses as a woman, gives a paradoxical definition of lesbian love when he characterizes his relationship to his brother and his brother's children. He formulates clearly why in this novel lesbian love is the ideal representation of loss of self:

> Is not a brother his brother also, the one blood cut up in lengths, one called Michael and the other Matthew? Except that people get befuddled seeing them walk in different directions? Who's to say that I'm not my brother's wife's husband and that his children were not fathered in my lap? Is it not to his honour that he strikes me as myself? And when she died, did my weeping make his weeping less?[117]

The love for his brother and the latter's children is imagined by the doctor as a non-sexual splitting.[118] Barnes seems to allude here to, and present a variation of, Plato's *Symposium*. In that text Aristophanes tells about the origin of the sexes. He distinguishes three sexes: male-male, female-female, and a third sex, the male-female called androgyne. The double people became too proud and tried to chase the gods from Olympus. Zeus punished them by splitting them in halves. Therefore, the double people try to retrieve their original state by embracing each other. The originally androgynous ones find satisfaction in that reunion, a satisfaction that entails the procreation of the species. The androgynous couple thus becomes the representative of a heterosexuality primarily destined to procreation. The male-male people and the female-female people of Aristophane's myth do not find satisfaction in the embrace of the other sex; when they find their other half they find a great friendship and love that continues even into the realm of the dead. It is an everlasting bond that is not created for procreation but for love only.

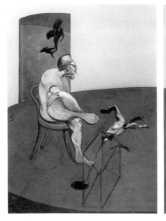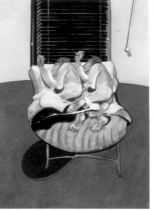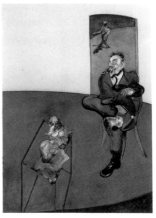

Barnes uses Plato's story to cancel out the distinction be-
tween love and procreation. She redefines love as a procrea-
tion of the self. The doctor's description is also suggestive of
the reproduction of worms, in which the other is not an
Aristophanic complement but the result of parting, the result
of a mode of reproduction in which one being is split in two.
The other is a clone of the self, not just someone in which the
subject recognizes herself metaphorically, but also someone in
which the subject has been lost, metonymically, as the mother
relates metonymically to her child. From this perspective it is
understandable that, according to the doctor, lesbian love
consists of the mad desire for motherhood. The doll is not,
then, the child that one cannot have but the fixed self-image in
an other that exists outside of the self; the doll is a symbol of
lesbian love and thereby a symbol of the ideal of absolute loss
of self.

This definition of identity as loss of self through replication
may shed light on those paintings by Bacon where forms (and
thereby figures) seem to duplicate themselves as doubles,
mirror images, and twins. In addition to the meanings at-
tributed to doubleness and mirroring in Chapter Two, we may
now say, with Barnes, that the figures' identical features turn
them into clones of each other, and so relieve them of their
selfhood.

In the middle panel of *Triptych – Two Figures Lying on a Bed
with Attendants* (illus. 82) the two prone figures again signify
their identity by the unlikely similarity of their poses. Indeed,
peacefully sleeping on one level, the figures *play* their sim-
ilarity *out* into a repetitious rhythm of body-parts raised,

81, 82, 83 *Triptych –
Two Figures Lying
on a Bed with
Attendants*, 1968, oil
on canvas. Location
unknown.

curved, and offered to the viewer. If the direction of their gazes suggests that they belong to one, contiguous space, then the two attendants on the side panels seem to meditate upon this blissful state – a state they have not yet reached. The right-hand figure, fully dressed, has before him a naked shape in/on a box-like frame; this shape is repeated at the left, yet there the shape, turned into a bird, has already escaped its box in order to fly toward or point toward the bed-scene, the other boxed figure, or the one via the other. This gesture seems to show the way toward loss of self in cloning. These two boxed shapes, apparently aspiring for some sort of unification, might well signify yet another image of complementarity: the doubling of the attendants may demonstrate the converse of the scene on the bed, that is, the desire to *become* as identical as the lying figures are. The non-identity of the boxed shapes conveys the idea that achieving the state of unity enjoyed by the figures in the central panel is impossible. The boxed shapes, exemplifying and symbolizing the state of the attendants, show that they are trapped in complementarity.

Finally, as was mentioned earlier, the left-hand panel of *Triptych Inspired by T. S. Eliot's Poem 'Sweeney Agonistes'* (illus. 36), represents, again, two identical figures, this time female. These two figures, even more than the two embracing figures discussed above, show signs of cloning. The semiotic nature of their state is underlined by the impossibly strained pose, as well as by the triply redundant indication of their display *as* identical. Tipping over the edge of the three-tiered platform they lie on, the figure in the foreground does not lose balance, as one might expect realistically, for losing balance and leaning down would break the spell of their identity. That this is not chance, but a sign, is indicated by the mirror-image, which again emphasizes the lack of weight of the figure tipping over the edge. Consisting of curves only, the figures stand out against the stern squares of platforms and box. Like the squares they stand out against, they seem to be two identical forms – the ideal image of cloning. And cloning, as *Nightwood* suggests, is ideal because it is a loss of self in its purest form; the new self is produced by breaking the old self into two halves that confirm each other by their sameness. Barnes's novel relates this image to motherhood, as an image of the production of identity, but obviously this should not be taken literally.

That lesbian love in *Nightwood* represents an experience of subjectivity and of sexuality as loss of self is suggested by the definition of lesbian love offered by the doctor from his own experience. His fatherhood of his brother's children is lesbian because he perceives the children as clones, split versions of himself. Defining himself by what he is not, his fictional fatherhood is experienced as motherhood. He is the boy who should have been a girl, and he shapes motherhood through the fatherhood that he was denied. By losing himself in men he becomes the woman that he is not. Loss of self is multiplied exponentially in the impossible desires of Doctor Matthew. For him, sexuality does not lead to a swollen experiencing of his subjectivity, but to a complete loss of self within the object of his desire. He de-composes into a woman, a mother, and this de-composition, this loss of self, turns him into a lesbian;[119] and that experience is what he has formulated in the passage quoted above.

This loss of self as an ideal position within and against cultural constructions of the body also implies a particular conception of visuality. In visual art the loss of self questions the construction of images through delineation, and we have already seen how Bacon's work disconcerts because of its relentless challenging of unified shape. In an art which represents bodies in space, the question of the mutual shaping of bodies and surrounding space is particularly pressing, and it is here, perhaps, that Bacon's painting is at its most radical in its undermining of cultural assumptions.

BODYSCAPES

I have argued above that Bacon's figures seem to avoid the construction of self in a self/other relationship. Like Robin Vote in Djuna Barnes's novel *Nightwood*, his figures do not seem to suffer from their loss or lack of self; rather, they seem to keep a safe distance from a stabilized self. In the next chapter I will deal with the question of why this is so: How can a fragmented experience of self be preferable to an experience of the self as whole? But before I go into that matter, I will show how Bacon's paintings obstruct the experience of self in ways which do not correspond with Bakhtin's theory of the construction of selves. While for Bakhtin the self is constructed in the relationship between a subject and another individual,

Bacon adds the space of representation as a constitutive force in this process.

I have pointed out, first, that in Bacon's paintings looking-relations between figures are avoided, and second, that figures are confined to positions in space that allow them no other perspective on their place in the world. They can never see themselves represented as part of a world. But there is more to say about the figures and the spaces which surround them. While the position of the figures in their space obstructs their self experience, the ambiguous identity of the space itself prevents it from providing a clear and comfortable frame. This lack of a capacity to frame means that Bacon's spaces do not bestow shape.

This first became clear in the so-called Van Gogh series, painted in 1957. In these famous paintings Bacon relates figure and space, in these cases landscapes, in a way that is unique in his whole oeuvre. Normally, and more extremely after 1957, his figures are painted using the impasto technique, whereas the surrounding space is evoked by a strikingly flat surface. In the 'Van Gogh' paintings both the figures and the space are painted in heavy impasto. (In the treatment of paint, the figures almost remind one of Willem de Kooning's paintings of women.)

In *Study for Portrait of Van Gogh III* (illus. 74) we see Vincent van Gogh standing still on a road. The road is composed of large strokes of thick paint. The impasto technique is even more strikingly used in painting the road than in painting the figure. Vincent van Gogh is painted very dark blue and black. These colours and the grimace on his face turn him into a personification of death. His body is not bodily at all, it signifies the emptiness of death. The road, on the contrary, is extremely body-like. The red, pink and white strokes of paint turn it into a meat-like surface. It reminds one of the slaughtered oxen in *Three Studies for a Crucifixion* (illus. 49, 50, 51) and *Crucifixion 1965* (illus. 52, 53, 54).

The specific meaning of this painting, and the other paintings in the Van Gogh series, becomes clear when we compare it with the paintings on which it was modelled. I do not mean to compare it with the specific painting by Van Gogh which served as a model for Bacon, *The Painter on the Road to Tarascon* from 1888;[120] such a comparison would come too close to a source study. Rather, in light of a discussion of the body in its

relation to subjectivity, the painting can be illuminated through a confrontation with Van Gogh's self-portraits. In a peculiar way, Bacon's 'Van Gogh' paintings are a reversal of many of those self-portraits.

Van Gogh paints his body in his self-portraits as if his body were a landscape. In the self-portrait of 1887, now in the Musée d'Orsay in Paris, his face is composed of yellow strokes that give it the texture of a cornfield. And, from another perspective, when we relate the yellow strokes of the face to the dark blue strokes of the surrounding background, the face becomes a shining star against a dark sky. The directions of the strokes, the rotating movement, substantiate this connotation. In another of his self-portraits, *Self-portrait with Soft Hat* (1887–8), which is in the National Museum of Vincent van Gogh in Amsterdam, his face is composed of little dots and strokes that are as colourful as a pasture in spring. Van Gogh's equal treatment of body and space turns the body into a landscape. As a consequence, his bodies are totally unerotic.

Bacon, in contrast, makes the space which surrounds Van Gogh in the Van Gogh series into a metaphor of the body. In *Study for Portrait of Van Gogh III* (illus. 74) and *VI* the road and the land have the rawness of decomposing meat. In *Study for Portrait of Van Gogh II* (illus. 84) the body metaphor is less violent. The road is mainly pink and the rest of the landscape and the sky is painted in a quieter manner than in the other 'Van Gogh' paintings. But, although the body metaphor is here more idyllic, this does not mean that death is absent. The black area in the lower part of the painting and the blackness of the figure suggest that this is the threatening silence before the storm begins.

The bodily landscapes and the ferine bodies in these paintings form one continuity. Van Gogh's deathly appearance is stressed, perhaps even caused, by the bodily landscape, which is not distinct enough to frame him. The landscape is in fact a bodyscape, and a bodyscape cannot frame the body into a whole because, as the expression already suggests, it is part of that which has to be framed.

The lack of difference between body and space is also very clear in the few paintings Bacon has painted in which no figure is represented at all. The red haze over the grass in *Landscape near Malabata, Tangier* (illus. 76) gives this pasture uncanny bodily qualities. The bright red strokes on the left side and the

144

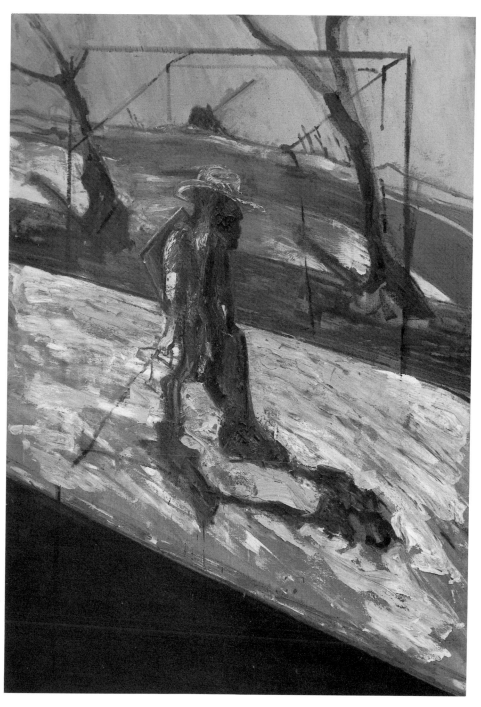

84 *Study for Portrait of Van Gogh II*, 1957, oil on canvas. Private collection.

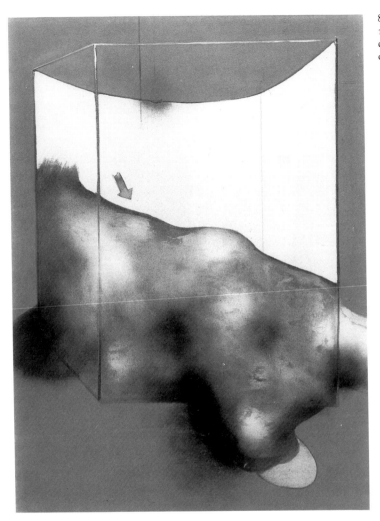

organ-like stain of paint in the middle strengthen this impression. And while we expect to see the infinitude of the African savanna, we see instead a space that is tightly closed off. The difference between inside and outside is challenged here, and that challenge is posed when body and space form one continuous field of dispersed elements. I will return to this in a moment.

The so-called sand dune in *Sand Dune* (1981; illus. 75) has the softness and hairiness of a body. While the rest of the space is clean, cool and impersonal like a swimming pool, the sand dune represents an intrusion of bodily turbulence. The same can be argued for the splash of water in *Water from a Running*

*Tap, 1982*, and in *Jet of Water, 1988*. Again, the sand dune in *Sand Dune* (1983; illus. 85) has the softness and roundness of a body, while the space is closed off like the landscape in *Landscape near Malabata, Tangier*. The conceptual categories of inside and outside, or innerness and outerness, seem to be evoked, but they cannot be attributed to a specific space within the picture. In all the paintings I have just mentioned this ambiguity of the space results in a situation in which the space cannot be described. Put more radically, we are not even sure if there is something which can be defined as 'space', in which the body can be framed or embedded. Bodyscapes, then, offer no bodies and no landscapes but represent the impossibility of both.

## INSIDE OR OUTSIDE: REPRESENTATION

One of the reasons why the spaces in Bacon's paintings do not function as frames of the body, is, as I have just pointed out briefly, the entanglement between inside and outside. This motif manifests itself in several ways. First of all it is figured through the representation of landscapes as closed off – as interiors. But representation also functions the other way around: interiors have the infinitude of an empty world. For instance, the edge between floor and wall in *Three Studies for Portrait of Lucian Freud* (illus. 86, 87, 88) is curved. Although the pattern on the floor clearly signifies a carpet, as part of an interior, the curved line evokes the horizon: it is like the rounding of the globe. The fact that the curve creates one spatial continuity between the three separate panels, and the

86, 87, 88 *Three Studies for Portrait of Lucian Freud*, 1966, oil on canvas. Private collection.

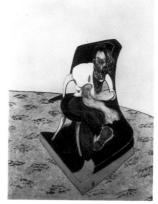

fact that the curve in the central panel is even increased, foreground the illusion of the empty globe, while at the same time the existence of the bourgeois carpet is quite obtrusive. The chair on which the figure is sitting is backed up by a kind of couch or cushion corner. The figure seems to hide himself behind it, as a defence against the infinite space of the room. A similar conflict between signs that signify interior, and those that signify exterior, occurs in *Three Studies of Lucian Freud* (illus. 8, 9, 10). The chair on which the figure is sitting is here supported by the ubiquitous cage structure and by bed-ends. But they are only powerless signs of the idea of an interior, rather than an effective means of creating an interior.

*Self Portrait* (illus. 89) and *Study for Portrait of Lucian Freud Sideways* (1971) have the same curved horizon. The bar-stool on which the figures in both paintings are sitting, however, creates the atmosphere of an interior, while the rotating lines around the figures introduce the void of celestial bodies. In *Figure in Movement* (illus. 90) the infinitude of the surrounding space is only increased by the artificial closing off of the central space – the platform embraced by a cage structure. In *Portrait of George Dyer Crouching* (illus. 91) we see a figure crouched on a diving-board. The space in which he is supposed to jump or dive consists of a round, closed-off couch. The couch, however, is again situated in a space which might equally well be a room or a globe. Like many other Bacon paintings, this painting contains signs whose meanings are in conflict. Taken together, the signs do not constitute a homogeneous space that could give form and identity to the subject within it.

There is a situation repeatedly represented in Bacon's paintings that seems to depict literally this idea of the tension between inside and outside. For example, *Three Studies of Isabel Rawsthorne* (illus. 93), the central panel of *In Memory of George Dyer* (illus. 122), *Painting 1978* (illus. 92), the outer panels of *Triptych, 1981*, and *Study of the Human Body, 1983*, all show figures opening or closing a door. In *Painting 1978* a naked figure tries to lock (or unlock) the door with his foot. This extremely artificial pose seems to express the danger and anxiety involved in this simple act. It remains unclear whether the danger is caused by something that is inside or outside, or by the act of drawing a line between inside and outside.

This brings me to a motif in which all the things I have said so far about the ambiguity of space, about inside and outside,

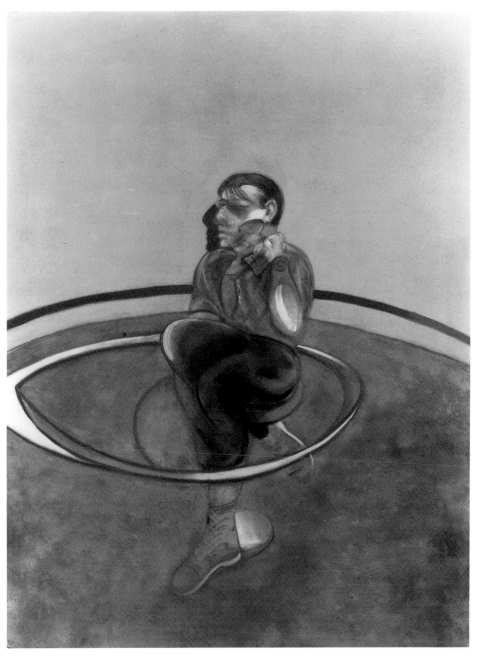

89 *Self Portrait*, 1978, oil on canvas. Private collection.

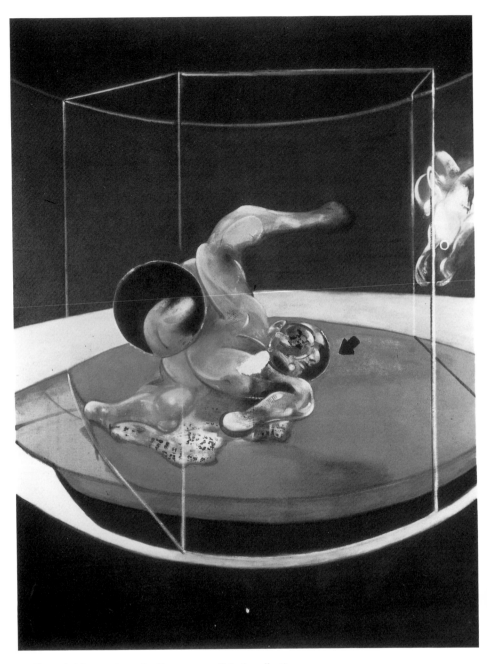

90 *Figure in Movement*, 1976, oil on canvas. Private collection.

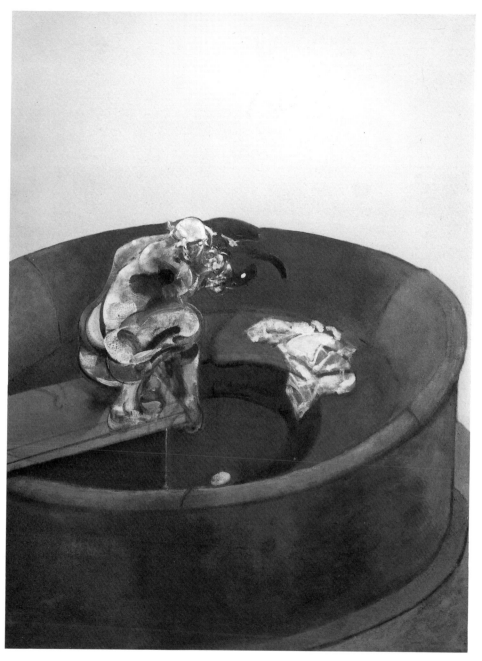

91 *Portrait of George Dyer Crouching*, 1966, oil on canvas. Private collection.

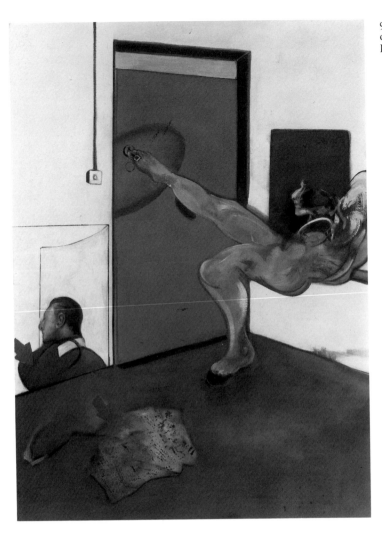

come together. The inside and outside distinction *in* space
repeats itself when it is represented as being applied *to* space.
Figural, represented space cannot be distinguished clearly
from literal, primary space. The space of representation is an
ambiguous zone. Just as the line between inside and outside
cannot be drawn, so also the distinction between model and
representation is fluid. This tangle of ontological dimensions is
apparent in *Three Studies of Isabel Rawsthorne* (illus. 93). We see a
female figure inside and outside a room; we see her as a
shadow on the white door, and in a drawing or painting nailed
on the wall. This image on the wall encapsulates the tensions
produced by the painting that it is a part of. As in many other

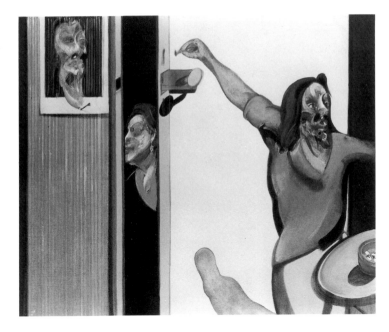

Bacon paintings, it is as if the represented figure is coming out of the image; or perhaps it is the other way around and a figure is being sucked into an image. The figure is both inside and outside the image on the wall.

*Studies from the Human Body* (illus. 94) contains a comparable situation. On the right side we see a female figure walking in the primary space. In the centre there is a male figure half inside, half outside the flat surface of an image – or is it a window? On the left side a figure is totally encompassed by the dimension of representation. The direction in which the female figure walks, and in which the male figure lies down, and the third figure looks, suggests that these figures are being sucked into the level of representation. If we read the direction of the movement in the painting in this way, it is also possible to read the framing of the female figure's face by a circle as the beginning of this process. The circle has the same light blue colour as the two surfaces of the levels of representation.

A seminal painting for an understanding of the representational logic of Bacon's work in relation to the body is *Triptych 1974–77* (illus. 95, 96, 97). On the outer panels we see a male figure on a sandy beach behind a black umbrella. In the background is a view of the open sea. On the central panel the sandy beach continues, but the background looks more like a

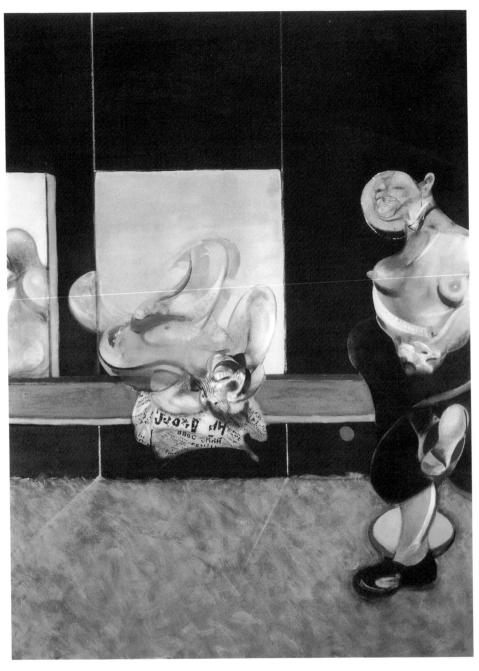

94 *Studies from the Human Body*, 1975, oil on canvas. Collection of Gilbert de
Botton, Switzerland.

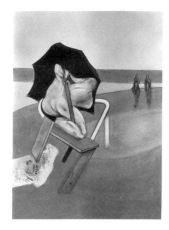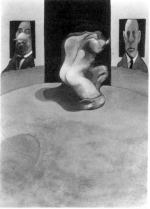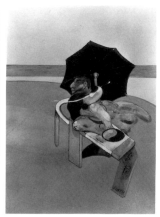

95, 96, 97 *Triptych*
*1974–77*, oil and
pastel on canvas.
Marlborough Fine
Art, London.

museum wall with paintings hanging on it. The paintings are portraits of austere-looking old men. The heads of these two represented men are partly inside, partly outside the painting. In the middle of the painting we recognize a repeat of the situation in the outer panels: a male figure hiding, in this case, however, not behind a black umbrella, but behind a black screen that reminds us of the surfaces on which the two men are represented. Is he hiding from the paintings, or from the eyes of the two men in the painting which are trying to focus on him?

The triptych as a whole is very symmetrical. Again, the line of the beach is curved like a globe. The figures in the outer panels are directed to the central panel, while the central panel itself emphasizes symmetricality in all respects. After we have taken note of what is depicted on the outer panels, our attention is directed to the situation of the figure behind the black screen in the middle of the central panel. The symmetricality of the triptych suggests that the situations in the three panels must be read as similar. What does this similarity consist of?

In the outer panels the figures are imprisoned by being positioned on small wooden structures. The space that they can move around on or in is in sharp contrast with the world around them. Their situation is comparable to the female figures balancing on ropes in *Triptych – Studies of the Human Body* (illus. 67, 68, 69), discussed above. They are not able to gain any external perspective on their place in the world. The question is, are they victimized by this position or have they

chosen it? Here we must be careful to avoid reading the triptych as an illustration of a narrative. Let us consider, instead, the consequences of the represented situations for us, viewers of the triptych. The umbrellas prevent the figures from being seen as part of the surrounding world. Our ability to define the figures with our gaze by embedding them in a context is therefore negated.

How can we compare the situation in the central panel to that in the outer panels? Just as the outer panels remove the possibility of defining the figures by their position in the surrounding world, so the central panel tries to prevent us from defining its figure in terms of the symbolic, representational level. But this attempt to avoid being framed by the outside world or by representation is quite futile. This is because the umbrellas and the black screen on which the figures have pinned their hopes themselves function as frames. There seems to be no way out of being framed. The end result is represented in the central panel: the two men are sucked into the flat surfaces of representation, which is another way of saying that they are losing their subjectivity at the very moment that the subjectivity is defined by its representation.

But perhaps this is not a condemnation of representation in general. The outer panels, after all, are statements about representation, which are then illustrated in the central panel. Instead we must conclude that the painting is a condemnation of a particular conception of representation – of representation seen as a view of the outside world. This form of representation, originating in the Renaissance, has dominated art for many centuries. As is well known, Leon Baptista Alberti set the tone in his *Della Pittura* (1436), when he compared a painting to a window. The 'window' refers to the illusion that we are seeing the real world through the flat surface of the picture. The Renaissance system of linear perspective is based on this principle: Alberti's window opens up the visual space along lines of receding perspective. As a result the type of visual representation that attempts to depict the real world by using the illusion of a painted window is closely connected with principles of perspective.

In Bacon's work the window metaphor, as well as the device of perspective, are highlighted and challenged. As I pointed out in the first chapter, the cage structures in which many of

Bacon's figures are imprisoned are a parody of the rules of traditional perspective. *Three Studies of Lucian Freud* (illus. 8, 9, 10) is an obvious example of this particular challenge to art historical conventions. Another telling triptych in this respect is *Triptych – Two Figures Lying on a Bed with Attendants* (illus. 81, 82, 83). In the outer panels we see small cage structures like the ones just described. In the central panel, behind the two figures on the bed, is a window closed by blinds. In the outer panels this form is repeated in that behind the so-called attendants are panels fixed on the wall. The three-dimensionality of these panels suggests that we should read them as paintings. But the symmetricality of the triptych as a

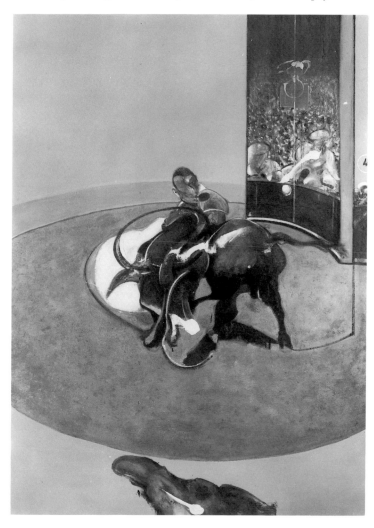

98 *Study for Bullfight No. 1*, 1969, oil on canvas. Private collection.

157

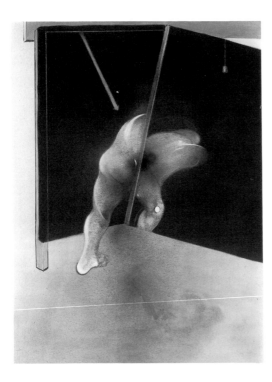

99 *Study from the Human Body*, 1981, oil on canvas. Private collection.

whole entices us to read these surfaces as windows or doors through which we have a view on the world behind. This ambiguity is, of course, the point here. Visual representation according to the logic of the Albertian window is represented and exposed.

Something along the same lines can be argued for *Study for Bullfight No. 1* (illus. 98). The curved panel at the right side of the painting could be a mirror or a painted screen. On it we see – the secondary ontological level of this painting – the public present at a bullfight. Since we expect the public to see at the same ontological level as the bullfight, one could argue that the point of this painting is the identification of these two levels in one continuous space. This continuity, or this identification of the representational level with its model, is clearly pertinent to *Study for Self Portrait, 1981* and *Study from the Human Body* (illus. 99). In the former painting the figure, Bacon himself, steps out of the panel or screen on which he is represented, while in the latter painting we see a human body transgressing from the primary space into the space of representation.

A similar situation is depicted in *Study for Portrait of Gilbert de Botton Speaking* (illus. 100). Here, Bacon ridicules the Albertian

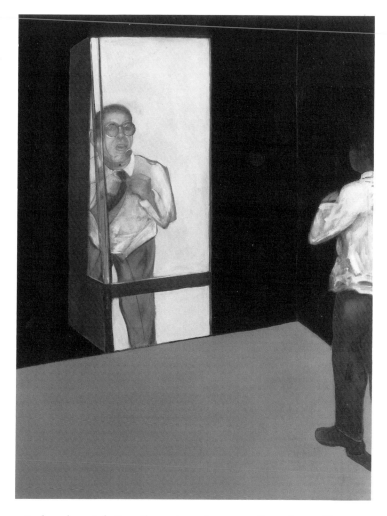

100 *Study for Portrait of Gilbert de Botton Speaking*, 1986, oil on canvas. Collection of Gilbert de Botton, Switzerland.

window by violating the rules of perspective. According to a realistic logic we expect to see a reflection of the figure in a mirror, a flat surface fixed on the wall. But strangely, the lines of perspective behind the mirroring surface turn the mirror into a box or cupboard *into* which we look.

The multiplication of framing spaces in Bacon's paintings does not lead to a more solid self for the figures and onlookers, but to a loss of the framing capacity of spaces. It leaves us in a fragmented, ambiguous space that is characterized by a loss of self similar to that exhibited by the figures. *Self Portrait* (illus. 101) repeats this effect. The viewer focuses first on Bacon's head, which seems to be a straightforward view of the artist. When the viewer's attention is attracted to the sides of the

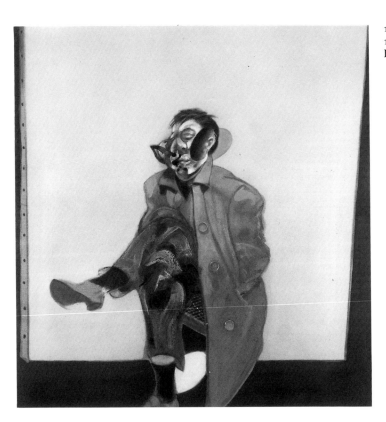

101 *Self Portrait*, 1970, oil on canvas. Private collection.

painting, however, it is apparent that the viewer has been looking at a painting of a painting of Francis Bacon. Yet the lower side of the painting appears to be a painting of Francis Bacon in front of a painting. These readings, occurring in sequence, exclude each other at a realistic level. We can only conclude that this painting short-circuits the illusion of the Albertian window and of realistic space.

The multiplication of frames is very literally pursued in *Study for Portrait* (illus. 102). A figure sitting on a chair is isolated by a cage structure. The cage can be seen as a remedy against the ambiguity of the overall space. This space has no clear identity; as usual it has the closedness of a room as well as the infinitude of a globe. The cage structure fails as a remedy because its execution violates all the rules of perspective. It leaves us again in an undefinable space. So another, smaller, cage structure is constructed around the figure's head.[121] But this cage also does not construct an identifiable space. The cage is transparent (we see the figure's head through it) as well

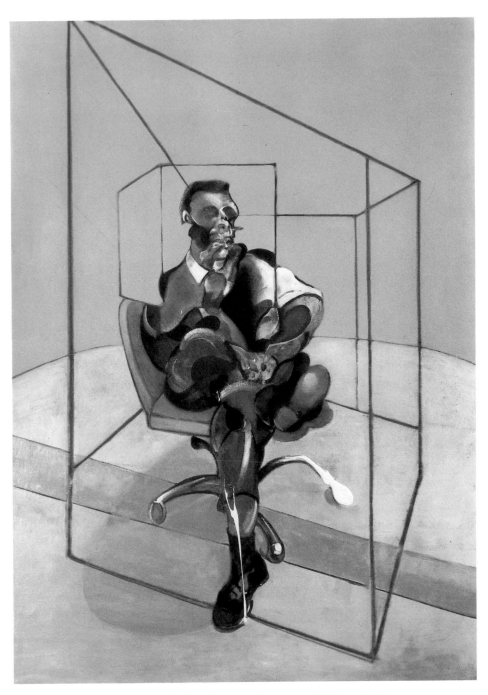

102 *Study for Portrait*, 1971, oil on canvas. Private collection.

as opaque (the left side of the cage makes part of the figure invisible). And if the cage is transparent, why then do we not see the edges at the other side of the cage? The multiplication of frames underlines the artificiality of the framing device. As a means of bestowing form and identity, the frame is here revealed as powerless.

Bacon seems to consistently deny the possibility that subjects can be defined by the space that surrounds them. When I say subjects, I mean the figures in the paintings as well as the lookers in front of the paintings. Representational space is no refuge for the framing, subjecting power of space. On the contrary, its framing capacity can only be sustained as long as representation is seen as a continuation of primary space, and that is what Bacon resists.

This is, then, Bacon's intervention in cultural theory. Bacon's work pursues a negative effect: it refuses to offer clear-cut frames, and it offers no embedding of subjects within a meaningful world (as Bakhtin would have it). He leaves figures, as well as lookers, with their lack of self, which is paradoxically the only situation in which the idea of self, not defined by others or by the surrounding space, can be felt and kept alive. Bacon responds to the lack of self that Barnes represented with a complementary vision: the space surrounding the body comes to hold bodily qualities, into which the body decomposes. Lack of self is represented by a lack of shape.

This merciless view of space also has implications for our understanding of subjectivity and, as I will argue in more depth in the next chapter, of sexual identity and gender. Contrary to the standard view of sexuality as the uniting of two bodies, the lesbian ideal of cloning as proposed in *Nightwood* suggests separation, and Bacon endorses and then continues this view. The lost self disunites and, decomposing, invades and contaminates the surrounding space. Ambiguously wavering between model and representation, as well as between inner and outer, space has no identity and therefore fails to sustain the bodyshape. The body is thus deprived of substance, boundaries and form: of subjectivity. And where neither landscape nor body are possible, only unclear, confusing bodyscapes are present to undermine the self/other relationships proposed by cultural theories such as those of Bakhtin.

For the viewer, this situation entails a highly confrontational experience, which may explain why responses to Bacon's work tend to be so strong. Representation does not offer space as its referent, yet the works are figurative. As Bacon's works make clear, figurativity is not necessarily a subjectivity bestowing idiom. Instead, the viewer's subjectivity is forced to engage in a confrontation with figures that block the very possibility of subject construction. But these works are not committed to this negative view for the sake of negativity. Their target is a specific element in subject formation in the Western world. They aim, that is, to respond through their specifically visual discourse to cultural discourses that are central to our culture. One such discourse, that pertains to visual art as much as to cultural theory, is that of gender.

# 5 Masculinity

*I was always dreaming about very powerful people.*
*Dictators and things like that.*
ARNOLD SCHWARZENEGGER, 1975

*Everybody wants to live forever . . . every man wants to be bigger*
*than Dad . . .*
Title song of *Pumping Iron*, 1976

## THE CREATION OF SELF THROUGH DISCOURSE

In an artistic tradition such as the one that presently dominates our culture, the fact that Bacon devotes so many paintings to an exploration of the male figure is remarkable. In order to understand how masculinity is represented, and what that view of masculinity entails for Bacon's representational practice, it is necessary to clarify some aspects of the relationship between the 'self' and the 'other'. The fundamental point is that self/other relationships are not seen as form-bestowing, as in Bakhtin's account of these relations, but rather as the cause of the loss of self.

At first sight Roland Barthes' view of the self/other relationship is very similar to the early Bakhtinian position.[122] In both accounts the subject's experience of self is determined by the position of (assuming the subject to be female) her body in the world and by the very limited perspective she has on her body. In both stories about the creation of self the other has a strong hold over the subject through the ability of the other to represent the body of the subject, an ability that the subject herself lacks. While in Bakhtin's account, however, this relationship of dependence on the other is sweet, loving and desirable, in Barthes' account the subject is condemned by this dependence.

In *Roland Barthes par Roland Barthes* (note, in this title, Barthes' effort not to be defined or represented by the other: *par* Roland Barthes) he expresses the pain of this dependence:

You are the only one who can never see yourself except as an

image . . . : even, indeed especially, in the case of your body, you are condemned to the repertoire of its images.[123]

In *Camera Lucida* Barthes even describes the dependence on the form-bestowing relation with the other as mortifying: 'I feel that the photograph creates my body or mortifies it, according to its caprice.'[124]

The objectification of the subject is, in Barthes' view, not the work of another individual subject. For him the other is discursive. The objectification of the subject that bestows on her or him the experience of wholeness is a discursive transformation that translates the subject into the terms of the *doxa*, the already-said, the platitudes of public opinion. The dependence on the other for wholeness is insufferable for Barthes because:

> It is through the other that the subject falls prey to a representation that constructs him in terms of the stereo-type. The Barthesian subject is alienated not merely by becoming an image in the eyes of the other but through this assimilation into the *doxa*.[125]

There is no longer a loving, shaping, self/other relationship, but a grim conflict between discourses.

The only thing the subject can do in order to fight the mortifying images of the *doxa* is to try to undo the objectification/mortification of the self through the *practice* of writing or representing. But the assertion of an alternative discourse of her/his own is impossible because the subject cannot avoid using the elements of the discourse which preceded it to built up a 'private' one. The doxa will be lurking even behind the most individual style of discourse developed by the subject. Only the practice of representation as an ongoing bodily activity, with no special object as its goal besides this representational movement itself, succeeds in destabilizing the objectifying transformations of the other through discourse: 'In this practice the body's relationship to language is altered from being the object of its representation to becoming the support and condition of a certain linguistic activity.'[126]

Instead of allowing the *doxa* to objectify the body, Barthes proposes to keep the body in a movement that asserts its resistance against, even if through the use of, the *doxa*. This

movement re-subjectifies the body, thus escaping total colon-ization through full awareness of the dependence on the discourses of the other.

Barthes' account of the self/other relationship as a conflict between discourses makes it possible to reconsider Bacon's paintings and see them as efforts to unsettle representations of the self (of the body that is) that mortify any experience of the self. In his interviews with David Sylvester, Bacon's incessant emphasis on the need for distortion in order to represent the 'real' appearance of somebody can be understood as a fight against stereotypical representations of the body:

> FB: What I want to do is to distort the thing far beyond the appearance, but in the distortion to bring it back to a recording of the appearance.
> DS: Are you saying that painting is almost a way of bringing somebody back, that the process of painting is almost like the process of recalling?
> FB: I am saying it. And I think that the methods by which this is done are so artificial that the model before you, in my case, inhibits the artificiality by which this thing can be brought back.[127]

It seems that Bacon wants to represent the self of a subject without the mediating, form-bestowing role of the perspective that the other/discourse offers. As a result, his paintings become a discourse that mortifies the self-experience of the viewers of his paintings.

His remarks about the effect he strives to make show that he aims for the opposite of an objectifying discourse: 'It's an attempt to bring the figurative thing up onto the nervous system more violently and more poignantly.'[128] His paintings try to avoid offering the objectifying, healing effect that makes the onlooker's self feel whole; instead his images attempt to evoke a violent, *direct* response in the onlooker.

Bacon does not allow the gaze of the other, represented and embodied in the image, to offer an image of the subject's self as whole. The presented image should cling to the fragmentation and shatteredness that the subject recognizes as the original inner-self experience. By calling on the nervous system, Bacon tries *to fragment again* the experience of self in order to 're-call' the real 'appearance' of a subject. He re-shatters the viewer's sense of self by refusing to offer the projections of whole

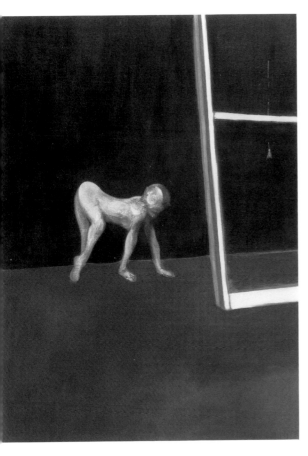
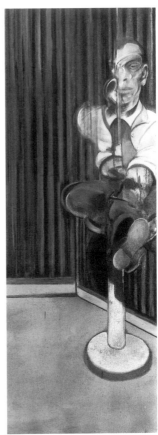

103 *Paralytic Child Walking on All Fours (from Muybridge)*, 1961, oil on canvas. Haags Gemeentemuseum, The Hague.

104 *Portrait of a Dwarf*, 1975, oil on canvas. Private collection.

bodies that enable the onlooker to experience her/himself as whole.

This refusal manifests itself literally in the representation of bodies *as* clearly fragmented. Bacon's recurrent subject matter of disfigured people, such as the paralytic child or the dwarf, can however also be understood in this light. The strange posture of the paralytic child in *Paralytic Child Walking on All Fours (from Muybridge)* (illus. 103) has a very uncanny effect. It is as if his limbs do not fit his body. Bacon's choice for this subject could be explained by arguing that the paralytic child is already fragmented by nature. There is in fact no need to fragment this body by representation. The short legs and big head of the dwarf in *Portrait of a Dwarf* (illus. 104) make up a body which is already not 'whole'. The shortness of his legs is even emphasized by his being depicted sitting on a bar-stool. His limbs do not 'fit' together, so the body remains frag-

mented. At the same time there is no radical difference between the dwarf, the paralytic child, and the 'normal' figures in Bacon's paintings. All figures are fragmented as if they are dwarfs or paralytics. Every figure, deformed or not, is disfigured.

Bacon's position, then, appears highly ambivalent. On the one hand, he fights against the mortification of the subject by the objectifying force of the gaze of the other; instead he folds the subject back onto itself, endorsing the resulting fragmentation as the inevitable consequence of this denial of the power of the other. His statements in the interviews emphasize this denial. On the other hand, part of the reasoning behind Bacon's representations of bodies is illuminated by the story of Robin in Barnes's novel. Struggling free of the either/or mechanism of discourse, Bacon fights the domination of the other by drawing the other in. Like Nora, Felix and Jenny, the viewer cannot resist the violent and powerful figures whose wholeness is lost, but whose presence is absolute. Like Robin, the endorsement of the loss of self bestows on these figures a power of absorption that accounts for the strong responses they arouse.

THE DECONSTRUCTION OF MASCULINITY

As I wrote earlier, it is impossible to avoid using elements of preceding, already existing discourses. Similarly Bacon's images of fragmented bodies do not form a completely new ideolect either. But they do try to disempower the mortifying effect of stereotypical discourse by confronting it, beating it, deconstructing it. This raises the following question: What kind of stereotypical discourse is Bacon working on or against? It is obvious that the large majority of images in Bacon's paintings are men, dressed or nude, presented as busts or full-length portraits. There are few painters in the modern period of Western art who have so dedicated themselves to representing the male body. In acknowledging this subject matter, it becomes apparent that the Western construction of masculinity is one of the major stereotypical discourses challenged by Bacon.

But the cultural construction of masculinity is, in turn, predicated upon another tradition – a tradition more central to the history of Western art, and one that might be considered as

the indirect construction of masculinity. This is the tradition of the female nude, that token of the masculine gaze, fetish of the Western eye, and most characteristic representation of objectification. It is essential, therefore, to begin examining any deconstructive effort in visual art, especially one so focused on the body, by setting up the female nude as the discourse of the other; in this way the tradition of the female nude is cast in the role of the combatted discourse.

At a superficial level, Bacon evokes the female nude simply by painting male nudes, because, as Gill Saunders notes:

> 'nude' is synonymous with 'female nude' because nakedness connotes passivity, vulnerability; it is powerless and anonymous. In other words it is a 'female' state and equated with feminity.[129]

The fact that Bacon paints mainly male, instead of female, nudes is in itself a strategy for disempowering the tradition of the objectification of women. Precisely because one cannot simply break away from existing discourses, Bacon's privileging of the male body is more than a statement on masculinity through a representation of the male body. It is also a statement on masculinity as it is represented in images of the *female* body: the masculinity of the objectifying gaze. Therefore, differentiating Bacon's work from the tradition of the female nude is a first step toward understanding his (de)construction of masculinity.

It has often been remarked that the traditional representation of the female nude placed women on display for the voyeuristic pleasure of the male spectator. The naked body of the represented woman becomes an imaginary erotic object offered to the man's gaze. John Berger formulates this practice as follows: 'almost all post-Renaissance European sexual imagery is frontal – either literally or metaphorically – because the sexual protagonist is the spectator-owner looking at it.'[130] The convention of deleting female body hair from paintings, for example, can be explained as supporting this objectifying gaze: every hint of physical desire or animal passion on the part of the woman is eliminated. She is completely subjugated to the male gaze by the erasure of any threatening sign of the woman's desiring subjectivity.

One of the most famous and successful examples of this kind of elimination of female subjectivity through the repres-

105 Giorgione, *The Sleeping Venus*, c. 1476, oil on canvas, Gemäldegalerie, Dresden.

enting of the female body as completely whole, without any disturbing signs of threat, is *The Sleeping Venus* (illus. 105) by Giorgione. In his study *L'érotisme*, Bataille expressed this male desire to transform women into a commodity. Prostitution is, for Bataille, the logical consequence of the feminine attitude. The commodity value that women have for him can also be recognized in his valuation of representations of women:

> The erotic value of feminine forms is linked to the efface-ment of that natural heaviness that recalls the material use of the members and the necessity of a skeleton. The more unreal the forms, the less clearly they are subject to animal truth, to the physiological truth of the human body, the better they answer to the generally accepted image of the desirable woman.[131]

The ongoing debate about Manet's *Olympia* suggests that the indignant contemporary responses to this painting of a female nude can be explained by the fact that the represented Olympia has several features that disturb the possibility of her functioning as an imaginary object of sexual desire. Bernheimer, especially, has convincingly argued, in reaction to Clark's socio-historical analysis of the painting and its responses,[132] that 'Manet's depiction of woman's nakedness may be his way of exposing the inevitable collapse of class difference under the pressure of a male gaze preoccupied with sexual difference.'[133] He refers to Laura Mulvey's influential article,[134] in which she claims that 'woman as icon for the gaze

170

and enjoyment of men, the active controllers of the look, always threatens to evoke the anxiety [that icon] originally signified, that is, woman's lack of penis, implying a threat of castration and hence unpleasure.'[135] Processes of displacement and substitution are able to provide the male viewer with a safe construct of woman as fetish. Manet's *Olympia* (illus. 106) was such a disturbing image for Manet's contemporaries because it contains several *displaced* signs of her sexuality: the gesture of her hand, the cat, the black female, the bouquet of flowers. Yet, as Bernheimer argues:

> none of them resolves the castration threat associated with that uncanny identity. Olympia's scandalous hand initiates a circuit of displacements that reflect back to the male viewer the fetishizing desire in his gaze without fulfilling it.[136]

If we compare the tradition of the female nude, and Manet's *Olympia* as a scandalization of that tradition, with Bacon's few paintings of female nudes, we see immediately that he radicalizes Manet's scandal. In *Study for a Portrait* (illus. 107) we see a reclining woman on a kind of chaise-longue, exactly the setting of a classical nude. In this painting the signs of an aggressive sexual subjectivity are not even displaced to her surrounding context. She grimaces, showing her teeth, as if laughing in cynical mockery; her arms look like animal bones; her hair is loose and wild. Her hairiness is reminiscent of that other hairy, ape-like woman figure in *Study of Nude with Figure in a Mirror* (illus. 34), already discussed in Chapter Two.

106 Edouard Manet, *Olympia*, 1863, oil on canvas. Musée d'Orsay, Paris.

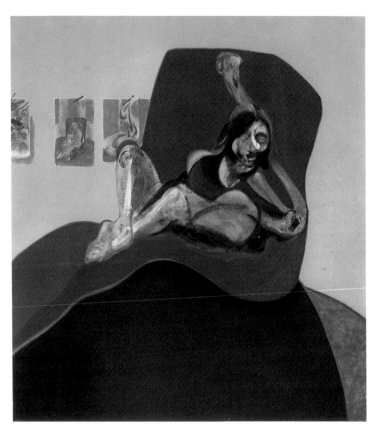

107 *Study for a Portrait*, 1967, oil on canvas. Richard E. Lang and Jane M. Davis Collection, Medina, Washington.

In that discussion, I suggested that the male onlooker, far from being on the safe side of the image, is contaminated by what he sees, and adopts the woman's pose as if to demonstrate the extent to which the viewer is dependent on, constructed by, the figure, as opposed to the received and much more reassuring view. A similar onlooker is implied, albeit not represented, in *Reclining Woman* (illus. 108), an image which is even more unsettling. The posture of this woman on the couch – her legs spread open, her hair wild and disordered – do not make her a suitable object of sexual desire; instead, she is herself the embodiment of sexual desire. Her head tips backward as if expressing the rapture of orgasm. Her eye confronts the onlooker, leaving him no room to look away; but looking is painful because, rather than offering her beauty to the viewer (beauty is clearly irrelevant as a category here) she is pure subject, active, and not available for construction by the other. Without having any use for the viewer, she does not

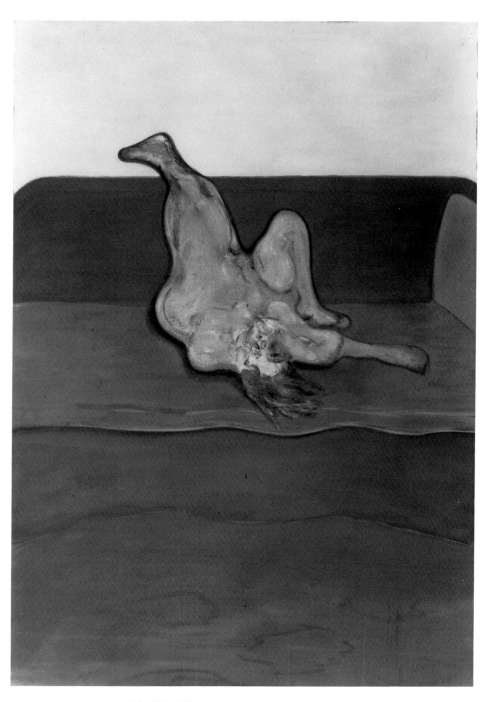

108 *Reclining Woman*, 1961, oil on canvas. Tate Gallery, London.

leave him alone; the viewer is forced to know about her sexual experience, but cannot partake of it.

This confrontation precludes the traditional objectification of the female body in male desire and visual pleasure; the gaze becomes self-endangering, and far from enjoying without being implicated in this view, the viewer is implicated without being able to enjoy. The viewer's only function here is to be voyeuristic object. The woman undresses the onlooker with her eye, and she gets her pleasure from that.

The traditional objectification of female beauty is also undermined by Bacon's use of physical distortion in *Reclining Woman*, where one arm is lacking altogether, while the hip on that side of her body has taken on monstrous proportions; this is also the case in *Study for a Portrait*, where one arm grows out of the woman's back, not her shoulder. None of these female figures share the neat, smooth, and pleasant wholeness of, say, the *Sleeping Venus*; they are emphatically distorted in pose, disfigured in features, and dismembered in body. They torture the viewer; they do not dismiss him, as Manet's woman does. And unlike the desirable female 'commodity' Bataille describes, these female figures are active. But while these images of female nudes draw in the male viewer only to make him aware of the difficulty of his position, things become even more sinister when we look at the male nude in Bacon.

THE CONSTRUCTION OF MASCULINITY

In the preceding section I assumed that Bacon's work could be seen as working against a stereotypical discourse of masculinity. In order to be able to discuss this undoing, this deconstruction of 'mortifying' images of masculinity, it is necessary to dwell at some length on traditional constructions of masculinity.

Gender positions, masculinity as well as femininity, are, as feminism has taught us, primarily a social construction, a cultural fabrication. To be a male subject requires a masquerade of the masculine. A male subject usually introjects masculine identity and projects it outwards onto other males as a continuous injunction to them to maintain the codes of masculinity. So masculinity is not merely constructed by the voyeuristic positioning of the male subject in relation to the

woman as object of the voyeuristic gaze; it is also produced by identification and projection between men.

In many of Bacon's works, indeed, masculinity is fore-grounded as a convulsive masquerade. This side of Bacon's work is extremely humorous and, I am afraid, usually over-looked. Critics tend to stress exclusively the dramatic side of suffering and violence in his work. The masculine masquer-ade, however, is represented as a play of children, dressing up *as* men. In *Two Seated Figures* (illus. 80), for instance, we see two men dressed identically in quite traditional masculine clothes. They both wear dark suits, white shirts, ties and bowler hats. Their dress is far from neutral. This is so because their clothing acts primarily as a signifier. It *means*, symbolizes, masculinity, and evokes super-masculine types such as gangs-ters or businessmen. The fact that the men are dressed identi-cally can in itself be seen as a sign of masculinity. In contrast with the role of dress in the construction of femininity, mas-culinity is not supposed to depend on dress. Being dressed identically signifies an indifference towards clothes, in other words, it is an active construction of masculinity as an essence that does not depend on appearance.[137] The two men in the right panel of *Crucifixion 1965* (illus. 109) are also dressed over-emphatically as men; they wear dark suits again, this time, however, not combined with black bowler hats, but with light straw hats.

But the signifying power of dress is even more insistently emphasized when it is absent, or nearly so. The artificiality of the masculine masquerade is foregrounded in many of the male nudes by the way they are not presented completely naked. The male figure in *Figure Writing Reflected in a Mirror* (illus. 30), wears only a white collar, symbol of a whole class of men. The figure in *Study for Portrait of John Edwards* (illus. 73) is invested with the same sign of masculinity. His nakedness is checked by a white collar. The white collar is a recurrent feature of Bacon's male figures. In many of the early dark paintings, such as *Three Studies of the Human Head* (illus. 110, 111, 112), we see the dark suits disappearing against an equally dark background. The only signs that jump out of this overall darkness are, again, the clichés of the masculine masquerade: white collars with ties.

The foregrounding of the constructedness of masculinity as a theatrical masquerade is the first phase in the process of

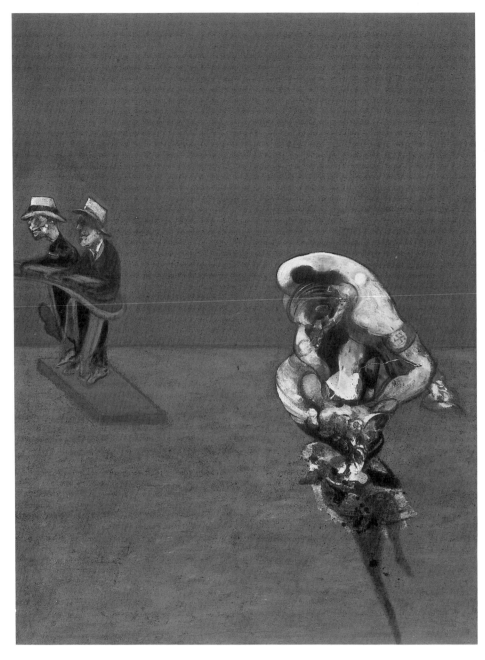

109 *Crucifixion 1965*, oil on canvas (right panel of triptych). Staatsgalerie
Moderner Kunst, Munich.

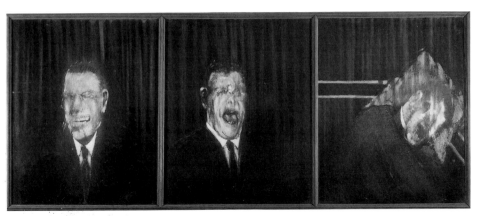

undoing the traditional discourse on masculinity. Masculinity is not different from femininity in this respect: both are cultural fabrications. The two gender positions are, however, not at all symmetrical with respect to the mechanisms that produce each position. Which problems, situations, mechanisms are specific to the production of masculinity? Does Bacon also deconstruct the content of traditional masculine subjectivity?

Norman Bryson's thought-provoking article 'Géricault and Masculinity' is very helpful in discussing this matter and in understanding the effect of Bacon's representation of masculinity.[138] Bryson's reading of Genesis 9:20, the story of the drunkenness of Noah, is most revealing, although I will ultimately propose another reading of the concerns that lie behind this biblical story. The story goes as follows:

> (Noah) planted a vineyard; and he drank of the wine, and became drunk, and lay uncovered in his tent. And Ham, the father of Canaan, saw the nakedness of his father, and told his two brothers outside. Then Shem and Japheth took a garment, laid it upon both their shoulders, and walked backward and covered the nakedness of their father; their faces were turned away, and they did not see their father's nakedness.

Bryson reads the problem caused by Ham's seeing his father's nakedness as symptomatic of the double Oedipal command imposed upon the male child: while the boy has to identify with the father in order to form his sexual identity, he is not allowed to be like the father with respect to the father's sexual

power. Father and son are both comrades and rivals. The latter aspect of their relationship, the interdiction against competing for or identifying with the sexually-based power of the father, is at work in Bryson's interpretation of the Noah story. Another of Bryson's examples on the same theme shows that the taboo on seeing the father's nakedness is not just an archaic, biblical phenomenon. In the early 1970s Bryson found himself a visitor at the Esalen Institute at Big Sur, where an experimental drug rehabilitation programme was in progress for Vietnam veterans. The only place the vets and the visitors to Esalen met was in the showers. Apparently the veterans participating in the programme showered together, supervised by their commanding officer. Bryson noticed a striking detail: while the men were showering naked, the officer wore swimming trunks.

Bryson's interpretation of the taboo noticed in the Bible and in his personal recollection, addresses the problem of what may be seen or should remain hidden. The case of Ham seeing Noah's nakedness, but also the case of the non-nakedness of the officer amidst his naked soldiers, makes it clear that there is a taboo against seeing the father's genitals. But why is it a taboo for men to *see* the genitals of other men who are in a position of power over them? Not because seeing them is a way of appropriating the power embodied in those genitals, but rather, because seeing them calls that power into question. And this exemplifies a central lesson of semiotic theory.

In Bryson's reading, seeing the father's genitals is forbidden because of what they mean symbolically: sexual privileges and power. The genitals themselves are only a signifier; the object that (still) has to be excluded from the son's construction of masculinity is their signified. Sons and soldiers are forbidden to look at their fathers' or superior officers' genitals because that sight would automatically lead to identification with what the genitals *mean*. Such an identification would lead to the appropriation of the privileges and authority of the father.

In this analysis the visual aspect of seeing the genitals is interdicted in order to allow the genitals to function within the general symbolic system. Let us ignore that interdiction for just a moment and imagine what Ham in the story of Genesis saw, and what the soldiers probably would have seen if their officer had undressed completely. They would have seen male genitals – not as signs but as things. There is no reason to

appropriate them because they already have them themselves. But what else might be noticed about the genitals of the father? I would say that, in the case of a showering officer or a father sleeping off his hangover, it is likely that the son would not see a proud penis, the iconic sign – motivated by resemblance – of patriarchal privilege, but would see instead a shrivelled shrimp – a sign of an altogether different kind. And such a sight would make it painfully clear that the privileges associated with the penis are arbitrary, imaginary.

While father and officer hope, and their cultural position pretends, that their phallic power is signified by motivated signification – through iconicity – by their penises, they are afraid that the sight of their penis will reveal the opposite: the arbitrary, symbolic production of this particularly crucial meaning. Sons and soldiers who, already invested in the same ideology, have been dreaming of a motivated relationship between penis and phallic power, will probably not reconsider the idea of the motivatedness of this relationship after seeing their father's flaccid penis (not reconsider their semiotic, that is) but will start to challenge the power of the father. However, the father may well fear that, rather than identifying *too totally* with him, the son will *refuse* to identify altogether with this unimpressive father, thereby undermining the very system of learning identity by identification through which patriarchal society recreates itself. And this threat involves another threat, a threat against the domain of the visual and the illusions of wholeness *it* promotes. The mode of seeing that Ham might apply, and for which he would be punished, is the one that follows the mirror-stage, that of the symbolic order where fracturation reigns and wholeness is only a dream-possibility that has to be negotiated time and again. For the father, his son's 'adult' way of looking is just too threatening; the fatherly penis must remain a dream-object so that it can remain a signifier.

In Bryson's reading the act of perception, assumed to be holistic, is in itself already a coup d'état because it automatically gives access to the symbolic realm of the phallus. But this reading is predicated upon the assumption that there is something to see: that the sign somehow *is* iconic. In my reading the act of perception is not so much a coup d'état, an appropriation within the same system, but a deconstruction, an undermining of the system as a whole: that is, a deconstruc-

tion of phallic power as something completely arbitrary because its mode of significance is arbitrary. In this light perception is dangerous, and worthy of tabooing. From this perspective, the penis is not the locus of masculinity but its opposite: it is the Achilles' heel of masculinity and phallic power. The sight of the penis can undo the belief in the phallus.

This changes the nature as well as the locus of identification. If identification is at issue in the story of Noah, it is identification with a moment: a moment of the naked exposure of the arbitrariness of power. Such a moment of (in)sight would transform, reorient, the male subject's future view of paternal power, including his view of it at the moment when he accedes to it himself. There lies the threat of this vision. The danger is much greater, much more radical, than Bryson suggests. Therefore, that identification must be, plainly and without conflict, forbidden.

It is not identification with the father, but a challenging of the semiotic which produces fathers, that is forbidden. But then, this process does not take place between human figures (one real, one represented) but between a subject (the viewer) and an aspect of his culture.

Two other examples in Bryson's challenging article show how the tiny male body part, the penis, is not so much the adored centre of masculinity, but a disturbing other. His discussions of the body-builder, Arnold Schwarzenegger, and of a Greek sculpture, the *Discophoros* of Polykleitos, both suggest that the penis has an uncanny role in the male self-image and subsequently in inter-male identification. As the Noah story shows, men hope that their phallic power and privileges are motivated by their penis. The possession of control claimed at the symbolic level is, however, shamefully denied at the level of the male body. The penis, the locus of masculinity, is disturbingly unstable and uncontrollable. Its appearance signifies not stability and control, but instability and lack of control. The uncanny experience that the penis has a life of its own can even give rise to doubt in the male subject as to the degree to which he is the subject of his own penis. This male insecurity can be seen as the motivation behind body-building. The desire to control the penis is displaced onto the body (illus. 113 and 114). As Bryson rightly points out, the inflated body becomes a metaphor for the inflated

2. Mike Ashley

3. Vince Comerford

4. Gary Strydom

5. J.J. Marsh

6. Nimrod King

7. Steve Brisbois

8. Tony Pearson

9. Pavel Jablonicky

10. Harry Dinger

113 Bodybuilders, from *Ironman* magazine.

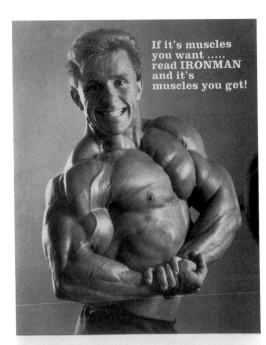

If it's muscles you want ..... read IRONMAN and it's muscles you get!

**Vince Comerford**

114 Bodybuilder, from *Ironman* magazine.

penis. The gain of this rhetorical strategy is the control that the man gains over his body, that he does not have, or has only to a limited degree, over his penis.

This issue of control suggests that it is easier to look like an erect penis than to have one. If gaining of control is the motivation behind the desire to look like an erect penis, as evidenced by body-building, then the male body in this image is a metonymically motivated metaphor of phallic power, rather than a synecdochically motivated metaphor of that power. The penis, because the subject lacks control over it, is denied status as part of the self-image; it becomes alien, other, and is only laterally (metonymically) related to the self.

Bryson's analysis of the Greek sculpture *Discophoros* by Polykleitos seems to point to a comparable male experience of the penis as alien. One could argue, for instance, about whether the genitals are diminished, as Bryson claims. What is the standard life-size of a penis? The possibility of having this discussion implies already that the penis is not a very stable signifier of masculinity. The most unstable extremity of the male body signifies in an ironic reversal the unmotivatedness

of its symbolic potency. But if we decide to qualify the penis of the *Discophoros* as diminished, then something more must be said about the fact that in the classic 'canon of perfect proportions' the genitals are diminished. Do diminished genitals make the male body more perfect, or is the perfect male body a displacement of the desired perfect penis (a stable one, that is)? The similarities between this sculpture and the more extreme tradition of body-building suggest that we opt for the second answer.

Again, we see that in the construction of masculinity the penis plays an uncanny role. The male subject seems to experience a yawning abyss between the qualities of his genitals and the symbolic privileges and power that are accorded to them. To compensate for the lack of semiotic potency of the penis, the male subject seems to displace his attention onto the rest of his body in order to produce a stable construction of masculinity. In contrast with traditional representations of the female body, where *wholeness* seems to be the desired quality, in the representation of the male body *stability* and *control* are the pursued effects. The culture of body-building, as well as the representation of the male body in Greek sculpture, point toward these desired qualities. But there is other evidence too.

In his article 'Vas' written in 1988, Paul Smith addresses another male practice of self-representation. He wonders why the male characters in pornographic movies never have an orgasm inside a woman's body? The moment of ejaculation is always visible. What kind of desire in the construction of masculinity is fulfilled here in an imaginary way? Although I think that Smith takes for his subject a practice that is amazingly overt in showing certain factors in the construction of masculinity, I completely disagree with his reading of it. He reads this practice as a vulnerable self-representation 'extending and complicating the peremptory simplicity of male sexual experience':

> These representations, so often repeating the image of cum scattered across a woman's body, speak not to a masculinity which fears women's bodies, fears its own lack of control over those bodies, or even fears repetition of castration. Rather, they speak to a masculinity for which the hysterical desire for somatic loss, the death of the body in an efflux of bodily substance, is a paramount element in its constitutive

reality. Perhaps porn video figures in some measure an overcoming, around and on the bodies of women, of the terrible finality of the male orgasm of which Wilhelm Reich spoke.[139]

It is possible, indeed, that the visibility of the male orgasm is not motivated by fantasies around women's sexuality or around male control and domination over women. But if we read it as a fantasy of male self-representation, for a moment unbothered by women, it is not the materiality, the bodily substance, of the ejaculation which is shown in all its vulnerability. The death of the body which is so often associated with the orgasm (*la petite mort*) is not played out but denied. The visibility of the ejaculation turns it into a sign of *action* and *production*. These two qualities seem to be pursued in order to cancel out the idea of the death of the body that could be evoked by an ejaculation inside the woman.

Adding the conclusion of this discussion of pornographic movies to the one of body-building and Greek sculpture, I contend that the four following goals are pursued in the traditional construction of masculinity: stability, control, action and production.[140] All four goals promote a strong intentional subjectivity for men. It is time now to consider the role these interests play in Bacon's representations of male bodies.

MASCULINITY LOST

Bacon seems to be intrigued by the display of masculinity through the body in traditional discourse. Many of his paintings are modelled on pictures of sportsmen: wrestlers, boxers, hockey players or cyclists. See, for example, *Portrait of George Dyer Riding a Bicycle* (illus. 115). In this painting, action is emphasized by the multiplication of wheels, while the figure also seems imprisoned in the acrobatic space indicated by the ropes. It is well known that the serial photographs of the scientist Muybridge have had an important influence on Bacon's work. Although Muybridge was a committed scientist who wanted to decompose human and animal movement, his work has little scientific value now. It is mainly used by artists who want to study movement or the idea of sequence for artistic purposes. It can, however, also be seen as a valuable document of dominant gender ideologies. Although Muybridge has 'decomposed' the movement of men as well as

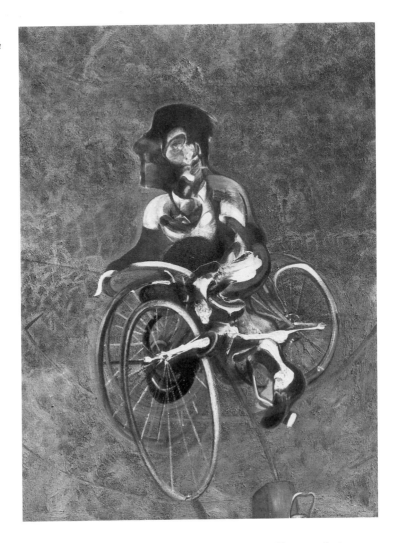

115 *Portrait of George Dyer Riding a Bicycle*, 1966, oil on canvas. Beyeler collection, Basel.

of women, of adults as well as of children, of human beings as well as of animals, the movements he has asked his models to make are strikingly different. While we see the women dressing and undressing, cleaning and sweeping, the men fight, run, play sports, or lift weights. The men are all caught in activities motivated by the desire to display the mastering of the body. The activities of the represented women and children are all casual, ordinary, without the semiotic value of promoting the body as having a specific value.

Except for the pictures of a paralytic child, Bacon responds solely to Muybridge's photographs of active men displaying their muscles and controlling their movements. *Triptych 1970*

185

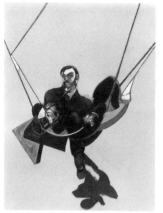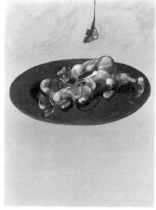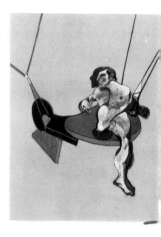

(illus. 116, 117, 118) is a good example. In the middle panel we can recognize one of Muybridge's photographs of wrestling men (illus. 119). The bodies of the wrestling men are, however, represented in such a way as to undermine the illusion of control over the body. The bodies are in turmoil. They are not represented as mastered, organized space or as the centres of controlled action. This results in a fragmentation of the body instead of an increase in its stability, in loss of self instead of control of self, in being the object of action instead of its subject. The lack of control over the penis is here not compensated for by control over the rest of the body, as a traditional discourse on masculinity would dictate. The body here is subject to the same uncanny instability as the penis. The body is no longer the space that secures the idea of self, it is the domain where the self is contested and ultimately lost.

The traditional construction of masculinity is evoked by the male nude in the right panel. His broad chest and his strong, round calves suggest that he is a sportsman. His position between ropes on a kind of swing can be seen as an allusion to

116, 117, 118 *Triptych 1970*, oil on canvas. Australian National Gallery, Canberra.

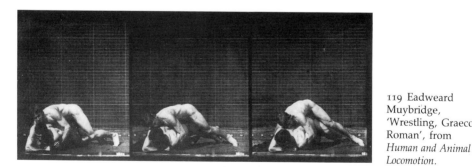

119 Eadweard Muybridge, 'Wrestling, Graeco-Roman', from *Human and Animal Locomotion*.

120 Anon., *The Venus of Melos.*
Musée du Louvre, Paris.

an acrobat. But the whole of the body – the way the body parts compose the male body – deconstructs the notions of traditional masculinity. His dissolving arms turn the male figure into a kind of *Venus of Melos*. But while in the *Venus of Melos* (illus. 120) the wholeness of the female body is evoked indexically, precisely and paradoxically by the mutilation of her representation, in this case the male figure is iconically represented as *fragmented*. The blue shadows contribute to this effect of fragmentation and dissolution. While the shadow of the head and the stretched leg can still be seen as mirrors of the body, affirming the masculine identity as stable, the shadow of the other leg and of the right arm form with the figure's body one contiguous mass of fragmented body parts.

The left and right panels of *In Memory of George Dyer* introduce even more complexity into the undoing of masculinity. In the left panel (illus. 121) we see an athlete, balancing like an

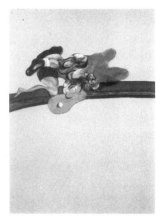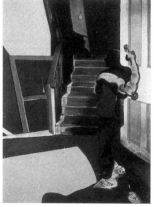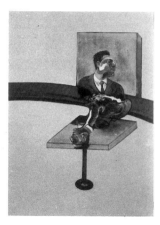

acrobat. His kicking leg and the posture of his arms suggest that he is a boxer, and thus representative of tough, uncivilized masculinity. In the right panel (illus. 123) the bust of a dressed male figure, probably George Dyer, is represented on three different levels: painted on the raised surface; mirrored on the table; dissolved, fragmented in the space in between the mirror and the painting. The three ontologically separated domains are here represented as one contiguous whole. The male figure is invested with the token of civilized masculinity: the white collar and tie. The symmetry of the collar, its contrast of white and black, make this token even more central than the figure's face.

121, 122, 123 *In Memory of George Dyer*, 1971, oil on canvas. Beyeler collection, Basel.

The body of the athlete in the left panel is contorted and projected backwards. The grey mass below the athlete can be taken as his shadow, technically comparable with the mirror-reflection in the right panel. This organ-like shape, with the same colours as the figure's body, could be a body-fluid. The white spot in the middle of this 'organ' suggests another reading, however. It could be a ping-pong ball in front of, or on, the organ-shaped fluid. But it could also be a hole *in* the shape. If we read it as a hole the shape becomes a palette, and the domain of representation is introduced self-reflexively *into* the painting. The left as well as the right panel contains a 'real' figure, a projection of that figure, and a representation of that figure. In the right panel that representation is iconic, in the left panel indexical: the surface on which the figure in the right panel is depicted looks like a represented canvas; the palette in the left panel points to the possibility of a painted representation of the figure. While the left panel evokes the discourse of

'tough' masculinity, the right panel evokes that of 'civilized' masculinity. But there is another difference between the panels. While in the left panel the figure itself is more real than its representations, in the right panel the figure is almost absent from the fictional reality, while his fictional representations take precedence.

The possibility of re-presenting or projecting these masculine figures presupposes, however, a stable, delimited masculine identity, in order for the figures to possess 'substance' as objects of representation or projection. In both panels, but especially in the left panel, the 'real' figure lacks demarcation. The 'real' figure in the left panel is almost identical with the unorganized materiality of the paint. In the left panel the male body is tormented, fragmented, and shows an utter lack of control and stability. This lack of masculine subjectivity results, in both panels, in one contiguous, turbid space of real, projected, and represented figures. Masculinity has lost all its substance.

Or should we reverse this logic? According to Bakhtin and Barthes, whose ideas of the self/other relationship I discussed at the beginning of this chapter, representations do not depend on a stable self; rather the constitution of a self depends on form-bestowing relationships with the other (Bakhtin) or with representations in discourse (Barthes). While according to Bakhtin these form-bestowing relationships are beneficial, according to Barthes they are mortifying. It is the mortifying effect of the relationship between self/other or, in the context of Bacon's work, between figure and representation, that predominates. In the right panel the two representations (the mirror-reflection and the painting) result in a totally decomposed self. The forms of a figure cannot be distinguished any longer. We see only the material of the body and the material of representation: a dot of paint representing only its own materiality. The two representations of civilized masculinity end up totally destroying the male figure.

In the left panel the emphasis is displaced from the representation to the 'real' figure. But the figure there is also caught up in its relationship with discourse. And although the representations of this discourse are less than clearly defined they, too, have a fragmenting effect. The self/other relationship, which Barthes described as a grim conflict between discourses, seems to be represented in this panel in the most literal way.

The figure, invested with the tokens of tough masculinity, fights against representation. The fact that his body is already in a state of fragmentation suggests, however, that he will be the loser.

In the work of Bacon the representation of the male body does not construct a masculine identity. On the contrary, Bacon's works show again and again the constructedness of masculinity and the ongoing fight against the stereotyped discourse on masculinity. The representations of masculine selves that we see in the paintings do not bestow form on the male figures; rather, they make the figures 'lose their selves' in Bersani's sense. Bacon's work is, from this perspective, less tragic, less horrifying, than is often contended. For the ongoing fragmentation of the body in Bacon's work can also be seen as a resistance to the objectifying transformations of stereotypical discourse, especially the discourse of masculinity. The male body is not phallicized: it shows no signs of stability, control, action, or production. Thus, the violent tension between body and representation as represented in Bacon's works can be seen as an ongoing escape from the objectification of representation.

Bacon's work is often seen as destructive and scary. But once we engage with the work this opinion seems warranted only by the superficial appearance of the images. Bacon's view of the self is, ultimately, uplifting. For his refusal to allow his figures to be defined by the 'other' results, paradoxically, in a loss of self that re-subjectifies the body. The self is secured by resisting gender-positions and by resisting any discourse on identity. And this resistance, seen as an ongoing bodily movement, *is* the self.

# References

1 Studies in which Bacon's work is discussed in terms of existential themes are, for instance, Leiris (1983), Trucchi (1978), Ooka (1978), Kroker (1987). Leiris, for example, speaks in the following way about Bacon's paintings:

> The space in which we breathe and the time in which we live here and now; this is what we find, almost without exception in Bacon's pictures, which seem to aim at the immediate expressions of something immediate . . . (p. 17)

2 I would place in this category *catalogues raisonnés* such as Rothenstein and Alley (1964), Ades and Forge (1985), Gowing and Hunter (1989), and, in spite of its importance, John Russell (1971).
3 See Jonathan Culler (1988).
4 Yve-Alain Bois (1990).
5 In the sense of Bakhtin; see Bakhtin (1990). For an illuminating discussion of the implications of dialogism, see Pechey (1989).
6 Sylvester (1987), p. 22.
7 For a discussion of the role of narrative in postmodernism see A. Kibédi Varga (1986). Lyotard's arguments can be found in his 1989 volume, pp. 31–7. Masterplots are defined as the dominant 'plots' of Western culture, and provide stereotypical and exemplary schemes that act as templates for all other representations.
8 See, for example, the following texts: Stanzel (1984), Genette (1973), Pavel (1985), Bal, *Narratology* (1988) and *Femmes Imaginaires* (1986).
9 See, for studies of similar purport, Bal (1991) and Kibédi Varga (1989).
10 Wendy Steiner (1988) suggests this much in her analysis of Benozzo Gozzoli's *The Dance of Salome and the Beheading of St John the Baptist*.
11 For an analysis of Bacon's treatment of the theme of the crucifixion, see Chalumeau (1978), Moorhouse (1989) and especially Zimmermann (1986).
12 The genre of the triptych originates in the Middle Ages. It had a function in the liturgy, and its content was determined by Christian iconography. From the fifteenth century on, the triptych slowly began to emancipate itself from its religious background, and to be used to represent profane topics. However, it never lost its lofty, sublime status, and continues to confer this lofty status on profane or abstract representations. See Klaus Lankheit (1959), Carel Blotkamp (1984) and the catalogue *Polyptyques* of the exhibition in the Louvre in Paris (1990).
13 In this study I will use the categories and definitions of the theory of narrative as developed by Mieke Bal in her *Narratology: Introduction to the Theory of Narrative* (1985).
14 Hugh M. Davies, 'Bacon's Black Triptychs', *Art in America* (May–April 1975).
15 This means that the fabula is represented from left to right. It does not imply that the gaze of the viewer follows that direction as well. Usually the viewer is supposed to look first at the main event or climax depicted in the central panel, next at the pre-history of that event on the left-hand panel, and finally at the resolution of the main event on the right-hand panel. There are also triptychs in which the central

panel represents the closure of the story. The closure is then the climax or completion of a development. See Blotkamp's discussion (1984) of Mondrian's triptych *Evolution*.

16 Davies, op. cit., p. 68.

17 Sylvester, *The Brutality of Fact* (London: Thames and Hudson), p. 22.

18 Sylvester (1987), p. 63.

19 Sylvester (1987), p. 65.

20 Deleuze (1984).

21 Sylvester (1987), p. 23.

22 Andrew Forge, 'About Bacon', in Ades and Forge (1985), p. 31.

23 Deleuze (1984), pp. 27–31.

24 See *The Concise Oxford Dictionary*.

25 Deleuze (1983), p. 29.

26 Forge, 'About Bacon', in Ades and Forge (1985), p. 31.

27 Deleuze (1983), p. 16. Deleuze, here, is indebted to the ideas of Merleau-Ponty (1964).

28 *Mise en abyme* is the technical term for a 'mirror text', a delimitable part of a text that signifies the whole text or a continuous aspect of the whole text. It is a metaphorical production of meaning which is self-referential: its meaning is intra-textual. See Dällenbach (1977) and Bal (1986).

29 John Berger (1980), p. 113.

30 The term 'difference within' is introduced by Barbara Johnson in *The Critical Difference* (1980). In this book Johnson shows brilliantly how differences between entities like prose and poetry, man and woman, literature and theory, are based on and made possible by a repression of differences within those entities. The 'difference within' of Bacon's *Three Portraits of Lucian Freud* concerns the identity of the figure. He is an active looker, addressing the figures in the other panels, as well as the viewer, aggressively, but he is also a passive object, exposed to the gaze of the viewer.

31 The notion of apostrophe as the key device of the lyric has been discussed by Culler (1981a). Johnson (1987) takes this idea to its most radical conclusion by defining it as a device whose difficulty, in turn, defines poetry by women.

32 The concept of focalization has a quite elaborate and specific bearing on the analysis of narrative discourse, and as such it refers to both narrative as a genre and to discourse as a semiotic system. The concept was first proposed by Genette (1973, English trans. 1980) and it was meant to distinguish narrative *voice* (who speaks?) from *vision* (who sees?). Yet Genette failed to ground the concept in a systematic theory of narrative. Bal has solved that problem (1985, 1986) by distinguishing systematically between subject and object of focalization (the former called focalizer), and by radicalizing the status of the concept. In Bal's theory, narrative focalization is not just the personal perspective (which colours only subjectivist texts like Proust's), as it is in Genette's theory, it is rather an aspect of every text. Focalization relates the narrative represented to its representation, in that it refers to the steering perspective of the events or fabula that is verbalized in the text by the narrator or voice. This verbalization is always an interpretation, a subjective content, while Genette still presupposes the possibility of objective representation by his concept of 'zero-focalization'.

An important distinction Bal makes is the one between external and internal focalizer. The external focalizer is in principle identifiable with the narrator, from whom it is distinguished in function, not in identity. This external focalizer can embed an internal diegetic focalizer. For the analysis of narrative, this 'embedding' is crucial. My following analysis

of Bacon's 'mirror works' shows that the distinction between external and internal focalization is also very pertinent to the analysis of images.

In a later work Bal shows how the concept of focalization can be made operational for the analysis of visual art. See Bal (1991).

33 There are only a few paintings without human figures, for example, *Jet of Water* (1979), *Sand Dune* (1981), *A Piece of Waste Land* (1982), *Water from a Running Tap* (1982) and *Sand Dune* (1983). But these sand dunes and jets of water are painted in such a way that they seem to exhibit all kinds of bodily features. Again the human figure is present, if only metaphorically.

34 See Jean-Francois Lyotard (1989).

35 Brian McHale (1987) claims a similar position for writers like Faulkner, whose *The Sound and the Fury* he considers modernist, while *Absalom, Absalom* can be seen as postmodernist.

36 Fredric Jameson (1983), p. 114.

37 See Allen Thiher (1984), p. 17.

38 Rosalind Krauss (1990), p. 197.

39 Rosalind Krauss (1983), p. 42.

40 Allen Thiher (1984), p. 3.

41 Thiher (1984, p. 5) points out that the belief in visual revelation of the twentieth century modernists differs from the belief of the earlier 'modernists' in the object of revelation. 'In the work of Virginia Woolf, for instance, the visual gives access to the mind mirroring its own desire, not to the mind mirroring the image or essence of nature as in Goethe and most of the romantics'.

42 For a critique of this concept of the gaze, see Bryson (1983). Bryson proposes an alternative way of looking, the glance, defined as a non-colonizing, involved look which puts the whole body of the looking subject at stake.

43 Emile Benveniste (1966).

44 'Modernes ou anciennes, certaines oeuvres picturales, en changeant la carte du corps humain, égarent dans la surréalité les banales croyances du spectateur relatives à son propre image. Elles l'obligent ainsi, par le saisissement esthétique que produit la subversion visuelle de la perception banale, à réinventer un instant son entendement, c'est-à-dire son discours intime sur lui-même et sur le monde de ses objets.' J. Guillaumin; 'L'oeil sur le divan', in R. Court, ed. *L'effet trompe-l'oeil dans l'art et la psychanalyse*, Paris (1988), pp. 43–72.

45 These metaphors have been examined for their insistent genderedness by Keller and Grontkowski (1983).

46 M. H. Abrahms (1953), p. ii.

47 Of course, the mimesis is not 'really' absolute, since the image is reversed. Nevertheless, semantically speaking one *thinks* of a mirror image as perfectly matching if not *being*, the model. Hence 'absolute mimesis' is the conventional meaning of the mirror image.

48 See Lasalle (1985) for an analysis of the motif of the mirror in Bacon's paintings. She reads Bacon's mirrors as a reversal of the function of the mirror in Lacan's theory of the subject. In Bacon's mirror the subject does not experience itself for the first time as unified, as a whole, but, on the contrary, 'dans le miroir, l'image du corps déformé echappe, explose, se clive' (p. 64).

49 In Mieke Bal's terms, this is an anonymous agent outside the represented fabula whose vision is represented here. It is a case of *external focalization* (1985, p. 105).

50 For an elaborate analysis of this painting, see T. J. Clark's chapter 'A Bar at the Folies-Bergère' in *The Painting of Modern Life: Paris in the Art of Manet and his Followers* (1985). Clark reads the painting as displaying the

unease and duplicity involved in the emergence of the new class of the petit-bourgeois, and the role of 'popular culture' in the emergence of that class.

51 Anne Tronche, 'Entretien entre Rene Major et Anne Tronche', *Opus International* 68 (Summer 1978), pp. 28–31. My translation. In French: Il arrive qu'une personne se regardant dans un miroir ne parvienne pas à se voir. C'est ce qu'on appelle l'hallucination négative. Je pense à un cas précis de quelqu'un qui a retrouvé son image dans le miroir aprés avoir brisé la surface en jetant un verre. L'image apparut d'abord morcellée avant que les fragments ne retrouvent leur unité habituelle. Le morcellement s'avere ici lié à l'impossibilité temporaire de faire apparaître une définition fixe et répétitive de son image. Cette hallucination négative est une expérience précoce qui peut être responsable du cri chez l'enfant, au moment où il ne perçoit pas la présence de sa mère alors même qu'elle est à ses côtés.

52 I discussed this dilemma in the first chapter with reference to the triptych *Three Studies of Lucian Freud*. There, the narrative of perception consisted of the irresolvable contradiction between a narrative reading and a non-narrative one, based on the direction of the eyes. Here a similar dilemma occurs. Focalization is the crux where the two readings shift. But while in the *Lucian Freud* two ways of looking were literally represented by two sets of gazes, a diegetic and an apostrophic one, here the situation is even more radical. The symbol of the split subject, the mirror in whose reflection the subject, according to Lacan, constitutes itself in alienation and distortion, becomes the subject, the other who does not even allow us to choose between two readings. Both are equally impossible, if not equally mad.

53 The male pair in the right panel must be seen as Bacon's own invention, according to Laessøe (1983, p. 116). Similarly, the bloody scene in the central panel has no direct reference to any scene in Eliot's poem. It can only be understood with regard to this poem as an indirect reference to the atmosphere of horror and nightmare expressed by the concluding chorus. Laessøe concludes that Bacon's triptych does not illustrate 'Sweeney Agonistes'; it provides 'a parallel and recalls partly its mood and partly an aspect of the philosophy which the melodrama expresses' (p. 117).

54 This criticism holds for his comparison between Bacon's individual triptych and Eliot's particular poem. But Laessøe also shows analogies between general features of Bacon's and Eliot's works that are indeed striking. The following verses from Eliot's poetry seem to sum up Bacon's work:

> Although he seems so firm to us
> He is merely flesh and blood.
> Flesh and blood is weak and frail
> Susceptible to nervous shock
> ('The Hippopotamus', *Poems*, 1920, p.51)

> Shape without form, shade without colour,
> Paralysed force, gesture without motion;
> ('The Hollow Men', *Poems*, 1929, p. 89)

55 Sass (1987), pp. 1–34.
56 James (1890).
57 Sass (1987), p. 10.
58 If the consciousness of schizophrenics is not primitive or infantile, but hyper-reflexive, how is it possible, then, that they give the impression of being mad? For hyper-reflexivity is a respected, desired quality, that

indicates intelligence, brightness. Sass argues that their hyper-reflexivity results in only partial self-control. 'For, what patients like those we have been considering cannot seem to control is self-control itself, what they cannot distance from is their own endless need for distancing, what they cannot be conscious of is their own hypertrophied self-consciousness and its effect on their world.' Sass (1987), p. 27.

59 Sass (1987), p. 13.

60 In an article on postmodernists, Baudrillard, and the painters Colville and Bacon, Arthur Kroker reads Bacon's works as mimetical representations of a postmodern world:

> In Bacon, Colville's hermetic body, where the body is so intense that identity is cancelled out, has been turned inside out: a *corps morcelée*, mutilated by all the signs of excremental culture as the essence of a society typified by the *predatory* exploitation of the vulnerable by the powerful, by the bleak exchange of host and parasite as the emblematic sign of *parasitical* culture, and by all the detritus of liberalism (1987, p. 191).

This reading is contradictory. It starts with Baudrillard's analysis of postmodern society, according to which repetition and the production of culture have changed radically under the postmodern condition. But then, Kroker reads a product of this postmodern society according to the traditional mimetic aesthetics: Bacon's work *reflects* postmodern society.

61 Jonathan Crary argues in his fascinating study *Techniques of the Observer* (1990) that the paradigm of the camera obscura is not an early stage of the ongoing autonomization and specialization of vision that continues into the nineteenth and twentieth centuries. In seventeenth- and eighteenth-century theories of perception the sense of touch is the key model for visual perception. Only in the nineteenth century does a separation of the senses occur. The industrial remapping of the body in the nineteenth century dissociates touch from sight.

> The loss of touch as a conceptional component of vision meant the unloosening of the eye from the network of referentiality incarnated in tactility and its subjective relation to perceived space. This autonomization of sight, occurring in many different domains, was a historical condition for the rebuilding of an observer fitted for the task of 'spectacular' consumption (Crary, 1990, p. 19).

When we read Bacon's work against the historical background as described by Crary we must conclude that Bacon's work dramatically acts out his resistance to the nineteenth-century autonomization of sight through 'the loss of touch as a conceptual component of vision'.

62 See also the right panel of *Crucifixion 1965*, the figure(s) in the central panel of *Triptych, August 1972*; the defecating and vomiting figures in both the left and right panels of *Triptych May–June 1973* (illus. 5, 7), the figure in the central panel of *Triptych March 1974* (illus. 33); and the figures in *Three Figures and a Portrait, 1975*.

63 Freud's theory of the pleasure principle and the death drive is perhaps the most developed theorization of this phenomenon.

64 Deleuze (1984), p. 54. My translation. In French: La chair descend des os, le corps descend des bras ou des cuisses dressés. La sensation se développe par chute, en tombant d'un niveau à l'autre.

65 Bacon comments on Rembrandt, and the conception of 'high art' his work stands for, in other ways too, e.g. through the motifs of the

slaughtered ox and of the anatomy lessons. Bacon takes issue with his prestigious predecessors precisely in the arena of bodily decay, death, and violence. On Rembrandt's views on art, see Alpers (1988).

66 The term 'index' is meant in the technical semiotic sense as defined in Peirce's typology of signs (1955). For the use of this concept in the visual arts see Bal and Bryson (1991) and Krauss (1976).

67 The negative conception of reproduction is not contradicted by the fact that Bacon is intrigued by certain photographs. He has been influenced, for instance, by the photographs of Muybridge, and by the photographs in the book *Positioning in Radiography*, showing the positions of the body for X-ray photographs to be taken. In one of the interviews with David Sylvester, Bacon declares that he has always been haunted by photographs. He explains this as follows:

> I think it is the slight remove from fact, which returns me onto the fact more violently. Through the photographic image I find myself beginning to wander into the image and unlock what I think of as its reality more than I can by looking at it. And photographs are not only points of reference; they are often triggers of ideas (1987, p. 30).

Bacon does not read photographs according to the general conception of photography, as mimetic reproduction, offering transparent images. For him, photographs are a *remove* from fact. This term *remove* indicates an indexical, rather than an iconic, conception of photography. In *Triptych, Three Portraits, 1975* Bacon represents photographs as iconic. They stand for iconicity and re-production, and therefore their connotation is destructive. The ground for this meaning is the generally accepted view of photography as the absolute ideal of an aesthetics of mimetic representation.

68 Davies (1975), pp. 62–8.

69 The phrase is adapted from the title of Evelyn Fox Keller's book, *A Feeling for the Organism* (1983).

70 Besides arrows Bacon's work also displays circles as devices for reading. They help the viewer to focus on certain parts of the representation by emphasizing details. *In Figure in Movement, 1976*, moreover, the circle involves an enlargement of a detail. In *Three Studies of Figures on Beds, 1972*, arrows as well as circles are foregrounded emphatically. It is not so much the content of these devices for reading which is meaningful, as the fact that they are used so explicitly. The foregrounding of these devices establishes a contiguous relationship with the viewer. The viewer is acknowledged in the painting as a presence in front of the painting. Classical representation, on the contrary, as has been argued by Foucault (1973), is based on the absence of the viewer.

71 See Alpers (1988).

72 Representation, then, becomes a mode of decomposition. This conception of representation is also evoked by the stains of paint which appear on many of Bacon's works. They figure as the marks of painting-accidents. As such, they represent painting as an activity which is not, or is only partly, directed by the painter. It is not the painter who paints, but the accident, an external factor. In addition to this self-reflexive reading of the stains of paint, these painting-accidents can also be read as amorphous bodies. The figures' dissolving bodies can be compared to these stains of paint. There is a contiguous relationship between the paint, the material of the representation, and the expressed content – the bodies.

73 'Der tod ist die Sanktion von allem, was der Erzähler berichten kann.

Vom Tode hat er seine Autorität geliehen.' Walter Benjamin, 'Der Erzähler, Betrachtungen zum Werk Nikolaï Lesskow' (1936), in *Illuminationen* (1966), Frankfurt am Main: Suhrkamp, pp. 409–36.

74 Joseph Conrad, *Heart of Darkness* (1902, repr. 1989), London: Penguin, p. 57.

75 There are no English translations available of Willem Brakman's novels, although he is one of the major contemporary Dutch and Flemish novelists. Born in 1922 he started to publish in the 1960s, at the pace of one or two novels a year. While his first works can still be read as psychological-realist, his later work has all the features of postmodernism. I discuss his work in the context of postmodernism in several articles: van Alphen (1987, 1988a, 1988b).

76 For a discussion of the relationship between Velázquez and Bacon, see Pradel (1978).

77 Brakman (1989), pp. 106–7. In Dutch: 'Tja', zei de stem, 'Zijne Heiligheid zat tegen een zwarte achtergrond en van de stoel waren alleen enkele krassende lijnen to zien, roze en rood. Vreemd, het was net of Hij in een glazen kubus zat en die indruk werd nog versterkt door het gevoel dat Zijne Heiligheid opeens heel onbereikbaar was, niet meer te horen. Voor de goede orde vermeld ik hier dat Hij het bekende paarse schedelkapje droeg en verder een paarsig habijt waaraan een witte band een akelig jolige noot verleende.

Het spijt me dat ik het zeggen moet, maar Zijne Heiligheid maakte een infantiele indruk; een beate grijns lag ondanks mijn waarschuwing onbeweeglijk op Zijn gezicht, de boventanden waren onnatuurlijk bloot en Hij scheen geheel verzonken in het belkoord dat Hij met kleine rukjes liet slingeren. Opeens zag ik hoe lelijk Hij was, hoe onaantrekkelijk met dat harde witte vlees, dat zo obsceen bloot aandeed.'

78 See Kibédi Varga (1988).

79 Baxandall (1985).

80 For a critical discussion of this authority relation, see Norman Bryson's *Tradition and Desire* (1984), based on Harold Bloom's *The Anxiety of Influence* (1973).

81 See also Brooks (1984), and a response to Brooks in Chase (1986).

82 Jonathan Culler (1981b) comes to a comparable conclusion in his chapter 'Story and Discourse in the Analysis of Narrative'. He argues that the traditional hierarchy between story and discourse should be reversed. The story, then, is not the model for the discourse, but is its effect. See also Chase (1986).

83 Brakman (1989), pp. 93–4. In Dutch: Als mijn instinct en mijn vingerspits van politieman mij niet bedriegen, dan is dit een van die gevallen waarin het ingewikkeld opsporen het verlangen naar de dader geheel doet verdwijnen.

84 Brakman (1989), p. 133. In Dutch: Als hij zijn lijden onder woorden moest brengen dan zou hij, de onvolledigheid onderstrepend, zijn toevlucht moeten nemen tot een slachtvisioen, het totaal omvat zijn door een splijten, hakken en kraken, door veel schreeuwend rood en gillende holten.

85 Brakman (1989), p. 138. In Dutch: Op vallend was het gat van de gesperde mond, waarin de gil was teruggestuurd, een beklagenswaardig gezicht, want een ieder weet hoezeer een brul de pijn verzacht.

86 According to Kemp (1986) this convention was actually inaugurated by Rembrandt.

87 As it happens, the round collar resembles the one worn by Catholic priests. Even more striking as a coincidence is the fact that the title of

Brakman's novel, *The Father-Killers*, uses the Dutch word *vadermoorder*, which means a stiff collar, a word almost identical with, and surely an allusion to, *vadermoordenaar* or father-killer. In an admittedly fanciful formulation of this coincidence – fanciful because, given the dates, Brakman cannot have known this painting – one could say that in this collar Bacon meets Brakman meeting Bacon meeting Velázquez by turning the decorum of Catholicism from an innocent and empty detail into a *revealing*, undressing sign. By choosing the 'wrong' noun for his title, Brakman suggests that the men who wear these collars are murderers.

88 Ann Jefferson (1989), p. 153. In this wonderfully illuminating article, entitled 'Bodymatters: Self and Other in Bakhtin, Sartre and Barthes', Jefferson shows how in the work of these authors the body is treated as the site and focus where the self is constituted or lost.

89 Bakhtin (1986/1990) pp. 9–191. Jefferson uses the French translation of Bakhtin's Russian text, the only one available when she wrote the essay. I have used the recent English translation, including quotations, in my account of Jefferson's discussion. See bibliography (Bakhtin, 1986) for full publication details.

90 Bakhtin (1986/1990), p. 51 (original italics).

91 Deleuze (1984), pp. 15, 48.

92 Bakhtin (1986/1990), p. 37.

93 For a more extensive reading of *Nightwood*, see my monograph *De verwoording van verwording: Zelfverlies in Nightwood van Djuna Barnes* (1990).

94 E. Bronfen (1987), p. 171.

95 Djuna Barnes, *Nightwood*, London and Boston: Faber and Faber, 1979 (1st ed. 1936), p. 52.

96 Djuna Barnes, *Nightwood*, p. 57.

97 Djuna Barnes, *Nightwood*, p. 70.

98 Djuna Barnes, *Nightwood*, p. 74.

99 Djuna Barnes, *Nightwood*, p. 74.

100 Djuna Barnes, *Nightwood*, p. 180.

101 Djuna Barnes, *Nightwood*, p. 181.

102 Robin seems to live in a different order precisely because she knows no desire. This suggestion is made plain when she is compared to plants or animals. Here is a description of her body:

> The perfume that her body exhaled was of the quality of that earth-flesh, fungi, which smells of captured dampness and yet is so dry, overcast with the odour of oil of amber, which is an inner malady of the sea, making her seem as if she had invaded a sleep incautious and entire. Her flesh was the texture of plant life. (*Nightwood*, pp. 55–6).

She is referred to as a woman in whom the animal has become human (p. 59). She also exerts a special power over the animals in the circus (p. 59). In the final chapter Robin, the woman in whom the animal has turned human, seems to revert to being an animal. Barking and yapping she crawls on all fours in imitation of Nora's dog. For an analysis of this animal/vegetal motif, see Kannenstine (1977), pp. 116–18.

103 This view is not endorsed by the later Bakhtin, whose concepts of *carnival* and *dialogue* foreground the idea of heterogeneity rather than coherence.

104 Ann Jefferson (1989), p. 155.

105 The other three problems which can disturb the self/other idyll are the following:

The self/hero does not like the 'judgment' that has been passed on him by the other/author

The self/hero internalizes an image of his external self

The self/hero's death is acknowledged as a part of the picture the other/author creates of him (Jefferson, 1989, p. 156).

106 Ann Jefferson (1989), p. 158.

107 See Silverman (1988) for an excellent discussion of masochism and masculinity.

108 See Bersani (1986) and (1987).

109 Bersani (1987), p. 218.

110 Bersani (1987), p. 217.

111 Bersani (1986), p. 39.

112 Bersani (1986), p. 39.

113 Bersani, in contrast, provides male homosexuality with this symbolic meaning. If male heterosexuality is the image *par excellence* of the phallocentric, proud, and swollen subjective experience of both men and women, male homosexuality, according to Bersani, is the image of an experience of the subject in terms of sacrifice and loss of self. Against the dramatic backdrop of the AIDS crisis, which gave this image a shocking literality, Bersani views the rectum as the grave in which the ideal of proud subjectivity is buried. The sacred value of the self is thus deconstructed in the rectum of the homosexual man:

> Gay men's 'obsession' with sex, far from being denied, should be celebrated – not because of its communal virtues, not because of its subversive potential for parodies of machismo, not because it offers a model of genuine pluralism to a society that at once celebrates and punishes pluralism, but rather because it never stops re-presenting the internalized phallic male as an infinitely loved object of sacrifice. Male homosexuality advertises the risk of the sexual itself as the risk of self-dismissal, of *losing sight* of the self, and in so doing it proposes and dangerously represents *jouissance* as a mode of ascesis (Bersani, 1987, p. 222; italics in text).

114 In one passage the dummy seems to suggest that the lesbian lover is a fiction, that she does not really exist.

> 'And do I know my Sodomites?' the doctor said unhappily, 'and what the heart goes bang up against if it loves one of them, especially if it's a woman loving one of them. What do they find then, that this lover has committed the unpardonable error of not being able to exist – and they come down with a dummy in their arms' (*Nightwood*, pp. 135–6).

But there are other passages in the novel where the dummy or the doll reappears with an even more sinister meaning. There the motif of the doll connects lesbian love with death, as if to subscribe to the standard homophobic link between lesbianism and sterility or corruption. One example is the passage where Nora tells the doctor about the doll that she had seen on the bed at Jenny's:

> 'We give death to a child when we give it a doll – it's the effigy and the shroud; when a woman gives it to a woman, it is the life they cannot have, it is their child, sacred and profane; so when I saw that other doll – ' Nora could not go on. She began to cry. 'What part of monstrosity am I that I am always crying at its side' (*Nightwood*, p. 201).

115 Baudelaire celebrates the lesbian precisely *as* corruption. The connection between lesbianism and corruption is by no means to be

199

repudiated as 'only' a nineteenth-century phenomenon. Zola's *Nana* represents the refuge Nana finds in the arms of her lesbian lover Satin as ambiguous, and modern critics tends to hasten to view this as a lapse, a fall into corruption, as if Nana's life as a courtesan were purity itself. See, for example, Gilman (1985).

116 Djuna Barnes, *Nightwood*, p. 112.

117 Djuna Barnes, *Nightwood*, p. 226.

118 For an analysis of androgyny in Plato and *Nightwood*, see Brugmann (1982).

119 This figurative celebration of lesbianism is not likely to be welcomed by women who *are* lesbians. A quality which formerly turned them away toward the margins of society is now taken away from them as soon as it can bestow honour upon them. Yet, I venture to submit that this widening of the concept of lesbianism could also have a positive effect on those who know the *reality* of lesbianism. History has demonstrated that heterosexual men were effectively privileged by the fact that their sexuality has become the image, no less figurative than the one we are discussing here, of the swollen, phallic experience of self. It would only be fair if lesbians would now draw advantages from the same tension between literal and figurative language use: the image of lesbian love as the ideal of the subject in self-loss.

120 Vincent van Gogh's painting *The Painter on the Road to Tarascon* (1888) was destroyed in World War II. Prior to this it was in the Kaiser-Friedrich Museum in Magdenburg.

121 The device of a frame around the head of a figure is used very often in Bacon's work. See, for example, *Study for a Portrait, 1978*; *Two Seated Figures, 1979* (illus. 80); *Seated Figure, 1979: Study for Portrait with Bird in Flight, 1980; Study for Self-Portrait, 1982*.

122 Jefferson (1989) argues that Barthes' view is also strongly influenced by Sartre in this respect of self/other relations. He has, as she calls it, 'an undeniably Sartrian streak' (p. 153). This is made explicit by Barthes himself in his dedication of *Camera Lucida* as an homage to Sartre's *L'Imaginaire*.

123 Roland Barthes (1975), pp. 82.

124 Roland Barthes (1975), p. 11.

125 Jefferson (1989), p. 170.

126 Jefferson, (1989), p. 170.

127 Sylvester (1987), p. 40.

128 Sylvester (1987), p. 12.

129 Saunders (1989), p. 7.

130 Berger (1972), p. 56.

131 Bataille (1957), p. 158.

132 Clark (1985).

133 Bernheimer (1989), p. 261.

134 Mulvey (1975), pp. 6–18.

135 Quoted by Bernheimer (1989), p. 269.

136 Bernheimer (1989), p. 272.

137 Of course, this indifference can only be signified by demonstrating it, hence, appearance does form the core of this form of masculinity.

138 Norman Bryson (1992). Bryson argues that the mechanisms of masculine masquerade imply the need for a modification of Mulvey's theory, which I mentioned already in the preceding section. The notion of the male gaze as simply voyeuristic has to be reconsidered. As he demonstrates, the need for a modification of Mulvey's theory becomes obvious as soon as we decide to deal with what is at stake in the male gaze focused upon another male. In the traditional model two aspects of looking were analysed: *voyeurism* is established as the central process

and attitude in the male spectator's relationship to the image of the female: and *identification* as the central process in the male spectator's positioning toward the image of the female. But what kind of process is at stake, if a male spectator watches, say, the images of warriors by Géricault or the male figures of Francis Bacon? This simple question leads to the exploration of a so far neglected field: the complex negotiations of inter-male identifications as a function of the construction of masculinity. In Bryson's article, identification is presented as a source of ambiguity and conflict.

139 Paul Smith (1988), p. 107.

140 The construction of masculinity seems to be more complex, seems to have more possibilities, than the construction of femininity. While the latter has as its main goal the quality of 'wholeness', masculinity can gain shape through stability, control, action, or production. This lack of symmetry between the two gender positions is not amazing if we realize which agents have the power to define the gender positions, of men as well as of women. While masculinity as well as femininity are constructions, masquerades, there is a crucial difference between the two. Crudely put: constructions of femininity are projections of men. While they hold up a mirror for women, women have had no say in their construction. Dominant constructions of masculinity, by contrast, are not just fantasies of the other. They are 'real' in two ways. First of all they have been produced by men for men and about men. In the second place these constructions of men have made history, have produced a social reality, namely that of patriarchal societies. Put briefly: dominant constructions of femininity are imaginary projections of women made by men, while constructions of men are 'real' fantasies of men by men. While masculinity is a kind of self-image, femininity is a projection of the other. It is not amazing that the privilege of self-definition leads to a more varied construction than the definition of otherness.

# Bibliography

Abrahms, M. H., 1979 (1953), *The Mirror and the Lamp: Romantic Theory and the Critical Tradition*, Oxford: Oxford University Press.

Ades, Dawn and Andrew Forge, 1985, *Francis Bacon*, with a note on technique by Andrew Durham, New York: Abrams.

Alpers, Svetlana, 1988, *Rembrandt's Enterprise: The Studio and the Market*, Chicago and London: University of Chicago Press.

Alphen, Ernst van, 1987, 'Literal Metaphors; Reading Post/Modernism', *Style* XXI, 2, pp. 208–18.

—— 1988a, 'Reading Visually', *Style* XXII, 2, pp. 219–29.

—— 1988b, *Bij wijze van lezen, Verleiding en verzet van Willem Brakman's lezer*, Muiderberg: Coutinho.

—— 1989, 'The Narrative of Perception and the Perception of Narrative', *Poetics Today*, X, 4 (Winter 1989), pp. 819–40.

—— 1990, *De verwoording van verwording: Zelfverlies in Nightwood van Djuna Barnes*, Amsterdam: Perdu.

Bakhtin, Mikhail, 1986 (1920–23), 'Avtor i geroi v estetichickoi deyatel' nosti', in *Estetika slovesnogo tvorchestva*, Moscow: Isskusstvo, pp. 9–191. French translation, 1984: 'L'auteur et le heros' in Mikhail Bakhtin, *Esthétique de la création verbale*, trans. Alfreda Aucouturier, Paris: Gallimard. English translation, 1990: 'Author and Hero in Aesthetic Activity' in Mikhail Bakhtin, *Art and Answerability. Early Philosophical Essays by M. M. Bakhtin*, ed. by H. Holquist and V. Liapunov, Austin: University of Texas Press.

Bal, Mieke, 1985 (1988) *Narratology: Introduction to the Theory of Narrative*, Toronto: University of Toronto Press.

—— 1986, *Femmes Imaginaires: L'ancien testament au risque d'un narratologie critique*, Utrecht: Hes; Paris: Nizet; Montréal: Hubertise.

—— 1991, *Reading Rembrandt; Beyond the Word-Image Opposition*, Cambridge: Cambridge University Press.

Bal, Mieke and Norman Bryson, 1991, 'Semiotics and Art History', *The Art Bulletin* LXXII, 2 (June, 1991), pp. 174–208.

Barnes, Djuna, 1979 (1936), *Nightwood*, with a preface by T. S. Eliot, London and Boston: Faber and Faber.

Barthes, Roland, 1975, *Roland Barthes par Roland Barthes*, Paris: Ed. du Seuil.

—— 1980, *La chambre claire. Note sur la photographie*, Paris: Cahiers du Cinéma, Gallimard, Ed. du Seuil. English translation, 1982: *Camera Lucida. Reflections on Photography*, trans. Richard Howard, London: Fontana.

Bataille, Georges, 1957, *L érotisme*, Paris: 10/18.

Baxandall, Michael, 1985, *Patterns of Intention: On the Historical Explanation of Pictures*, New Haven: Yale University Press.

Benveniste, Emile, 1966, *Problèmes de linguistique générale*, Paris: Gallimard.

Berger, John, 1972, *Ways of Seeing*, London: Penguin.

—— 1980, 'Francis Bacon and Walt Disney', *About Looking*, New York: Pantheon Books, pp. 111–18.

Bernheimer, Charles, 1989, 'Manet's *Olympia*: The Figuration of Scandal', *Poetics Today* X, 2 (Summer 1989), pp. 255–78.

Bersani, Leo, 1986, *The Freudian Body: Psychoanalysis and Art*, New York: Columbia University Press.

—— 1987, 'Is the Rectum a Grave?', *October* 43 (Winter 1987), pp. 197–223.

Bloom, Harold, 1973, *The Anxiety of Influence: A Theory of Poetry*, New York: Oxford University Press.

Blotkamp, Carel, 1984, *Triptieken in Stijl*, Amsterdam: VU uitgeverij.

Bois, Yve-Alain, 1990, *Painting as Model*, Cambridge MA: MIT Press.

Brakman, Willem, 1989, *De vadermoorders*, Amsterdam: Querido.

Bronfen, Elisabeth, 1987, 'Wandering in Mind or Body: Death, Narration and Gender in Djuna Barnes' Novel *Nightwood*', *Amerikastudien: American Studies (Amst)* 33, pp. 167–77.

Brooks, Peter, 1984, *Reading for the Plot: Design and Intention in Narrative*, New York: Knopf.

Brown, Norman O., 1959, *Life against Death*, Middletown, Iowa: Wesleyan University Press.

Brugman, Margret, 1982, 'Androgynie – Loon voor wilskracht versus vrolijke versplintering. Mogelijkheden en beperkingen van een ideaal', *Tijdschrift voor Vrouwenstudies*, X, 2, pp. 180–96.

Bryson, Norman, 1983, *Vision and Painting: The Logic of the Gaze*, New Haven and London: Yale University Press.

—— 1984, *Tradition and Desire: From David to Delacroix*, New York: Cambridge University Press.

—— 1992, 'Géricault and masculinity' in Norman Bryson, Michel Holly and Keith Moxey, eds., *The Politics of Looking*    (in press).

Chalumeau, Jean-Luc, 1978, 'Sur les crucifixions', *Opus International*, 68 (Summer 1978), pp. 16–17.

Chase, Cynthia, 1986, *Decomposing Figures: Rhetorical Readings in the Romantic Tradition*, Baltimore: Johns Hopkins University Press.

Clark, T. J., 1985, *The Painting of Modern Life: Paris in the Art of Manet and his Followers*, London: Thames and Hudson.

Crary, Jonathan, 1990, *Techniques of the Observer: On Vision and Modernity in the Nineteenth Century*, Cambridge MA: MIT Press.

Culler, Jonathan, 1981a, 'Apostrophe', *The Pursuit of Signs: Semiotics, Literature, Deconstruction*, Ithaca: Cornell University Press, pp. 135–54.

—— 1981b, 'Story of Discourse in the Analysis of Narrative' in *The Pursuit of Signs: Semiotics, Literature, Deconstruction*, Ithaca: Cornell University Press, pp. 169–87.

—— 1988, *Framing the Sign: Criticism and Its Institutions*, Norman and London: University of Oklahoma Press.

Dällenbach, Lucien, 1977, *Le récit spéculaire: Essai sur la mise en abyme*, Paris: Ed. du Seuil; English translation: *The Mirror in the Text*, Cambridge: Polity Press.

Davies, Hugh M., 1975, 'Bacon's Black Triptychs', *Art in America* (May–April 1975), pp. 62–8.

Deleuze, Gilles, 1983, 'Francis Bacon: The Logic of Sensation', *Flash Art* 112 (May 1983), pp. 8–16.

—— 1984, *Francis Bacon: Logique de la sensation*, Paris: Ed. de la Différence.

Deleuze, Gilles and Félix Guattari, 1972, *L'anti-Oedipe*, Paris: Minuit.

Forge, Andrew, 1985, 'About Bacon', in Dawn Ades and Andrew Forge, *Francis Bacon*, New York: Abrams, pp. 24–31.

Foucault, Michel, 1973, *The Order of Things*, New York: Random House, Vintage Books.

Genette, Gérard, 1973, *Figures III*, Paris: Ed. du Seuil; English translation, 1980: *Narrative Discourse: An Essay in Method*, trans. Jane Lewin, Ithaca: Cornell University Press.

Gilman, Sander, 1985, 'Black Bodies, White Bodies: Toward an Iconography of Female Sexuality in Late Nineteenth-Century Art, Medicine, and Literature', *Critical Inquiry*, 12, pp. 204–42.

Gowing, Lawrence and Sam Hunter, 1989, *Francis Bacon*, with a foreword by James T. Demetrion, New York and London: Thames and Hudson.

Guillaumin, J., 1988, 'L'oeil sur le divan: Du leurre et de l'absence dans le trompe-l'oeil, dans l'art et dans la psychanalyse' in R. Court et al., *L'effet trompe-l'oeil*, Paris: Durrod.

James, William, 1890, 'The Consciousness of Self' in *The Principle of Psychology* I, New York, 1890, pp. 291–401.

Jameson, Fredric, 1983, 'Postmodernism and Consumer Society' in Hal Foster, ed., *The Anti-Aesthetic: Essays on Postmodern Culture*, Port Townsend WA: Bay, pp. 11–25.

Jefferson, Ann, 1989, 'Bodymatters: Self and Other in Bakhtin, Sartre and Barthes' in Ken Hirschkop and David Shepherd, eds., *Bakhtin and Cultural Theory*, Manchester and New York: Manchester University Press.

Johnson, Barbara, 1980, *The Critical Difference*, Baltimore: Johns Hopkins University Press.

—— 1987, *A World of Difference*, Baltimore: Johns Hopkins University Press.

Kannenstine, Louis F., 1977, *The Art of Djuna Barnes: Duality and Damnation*, New York: New York University Press.

Keller, Evelyn Fox, 1983, *A Feeling for the Organism: The Life and Work of Barbara McClintock*, New York: Freeman.

Keller, Evelyn Fox and Christine Grontkowski, 1983, 'The Mind's Eye' in Sandra Harding and Merrill B. Hintikka, eds., *Discovering Reality*, New York: Reidel Publishing Company, pp. 207–24.

Kemp, Wolfgang, 1986, *Rembrandt Die Heilige Familie, oder die Kunst, einen Vorhang zu lüften*, Frankfurt am Main: Fischer Taschenbuch Verlag.

Kibédi Varga, A., 1986, 'Récit et postmodernité' in A. Kibédi Varga, ed., *Littérature et postmodernité*, Groningue: Cahiers de recherches des instituts néerlandais de langue et de littérature françaises.

—— 1989, *Discours, récit, image*, Bruxelles: Pierre Mardaga.

Krauss, Rosalind, 1976, 'Notes on the Index. Seventies Art in America' in *October* 3 (Winter 1976–77), pp. 68–81.

—— 1983, 'Sculpture in the Expanded Field', in Hal Foster, ed., *The Anti-Aesthetic: Essays on Postmodern Culture*, Port Townsend WA: Bay, pp. 31–43.

—— 1990, 'The Blink of an Eye', in David Caroll, ed., *The States of 'Theory', History, Art, and Critical Discourse*, New York: Columbia University Press, pp. 175–200.

Kroker, Arthur, 1987, 'Panic Value: Bacon, Colville, Baudrillard and the Aesthetics of Deprivation', John Fekete, ed., *Life after Postmodernism: Essays on Value and Culture*, New York: St. Martin's Press.

Laessøe, Rolf, 1983, 'Francis Bacon and T. S. Eliot', *Hafnia, Copenhagen Papers in The History of Art* 9, pp. 113–30.

Lankheit, Klaus, 1959, *Das Triptychon als Pathosformel*, Heidelberg: Carl Winter Universitätsverlag.

Laplanche, Jean, 1970, *Life and Death in Psychoanalysis*, trans. Jeffrey Mehlman, Baltimore and London: Johns Hopkins University Press.

Lasalle, Hélène, 1985, 'Les miroirs opaques de Francis Bacon', *Cahiers de psychologie de l'art et de la culture* 11 (Autumn 1985), pp. 63–74.

Leiris, Michel, 1983, *Francis Bacon: Full Face and in Profile*, New York: Rizzoli.

Lyotard, Jean-Francois, 1989, *The Postmodern Condition: A Report on Knowledge*, trans. by Geoff Bennington and Brian Massum, Minneapolis: University of Minnesota Press.

McHale, Brian, 1987, *Postmodernist Fiction*, New York and London: Methuen.

Merleau-Ponty, Maurice, 1964, *Le Visible et l'invisible*, Paris: Gallimard.

Moorhouse, Paul, 1989 'A Magnificent Armature: The Crucifixion in Bacon's Art in *Art International* 8 (Autumn 1989), pp. 23–7.

Mulvey, Laura, 1975, 'Visual Pleasure and Narrative Cinema', *Screen* XVI, 3, pp. 6–18.

Muybridge, Eadweard, 1979, *Muybridge's Complete Human and Animal Locomotion: All 781 Plates from the 1887 'Animal Locomotion'*, New York: Dover Publications.

Ooka, Makoto, 1978, 'Le crucifié parle', *L'arc* 73, pp. 25–26.

Pavel, Thomas G., 1985, *The Poetics of Plot: The Case of English Renaissance Drama*, Minneapolis: University of Minnesota Press.

Pechey, Graham, 1989, 'On the Borders of Bakhtin: Dialogisation, Decolonisation', in Ken Hirschhop and David Shepherd, eds., Manchester and New York: Manchester University Press, pp. 39–67.

Peirce, Charles S., 1955, *Philosophic Writings of Peirce*, New York: Dover Publications.

*Polyptiques: Le tableau multiple du moyen âge au vingtième siècle*, 1990, Paris: Réunion des musées nationaux.

Pradel, Jean Louis, 1978, 'Velásquez – Bacon' *Opus International* 68 (Summer 1978), pp. 18–20.

Rothenstein, Sir John and Ronald Alley, 1964, *Francis Bacon*, catalogue raisonné, London: Thames and Hudson.

Russell, John, 1971, *Francis Bacon*, London: Thames and Hudson.

Sass, Louis, A., 1987, 'Introspection, Schizophrenia and the Fragmentation of Self', *Representation* 19 (Summer 1987), pp. 1–34.

Saunders, Gill, 1989, *The Nude: A New Perspective*, New York: Harper and Row.

Scarry, Elaine, 1985, *The Body in Pain: The Making and Unmaking of the World*, New York and Oxford: Oxford University Press.

Silverman, Kaja, 1988, 'Masochism and Male Subjectivity', *Camera Obscura* 17, pp. 31–68.

—— 1989, 'Fassbinder and Lacan: A Reconsideration of Gaze, Look and Image', *Camera Obscura* 19, pp. 55–85.

Smith, Paul, 1988, 'Vas', *Camera Obscura* 17, pp. 89–112.

Stanzel, F. K., 1984 (1979), *A Theory of Narrative*, trans. from the German by C. Goedsche, Cambridge: Cambridge University Press.

Steiner, Wendy, 1988, *Pictures of Romance: Form Against Context in Painting and Literature*, Chicago and London: University of Chicago Press.

Sylvester, David, 1987 (1975), *The Brutality of Fact: Interviews with Francis Bacon*, London: Thames and Hudson.

Thiher, Allen, 1984, *Words in Reflection: Modern Language Theory and Postmodern Fiction*, Chicago and London: University of Chicago Press.

Todorov, Tzvetan, 1977, *The Poetics of Prose*, trans. from the French by Richard Howard, Ithaca: Cornell University Press.

Tronche, Anne, 1978, 'Entretien entre Rene Major et Anne Tronche', *Opus International* 68 (Summer 1978), pp. 28–31.

Trucchi, Lorenza, 1978, 'Dix paragraphes pour Francis Bacon', *L'arc* 73, pp. 4–11.

Zimmermann, Jörg, 1986, *Francis Bacon Kreuzigung: Versuch, eine gewalttätige Wirklichkeit neu zu sehen*, Frankfurt am Main: Fischer.

# List of Illustrations

Measurements are given in centimetres.
Photo: Marlborough = Photos courtesy of Marlborough Fine Art, London.

Arts Trust; Nathan Emory Coffin Collection of the Des Moines Art Center.

41 *Study for a Human Body (Man Turning on the Light)*, 1973–74, oil and acrylic on canvas (198 × 147.5). Royal College of Art, London.

42, 43, 44 *Triptych March 1974*, oil on canvas (each panel 198 × 147.5). Private collection, Madrid. Photo: Marlborough.

45, 46, 47 *Three Portraits: Posthumous Portrait of George Dyer, Self Portrait, Portrait of Lucian Freud*, 1973, oil on canvas (triptych, each panel 198 × 147.5). Private collection. Photo: Marlborough.

48 *Fragment of a Crucifixion*, 1950, oil and cotton wool on canvas (139.7 × 108.6). Stedelijk van Abbemusum, Eindhoven.

49, 50, 51 *Three Studies for a Crucifixion*, 1962, oil and sand on canvas (triptych, each panel 198.2 × 144.8). Solomon R. Guggenheim Museum, New York.

52, 53, 54 *Crucifixion 1965*, acrylic and oil on canvas (triptych, each panel 197.2 × 147). Staatsgalerie Moderner Kunst, Munich, gift of the Galerie-Vereins.

55 *Painting 1946*, oil on canvas (198.1 × 132.1). The Museum of Modern Art, New York.

56 *Figure with Meat*, 1954, oil on canvas (129.9 × 122). Art Institute of Chicago, Harriott A. Fox Fund.

57 *Study for Portrait II (after the Life Mask of William Blake)*, 1955, oil on canvas (61 × 50.1). The Trustees of the Tate Gallery, London.

58 *Study for Portrait III (after the Life Mask of William Blake)*, 1955, oil on canvas (60 × 51). Capricorn Art International SA, Panama. Photo: Marlborough.

59 *Study for Portrait*, 1949, oil on canvas (147.3 × 130.8). Museum of Contemporary Art, Chicago.

60 *Pope I*, 1951, oil on canvas (198 × 137). Aberdeen Art Gallery and Museums. Photo: City of Aberdeen Art Gallery and Museums Collections.

61 Rembrandt van Rijn, *The Holy Family with Painted Frame and Curtain*, 1646, oil on canvas (46.5 × 68.8). Gemäldegalerie, Kassel.

62, 63, 64 *Three Studies for Portraits including Self Portrait*, 1969, oil on canvas (triptych, each panel 35.5 × 30.5). Private collection. Photo: Marlborough.

65, 66 *Studies of George Dyer and Isabel Rawsthorne*, 1970, oil on canvas (diptych, each panel 35.5 × 30.5). Private collection. Photo: Marlborough.

67, 68, 69 *Triptych – Studies of the Human Body*, 1970, oil on canvas (each panel 198 × 147.5). Marlborough Fine Art, London. Photo: Marlborough.

70 *Two Figures*, 1953, oil on canvas (152.5 × 116.5). Private collection. Photo: Marlborough.

71 *Two Figures in the Grass*, 1954, oil on canvas (152 × 117). Private collection. Photo: Marlborough.

72 *Head VI*, 1949, oil on canvas (93.2 × 76.5). Arts Council Collection, London.

73 *Study for Portrait of John Edwards*, 1988, oil on canvas (198 × 147.5). Collection of Richard Nagy. Photo: Marlborough.

74 *Study for Portrait of Van Gogh III*, 1957, oil and sand on canvas (198.4 × 137.5). Hirshhorn Museum and Sculpture Garden, Smithsonian Institution, Washington DC; gift of the Joseph H. Hirshhorn Foundation. Photo: Lee Stalsworth.

75 *Sand Dune*, 1981, oil on canvas (198 × 147.5). Private collection. Photo: Marlborough.

76 *Landscape near Malabata, Tangier*, 1963, oil on canvas (198 × 145). Ivor Braka Limited, London. Photo: Marlborough.

77, 78, 79 *In Memory of George Dyer*, 1971, oil on canvas (triptych, each panel 198 × 147.5). Beyeler collection, Basel.

80 *Two Seated Figures*, 1979, oil on canvas (198 × 147.5). Beyeler collection, Basel.

81, 82, 83 *Triptych – Two Figures Lying on a Bed with Attendants*, 1968, oil on canvas (198 × 147.5). Location unknown. Photo: Marlborough.

84 *Study for Portrait of Van Gogh II*, 1957, oil on canvas (198 × 142). Private collection. Photo: Marlborough.

85 *Sand Dune*, 1983, oil and pastel on canvas (198 × 147.5). Beyeler collection, Basel.

86, 87, 88 *Three Studies for Portrait of Lucian Freud*, 1966, oil on canvas (triptych, each panel 198 × 147.5). Private collection. Photo: Marlborough.

89 *Self Portrait*, 1978, oil on canvas (198 × 147.5). Private collection. Photo: Marlborough.

90 *Figure in Movement*, 1976, oil on canvas (198 × 147.5). Private collection. Photo: Marlborough.

91 *Portrait of George Dyer Crouching*, 1966, oil on canvas (198 × 147.5). Private collection. Photo: Marlborough.

92 *Painting 1978*, oil on canvas (198 × 147.5). Private collection. Photo: Marlborough.

93 *Three Studies of Isabel Rawsthorne*, 1967, oil on canvas (119 × 152.5). Staatliche Museen Preussischer Kulturbesitz, Berlin. Photo: Jörg Anders.

94 *Studies from the Human Body*, 1975, oil on canvas (198 × 147.5). Collection of Gilbert de Botton, Switzerland. Photo: Marlborough.

95, 96, 97 *Triptych 1974–77*, oil and pastel on canvas (each panel 198 × 147.5). Marlborough Fine Art, London. Photo: Marlborough.

98 *Study for Bullfight No. 1*, 1969, oil on canvas (198 × 147.5). Private collection. Photo: Marlborough.

99 *Study from the Human Body*, 1981, oil on canvas (198 × 147.5). Private collection. Photo: Marlborough.

100 *Study for Portrait of Gilbert de Botton Speaking*, 1986, oil on canvas (198 × 147.5). Collection of Gilbert de Botton, Switzerland. Photo: Marlborough.

101 *Self Portrait*, 1970, oil on canvas (152 × 147.5). Private collection. Photo: Marlborough.

102 *Study for Portrait*, 1971, oil on canvas (198 × 147.5). Private collection. Photo: Marlborough.

103 *Paralytic Child Walking on All Fours (from Muybridge)*, 1961, oil on canvas (197.5 × 140.9). Haags Gemeentemuseum, The Hague.

104 *Portrait of a Dwarf*, 1975, oil on canvas (158.5 × 58.5). Private collection. Photo: Marlborough.

105 Giorgione, *The Sleeping Venus*, c. 1476, oil on canvas (108 × 175). Gemäldegalerie, Dresden.

106 Edouard Manet, *Olympia*, 1863, oil on canvas (130.5 × 190). Musée d'Orsay, Paris. Photo: Service Photographique de la Réunion des Musées Nationaux.

107 *Study for a Portrait*, 1967, oil on canvas (154.9 × 139.7). Richard E. Lang and Jane M. Davis Collection, Medina, Washington. Photo: Marlborough.

108 *Reclining Woman*, 1961, oil on canvas (78.2 × 55.7). Trustees of the Tate Gallery, London.

109 *Crucifixion 1965*, oil on canvas (right panel of triptych; 197.2 × 147). Staatsgalerie Moderner Kunst, Munich, gift of the Galerie-Vereins.

110, 111, 112 *Three Studies of the Human Head*, 1953, oil on canvas (triptych, each panel 61 × 51). Private collection. Photo: Marlborough.

113 Bodybuilders, from *Ironman* magazine, issue 3, 1990.

114 Bodybuilder, from *Ironman* magazine, issue 3, 1990.

115 *Portrait of George Dyer Riding a Bicycle*, 1966, oil on canvas (198 × 147.5). Beyeler collection, Basel.

116, 117, 118 *Triptych 1970*, oil on canvas (each panel 198 × 147.5). Australian National Gallery, Canberra.

119 Eadweard Muybridge, three frames from a set of six comprising Plate 347, 'Wrestling, Graeco-Roman' from *Human and Animal Locomotion*.

120 Anon., *The Venus of Melos*, Musée du Louvre, Paris. Photo: Service Photographique de la Réunion des Musées Nationaux.

121, 122, 123 *In Memory of George Dyer*, 1971, oil on canvas (triptych, each panel 198 × 147.5). Beyeler collection, Basel.